THE COMPACT BRICK BIBLE THE NEW TESTAMENT

A NEW SPIN ON THE STORY OF JESUS
AS TOLD AND ILLUSTRATED BY BRENDAN POWELL SMITH

LEGO is a trademark of the LEGO Group of companies which does not sponsor, authorize, or endorse this book.

This is an original, modern interpretation of the Bible, based on older public domain translations such as the King James Bible, Darby's Bible, and Young's Literal Bible. In addition, modern English Bible translations were used as references, and the author consulted the original Hebrew for certain passages.

Copyright @ 2012 by Brendan Powell Smith

New Skyhorse paperback edition 2020

All rights reserved. No part of this book may be reproduced in any manner without the express written consent of the publisher, except in the case of brief excerpts in critical reviews or articles. All inquiries should be addressed to Skyhorse Publishing, 307 West 36th Street, 11th Floor, New York, NY 10018.

Skyhorse Publishing books may be purchased in bulk at special discounts for sales promotion, corporate gifts, fund-raising, or educational purposes. Special editions can also be created to specifications. For details, contact the Special Sales Department, Skyhorse Publishing, 307 West 36th Street, 11th Floor, New York, NY 10018 or info@skyhorsepublishing.com.

Skyhorse® and Skyhorse Publishing® are registered trademarks of Skyhorse Publishing, Inc.®, a Delaware corporation.

Visit our website at www.skyhorsepublishing.com.

10987654321

Library of Congress Cataloging-in-Publication Data is available on file.

Cover design by Brian Peterson Cover photo credit: Brendan Powell Smith

Print ISBN: 978-1-5107-5257-3 Ebook ISBN: 978-1-62087-902-3

Printed in China

CONTENTS

I. THE GOSPELS - PAGE 8

JESUS IS BORN JESUS BAPTIZED BY JOHN THE BAPTIST SATAN TEMPTS JESUS **CALL OF THE DISCIPLES** WATER INTO WINE HEALING OF A LEPER JESUS TEACHES IN THE SYNAGOGUES SERMON ON THE PLAIN DEMONIAC CURED AT GERASA SERMON ON THE MOUNT JESUS REJECTED IN NAZARETH JOHN THE BAPTIST BEHEADED BY KING HEROD FEEDING OF THE FIVE THOUSAND JESUS WALKS ON WATER PARABLE OF THE GOOD SAMARITAN DISCIPLES SENT OUT PARABLE OF THE UNFORGIVING SERVANT PARABLE OF THE TALENTS PARABLE OF THE RICH MAN AND THE BEGGAR LAZARUS BROUGHT BACK FROM THE DEAD THE CLEANSING OF THE TEMPLE PARABLE OF THE WICKED HUSBANDMEN PARABLE OF THE GREAT BANQUET PHARISEES BRING ADULTERESS BEFORE JESUS THE WIDOW'S OFFERING THE SIGNS OF THE END TIMES THE LAST SUPPER JESUS IS ARRESTED JESUS IS TRIED BEFORE HEROD AND PILATE THE CRUCIFIXION THE EMPTY TOMB

JESUS APPEARS TO THE DISCIPLES

II. ACTS OF THE APOSTLES - PAGE 150

NEW APOSTLE CHOSEN THE STORY OF PENTECOST ANANIAS AND SAPPHIRA ANGEL LETS APOSTLES OUT OF JAIL THE DEATH OF STEPHEN SAUL PERSECUTES THE CHRISTIANS SAUL BLINDED ON ROAD TO DAMASCUS ANOTHER ANGEL LETS APOSTLES OUT OF JAIL THE DEATH OF HEROD PAUL AND THE CYPRUS MAGICIAN PAUL AND TIMOTHY'S TRAVELS PAUL IN ATHENS SPEAKING IN TONGUES THE SEVEN SONS OF SCEVA PAUL'S ALL-NIGHT SPEECH

III. REVELATION OF JOHN - PAGE 184

JOHN RECEIVES HIS VISION
THE FOUR LIVING CREATURES
THE LAMB OF GOD AND THE SCROLL
THE FOUR HORSEMEN OF THE APOCALYPSE
THE SEVEN SEALS
THE SEVEN TRUMPET BLASTS
THE GREAT RED DRAGON
THE BEAST FROM THE SEA
THE BEAST FROM THE GROUND
THE COMING OF THE SON OF MAN
BABYLON THE GREAT
THE BATTLE OF ARMAGEDDON
THE FINAL JUDGMENT
THE NEW PARADISE ON EARTH

by illustrating an old familiar book, the New Testament, with an old familiar toy, LEGO bricks. Smith uses direct quotes from the Bible to maintain the intent of the text, which he combines with modern language to make the stories easier for the reader to understand Each story is told as close to the original as possible.

Many people have the desire to read the Bible, but find it difficult for a number of

TO DO THE TOTAL OF THE PROPERTY OF THE PROPERT

easons. Many feel intimidated because they don't think they will be able to understand i Smith has created a Bible for adults that has simple, relatable pictures. This bold attempt o introduce the stories of the New Testament to readers who may not be as likely to a end church services or pick up and read the Bible is long overdue.

For those who have read the Bible, often the interpretation of its stories come not from one's own experiences, but rather from the understanding of others that has peen passed down from generation to generation. With this unconventional method o using toys to illustrate the New Testament. Smith courageously challenges us to read and e-read scriptural text through a new lens. This book challenges the conventional interpre

ations of Biblical text and pushes the reader to think beyond what he or she may have been taught in the past—whether at home, at school, at church, or elsewhere. Seeing the Bible in a new light provides the opportunity for the reader to consider a different interpre

ation and to even question his or her preconceived notions and beliefs. This version of the New Testament is structured around the story of Jesus-his pirth, teachings, and death-and also includes the story of Paul, It ends, of course, with Revelation. Additionally, Jesus's teachings are set in a modern-day context to bring his

vords greater meaning.

This book is for people who feel that the Bible is not relevant today. It is for those who feel the Bible is outdated and the stories only relate to people of long ago. With the ise of a familiar toy. Smith demonstrates that the Rible is not a sterile book and it does no begin to see how the Biblical stories of old also relate directly to the present. The Bible then comes alive once readers begin to understand the stories and find them relevant to their own lives, and Smith's rendition of the New Testament allows for just this to happen.

You may wonder, can God's word be understood in today's world through the use of pictures? Picture books are usually reserved for children, with the assumption that children can better understand a picture and then connect it to words. Art has been used for centuries, however, to demonstrate various interpretations of scriptural text. With the use of a familiar toy and modern language, this Bible recognizes the importance of illustrations for all ages and certainly proves that a picture really is worth a thousand words.

You are invited to read the stories of the New Testament for the first time or to re-read sections with a more open mind. Whether you are a Biblical scholar or a first-time reader, you will be intrigued by how Smith has used the simplicity of a toy to tell of the mighty acts of God in the world. Some stories within will confirm what the reader already believes. Many of the stories may seem to contradict what the reader has experienced as his or her truth. Either way, Smith has created a new conversation around these timeless stories of the New Testament.

Above all, The Brick Bible: The New Testament encourages you to read the Bible.

Wanda M. Lundy Professor of Ministry Studies New York Theological Seminary

PART I. THE GOSPELS

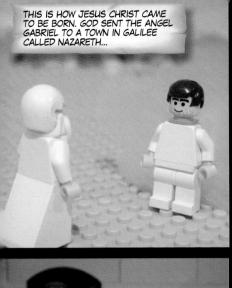

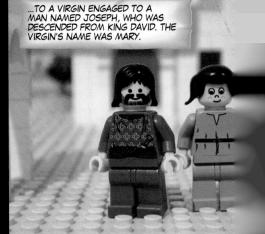

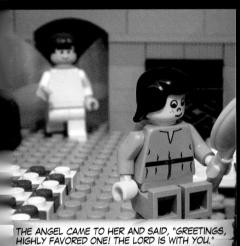

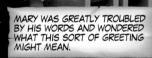

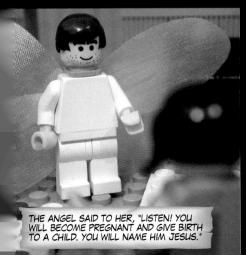

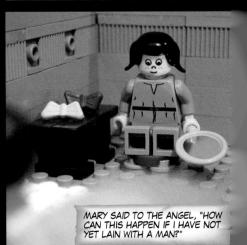

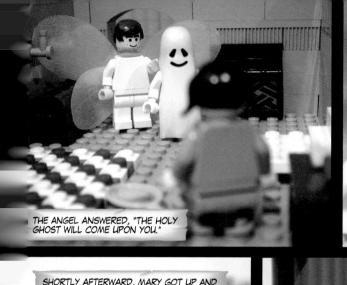

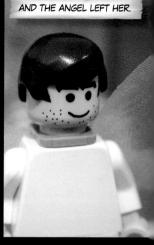

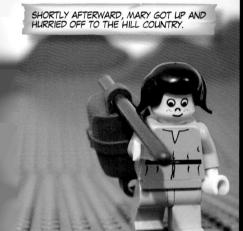

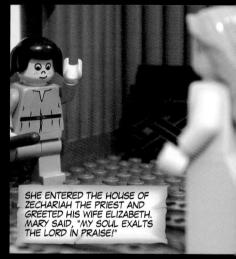

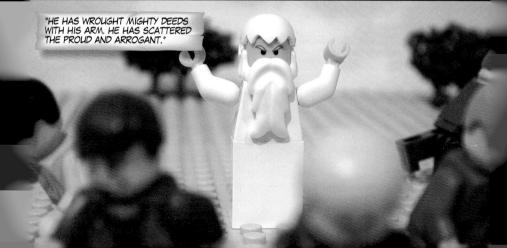

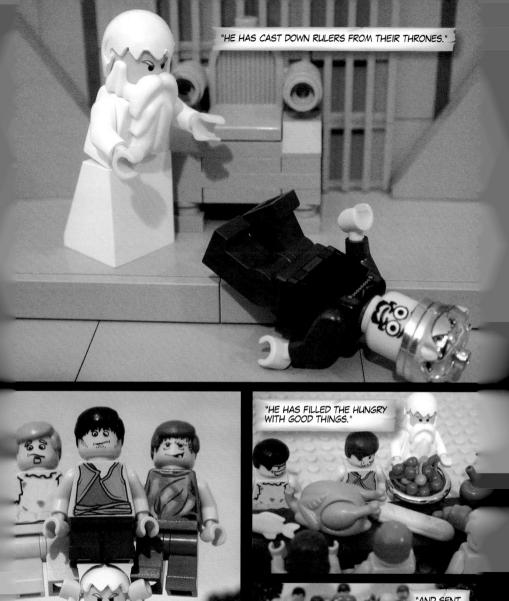

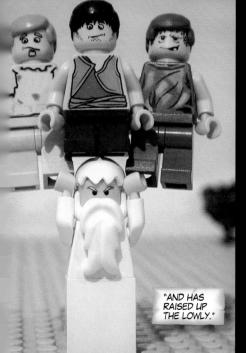

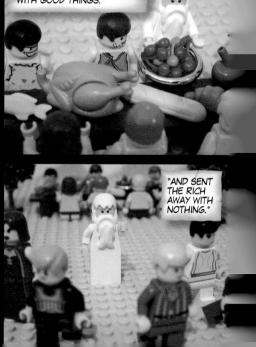

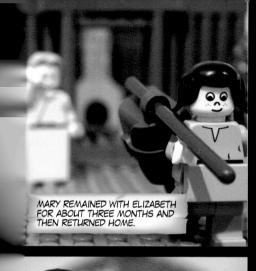

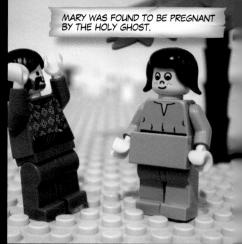

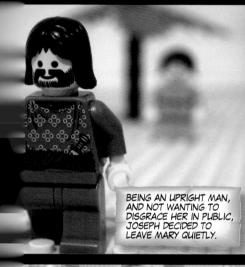

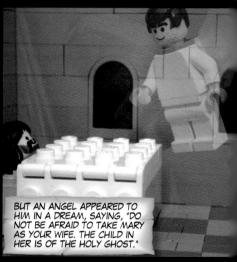

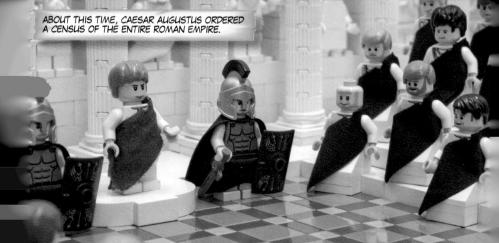

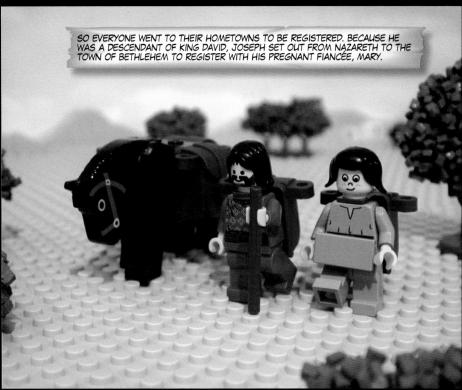

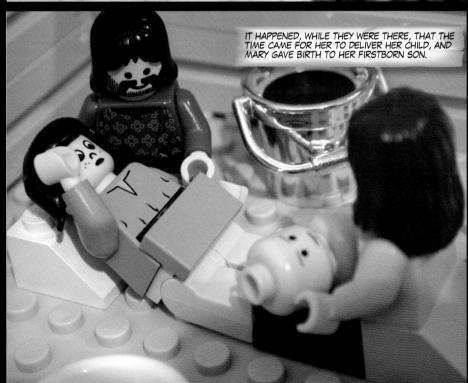

Lk 2:1, 2:3-5 | Lk 2:6-7

SHE WRAPPED HIM IN SWADDLING CLOTHES AND LAID HIM IN A MANGER, BECAUSE THERE WAS NO ROOM FOR THEM AT THE INN. NOW THERE WERE SOME SHEPHERDS OUT IN THE NEARBY FIELDS, KEEPING WATCH OVER THEIR FLOCKS AT NIGHT.

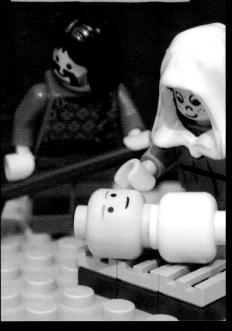

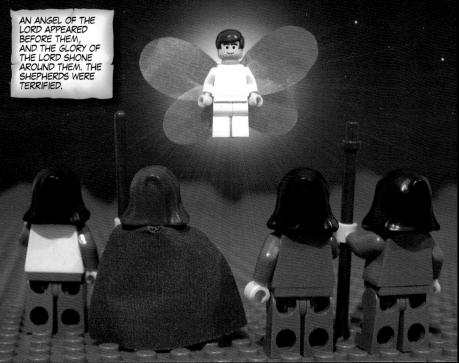

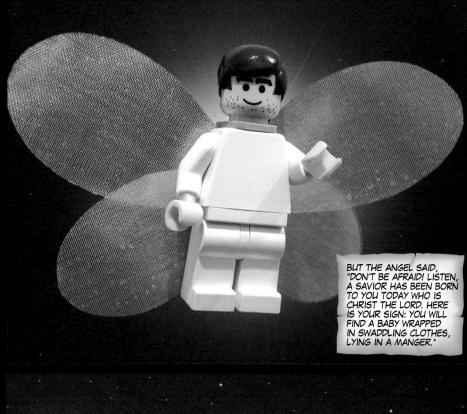

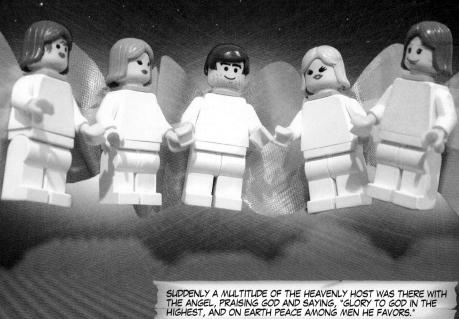

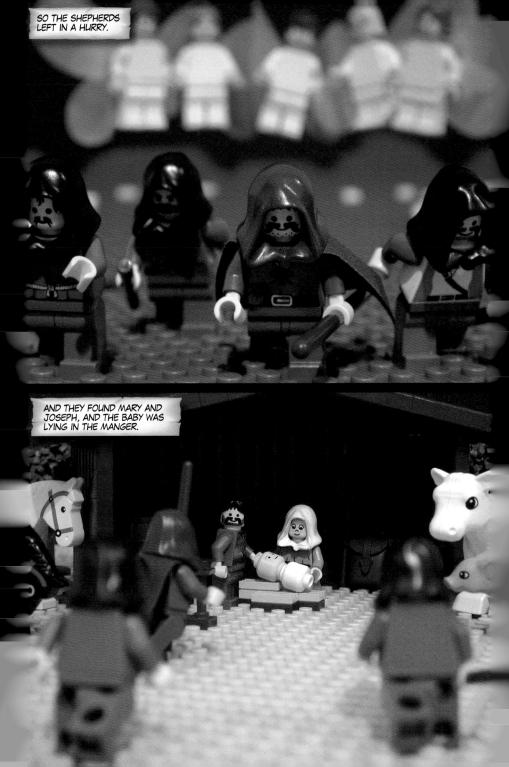

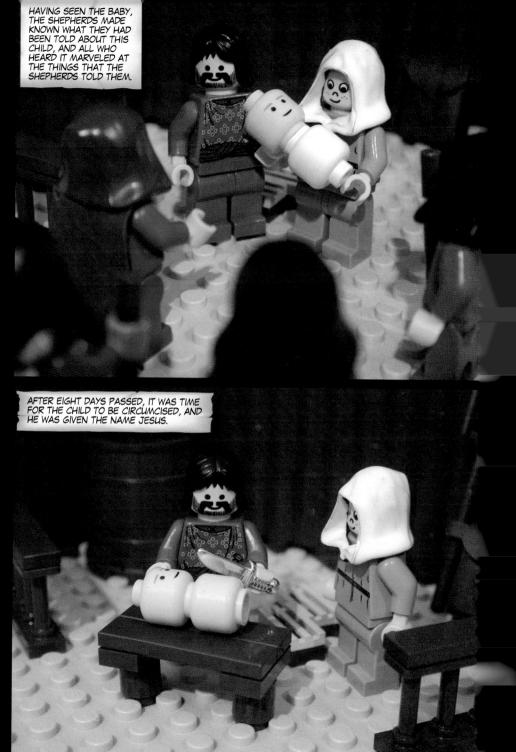

AFTER JESUS WAS BORN IN BETHLEHEM IN THE DAYS OF KING HEROD, SOME MAGI FROM THE EAST CAME TO JERUSALEM, SAYING, "WHERE IS HE WHO IS BORN KING OF THE JEWS? FOR WE SAW HIS STAR WHEN IT ROSE, AND HAVE COME TO DO HIM HOMAGE."

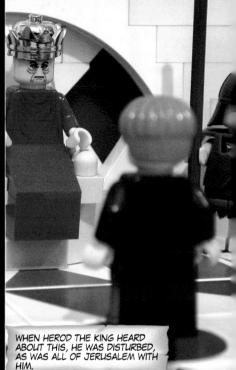

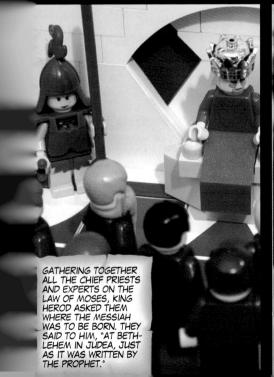

THEN KING HEROD SUMMONED THE MAGI. HE SENT THEM OFF TO BETHLEHEM, SAYING, "GO AND SEARCH FOR THE YOUNG CHILD. WHEN YOU HAVE FOUND HIM, LET ME KNOW, SO THAT I MAY ALSO GO AND DO HIM HOMAGE."

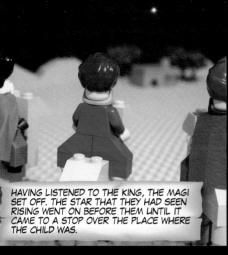

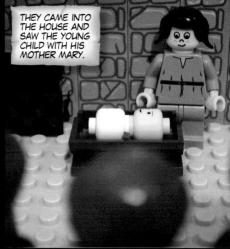

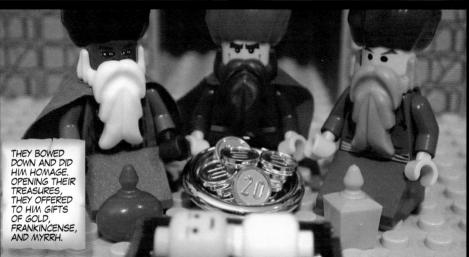

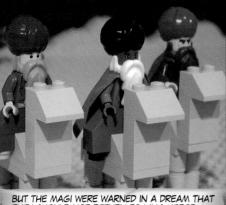

Mt 2:11

Mt 2:11

Mt 2:9

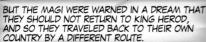

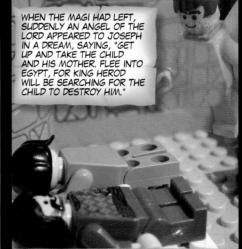

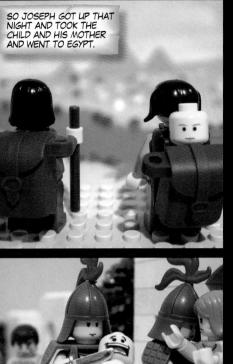

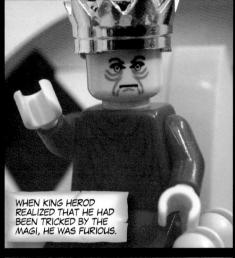

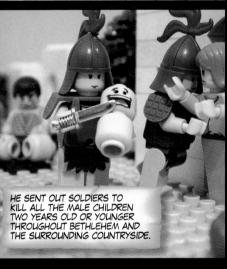

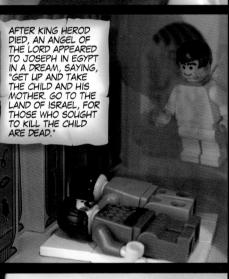

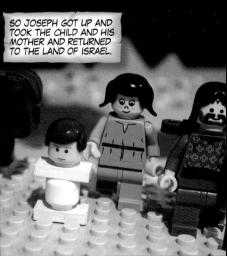

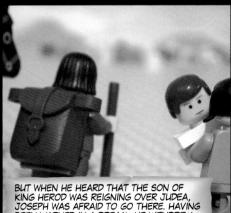

BEEN WARNED IN A DREAM, HE WITHDREW TO THE REGION OF GALLUE, AND CAME TO LIVE IN A TOWN CALLED NAZARETH.

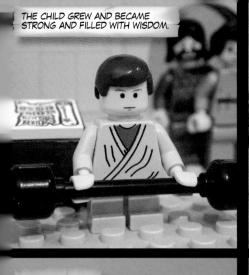

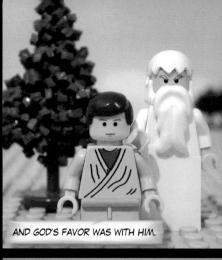

NOW IN THOSE DAYS, JOHN THE BAPTIST CAME INTO THE DESERT OF JUDEA. HE WORE CLOTHING MADE FROM CAMEL'S HAIR WITH A LAROUND HIS WAIST, AND HIS FOOD WAS LOCUSTS AND WILD HONEY.

HE WENT INTO THE REGION AROUND THE JORDAN RIVER, PREACHING A BAPTISM OF REPENTANCE FOR THE FORGIVENESS OF SINS, SAYING, "REPENT! FOR THE KINGDOM OF HEAVEN DRAWS NEAR!"

THE WHOLE JUDEAN
COUNTRYSIDE AND ALL
OF JERUSALEM WERE
GOING OUT TO HIM,
AND JOHN SAID TO THE
CROWDS COMING OUT
TO BE BAPTIZED BY HIM,
"YOU OFFSPRING OF
SNAKES! WHO WARNED
YOU TO FLEE FROM THE
COMING WRATH?"

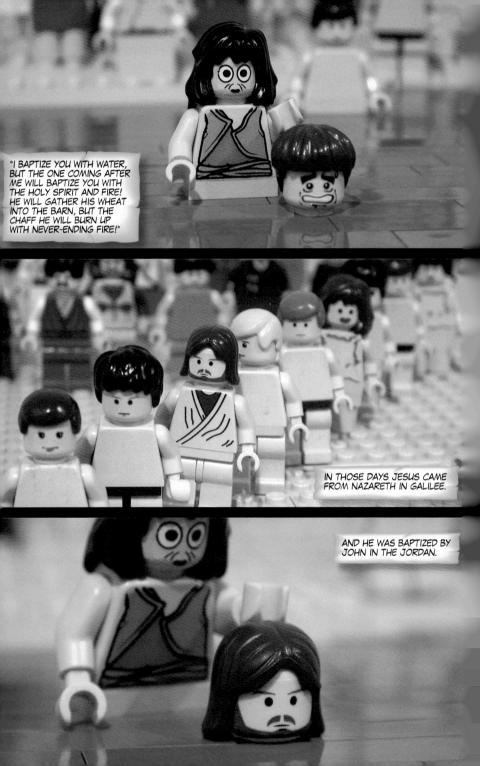

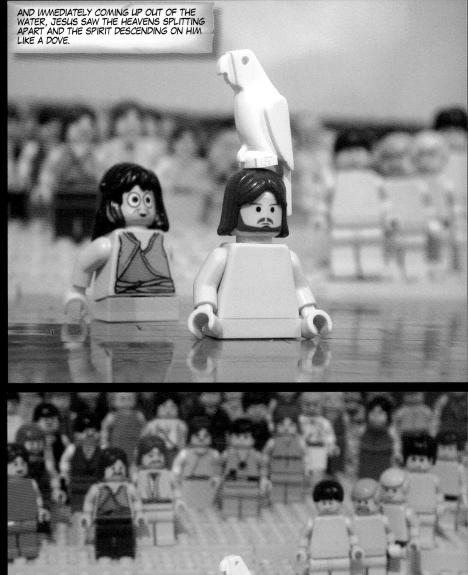

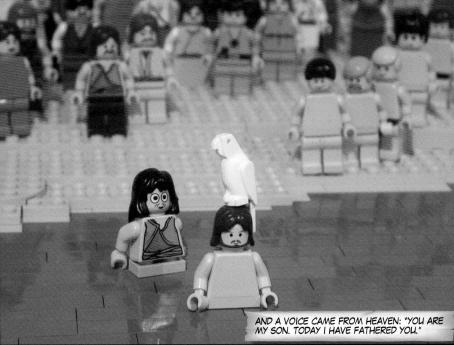

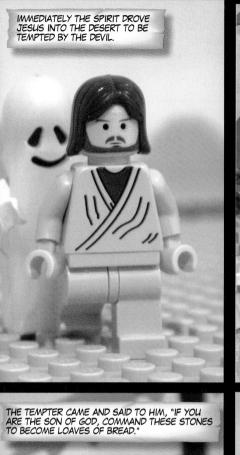

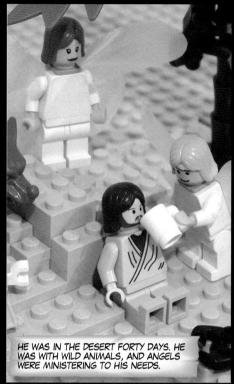

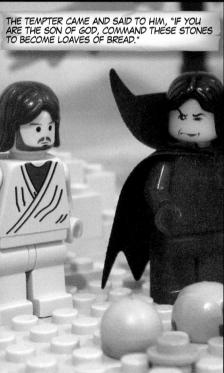

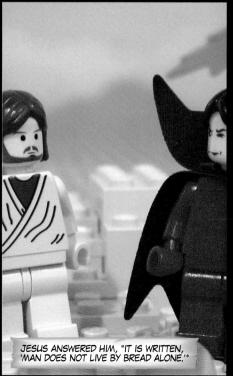

Mk 1:12; Mt 4:1 | Mk 1:13

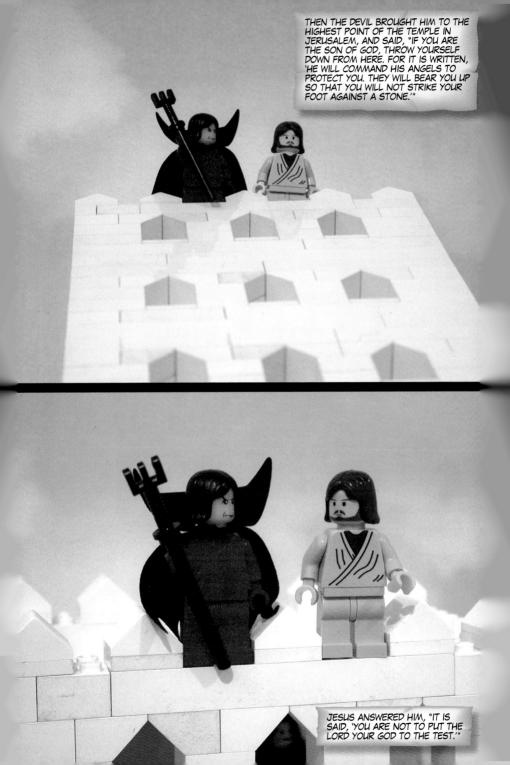

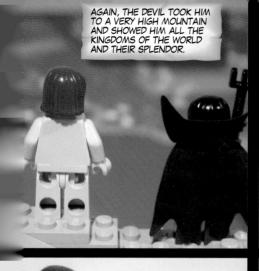

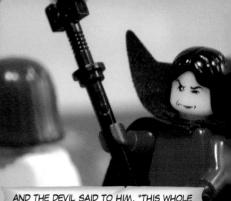

AND THE DEVIL SAID TO HIM, "THIS WHOLE REALM HAS BEEN GRANTED TO ME, AND I CAN GIVE IT TO WHOMEVER I WISH. IF YOU WORSHIP ME, IT SHALL ALL BE YOURS."

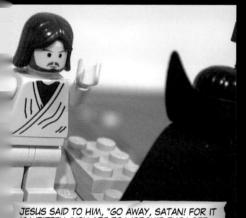

JESUS SAID TO HIM, "GO AWAY, SATAN! FOR IT IS WRITTEN: "YOU ARE TO WORSHIP THE LORD YOUR GOD AND SERVE ONLY HIM."

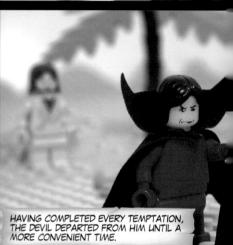

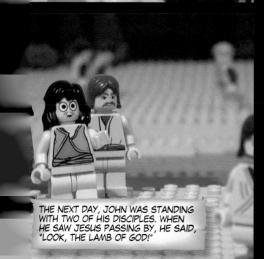

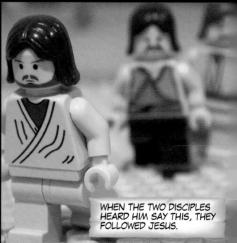

THEY SAID, "RABBI, WHERE ARE YOU STAYING?" AND HE SAID TO THEM, "COME AND SEE."

SO THEY CAME AND SAW WHERE HE WAS STAYING, AND THEY STAYED WITH HIM THAT DAY, IT BEING FOUR O'CLOCK IN THE AFTERNOON.

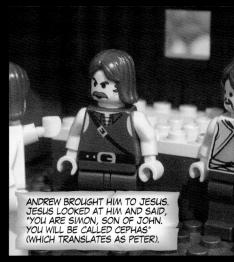

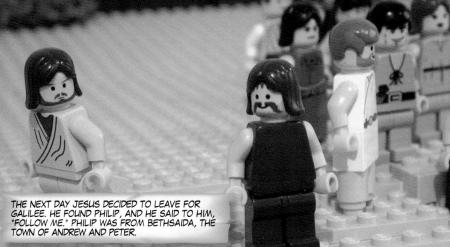

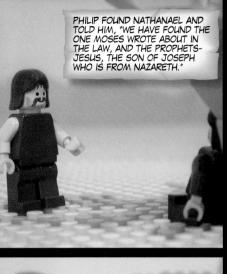

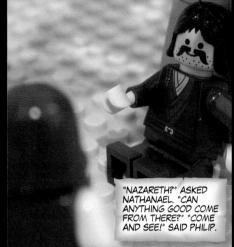

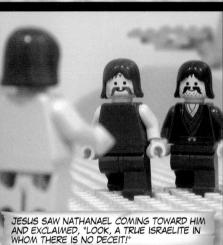

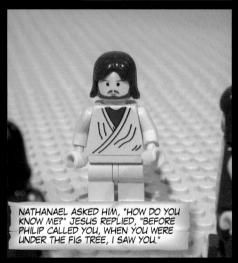

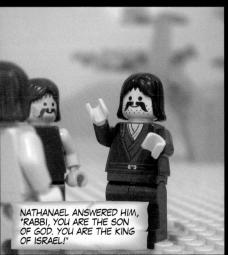

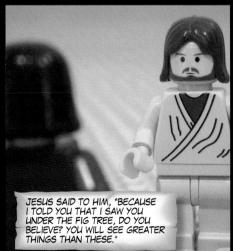

Jn 1;45 | Jn 1;46 | Jn 1;47 | Jn 1;48 | Jn 1;49 | Jn 1;50

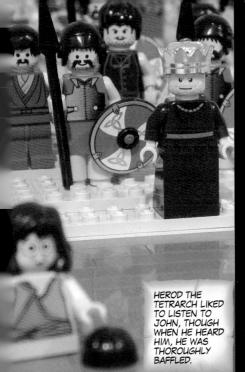

AND JOHN REBUKED HEROD ON ACCOUNT OF HERODIAS, HIS BROTHER PHILIP'S WIFE, BECAUSE HEROD HAD MARRIED HER. JOHN REPEATEDLY TOLD HEROD, "IT IS NOT LAWFUL FOR YOU TO HAVE YOUR BROTHER'S WIFE."

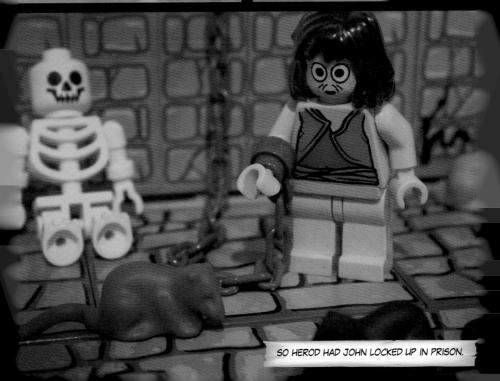

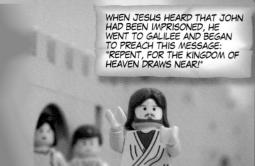

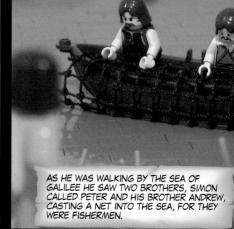

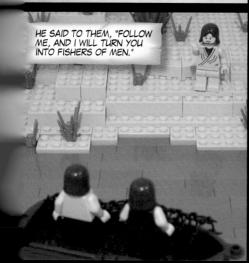

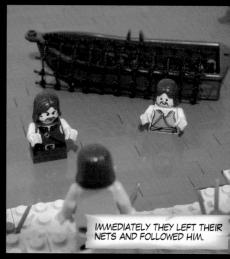

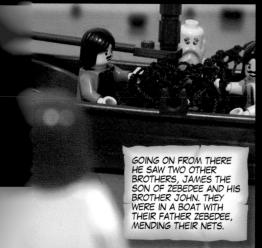

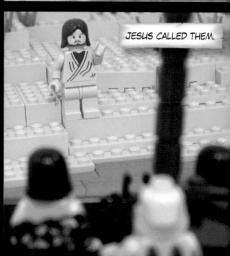

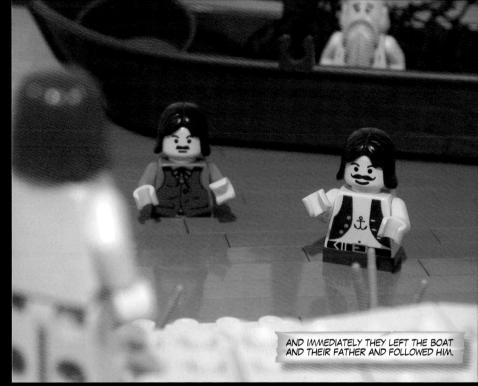

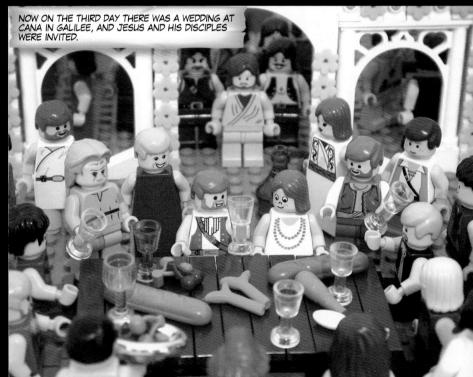

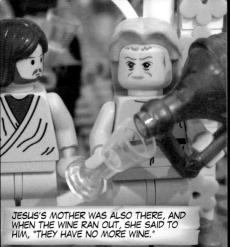

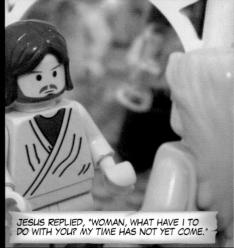

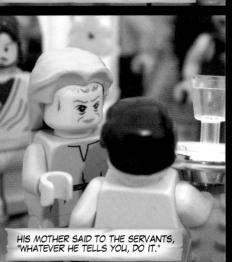

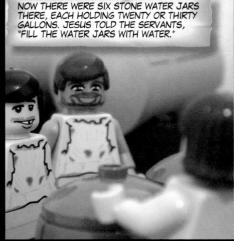

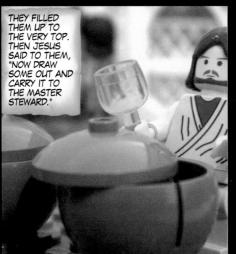

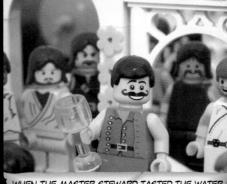

Jn 2:1, 2:3 | Jn 2:4 | Jn 2:5 | Jn 2:6-7 | Jn 2:7-8 |

WHEN THE MASTER STEWARD TASTED THE WATER THAT HAD BEEN TURNED TO WINE, HE SAID TO THE BRIDEGROOM, "EVERYONE SERVES GOOD WINE FIRST. THEN INFERIOR WINE WHEN THE GUESTS ARE DRUNK, BUT YOU HAVE SAVED THE GOOD WINE UNTIL NOW!"

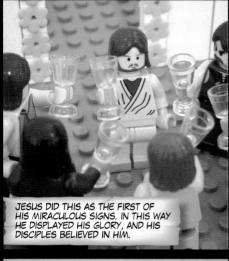

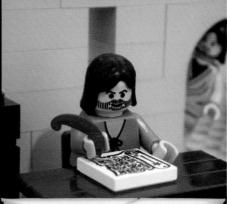

WHEN JESUS WENT OUT AFTER THIS, HE NOTICED A TAX COLLECTOR NAMED LEVI SITTING AT THE TAX OFFICE AND SAID TO HIM, "FOLLOW ME."

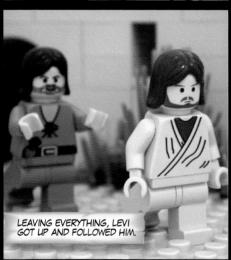

AS JESUS WAS WALKING ON FROM THERE HE SAW A MAN NAMED MATTHEW SITTING AT THE TAX OFFICE, AND HE SAID TO HIM, "FOLLOW ME."

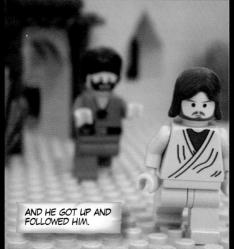

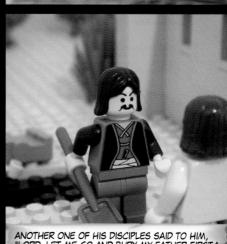

ANOTHER ONE OF HIS DISCIPLES SAID TO HIM, "LORD, LET ME GO AND BURY MY FATHER FIRST."

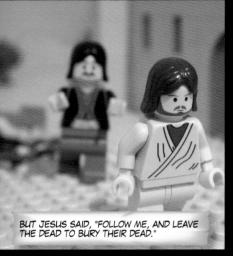

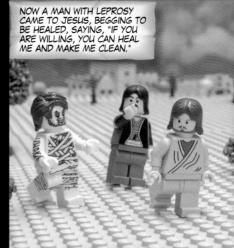

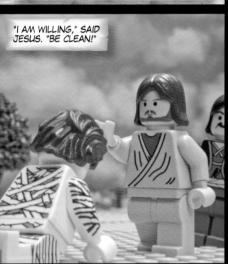

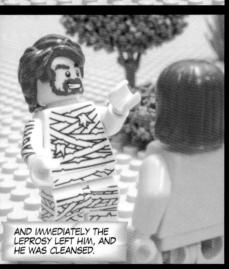

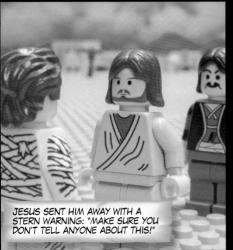

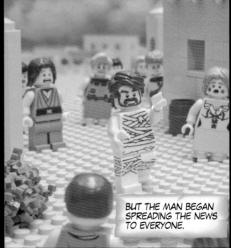

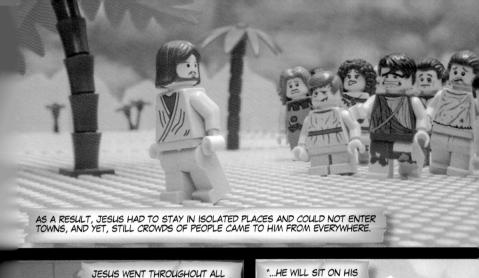

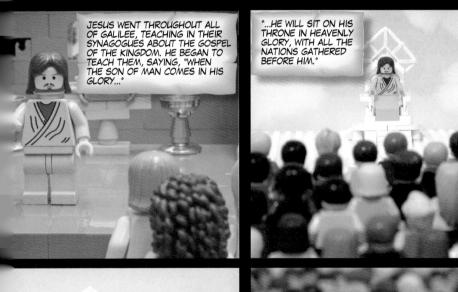

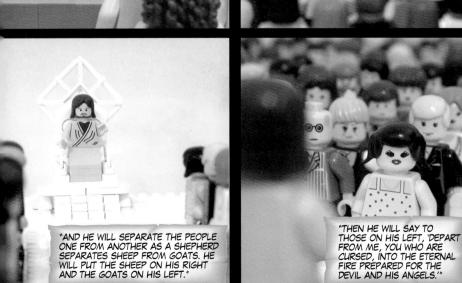

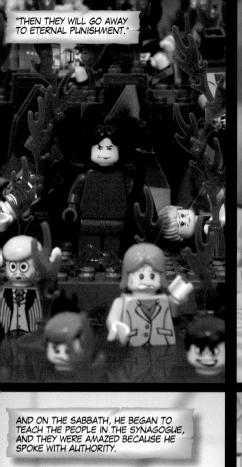

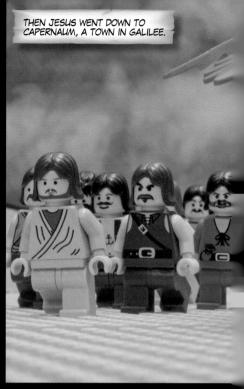

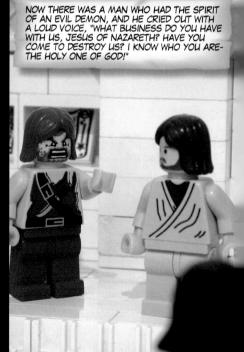

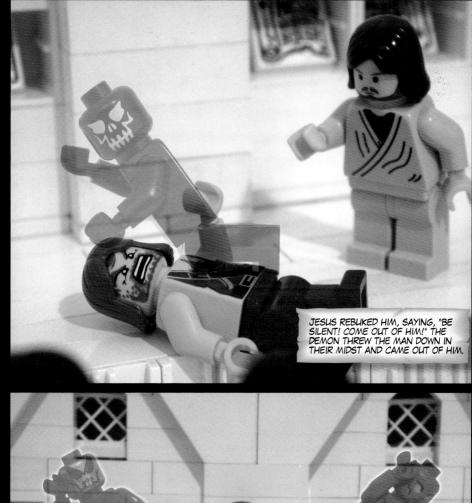

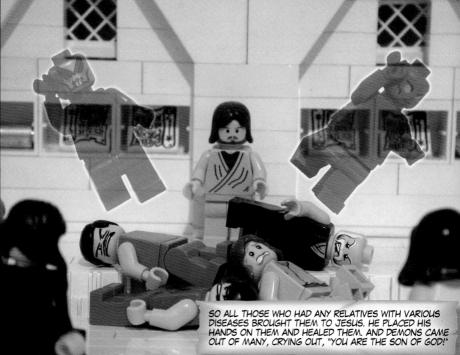

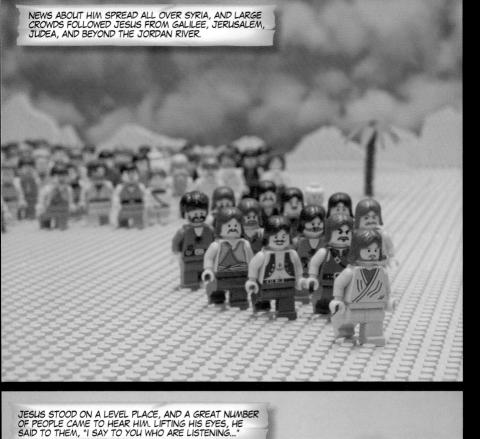

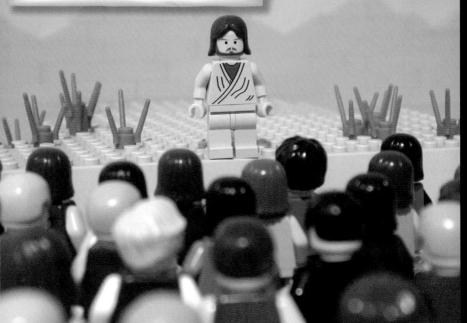

+4.24.25 | 1 | 6.17 | 6.20 | 6.27

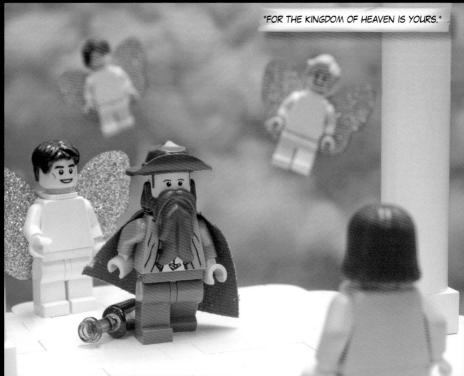

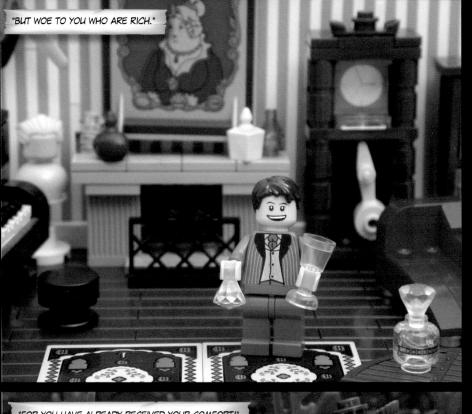

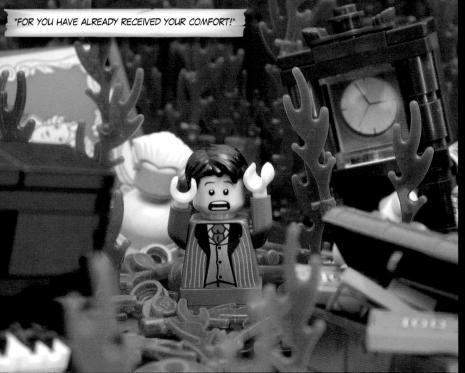

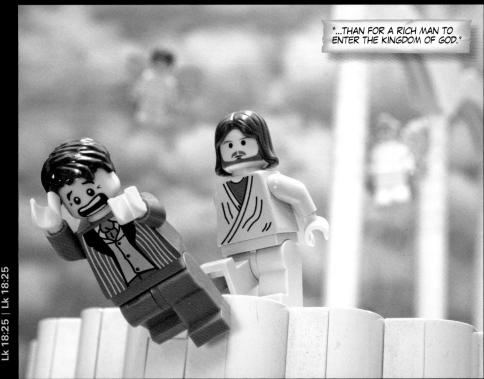

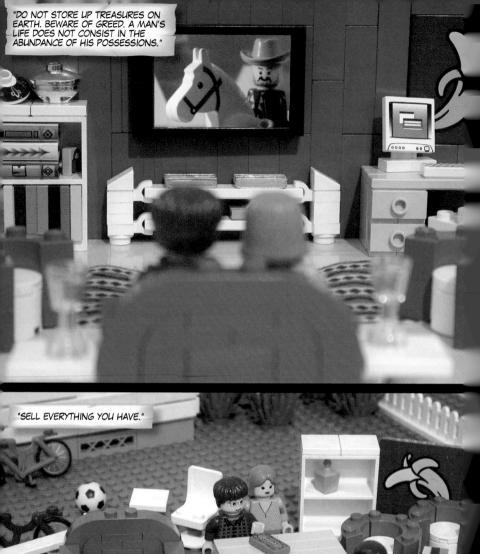

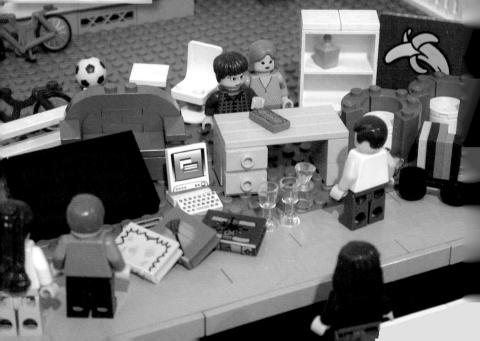

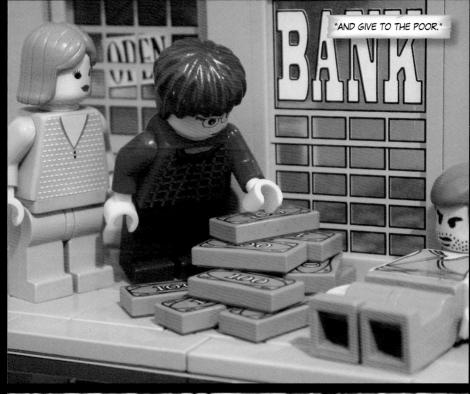

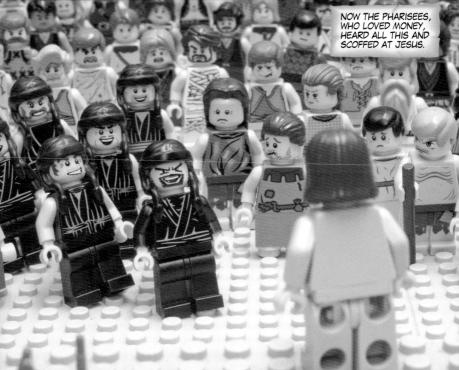

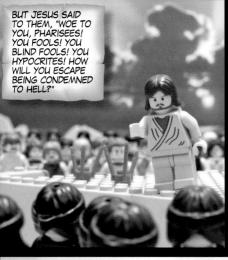

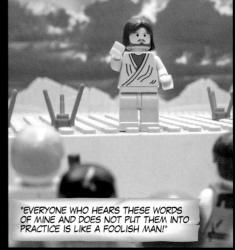

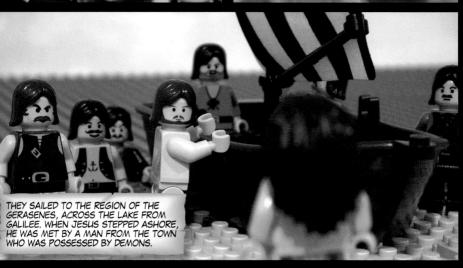

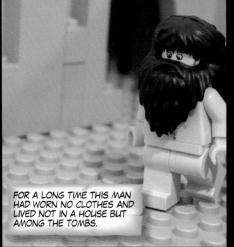

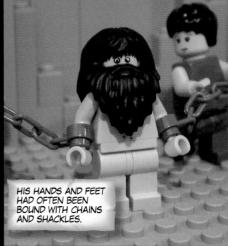

23-13 23-33 | Mt 7-26 | 1k 8-26-27 | 1k 8-2

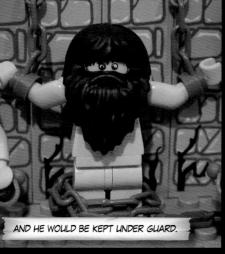

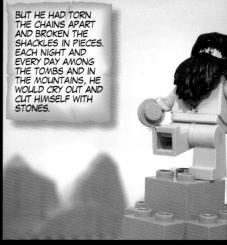

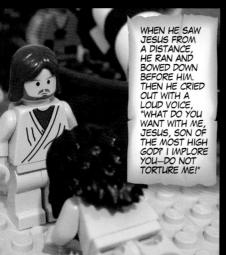

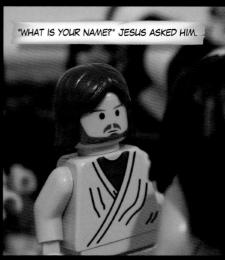

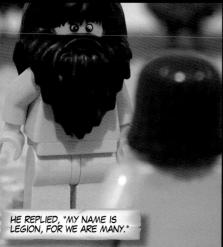

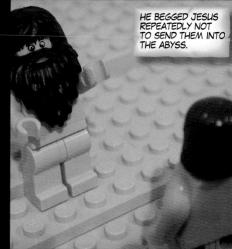

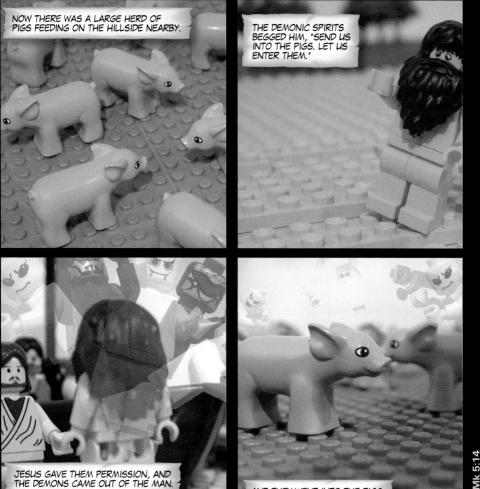

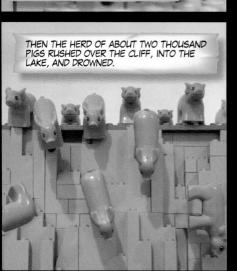

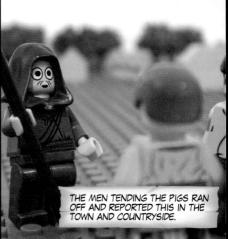

Mk 5:11

AND THEY WENT INTO THE PIGS.

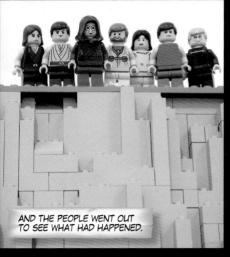

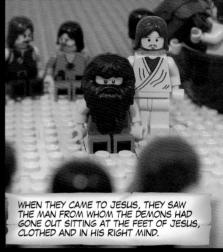

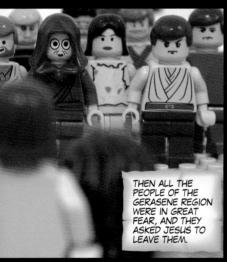

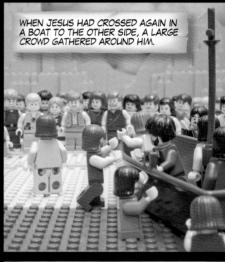

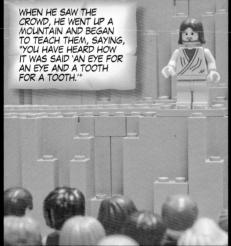

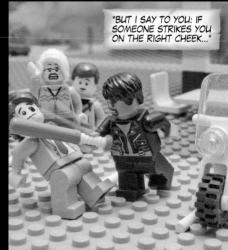

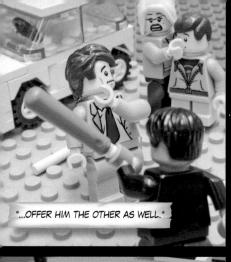

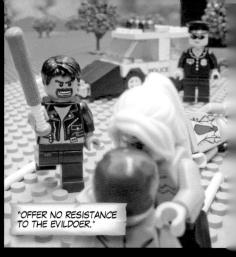

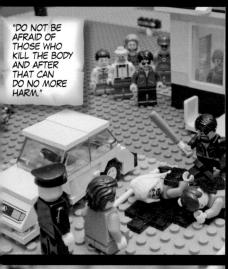

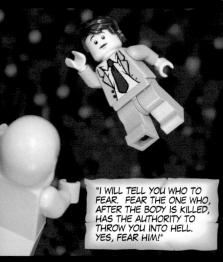

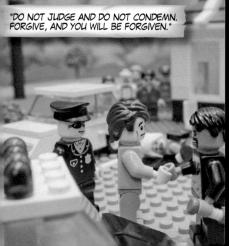

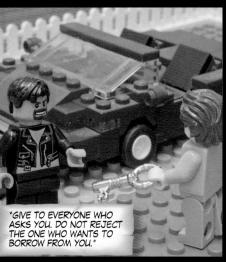

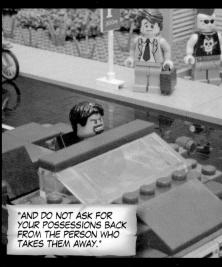

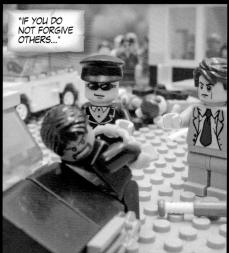

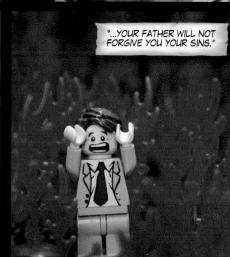

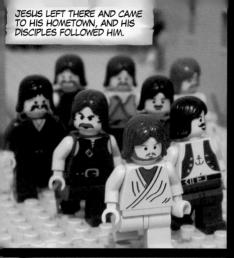

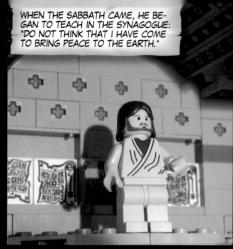

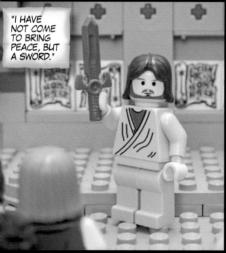

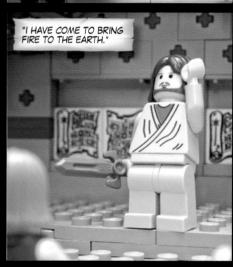

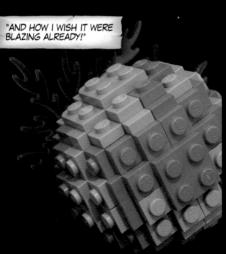

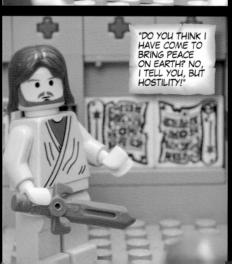

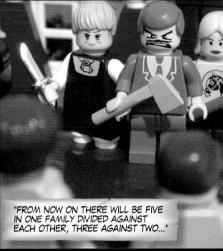

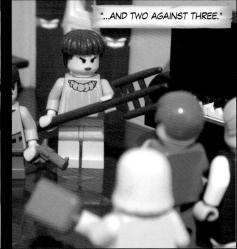

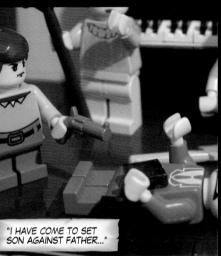

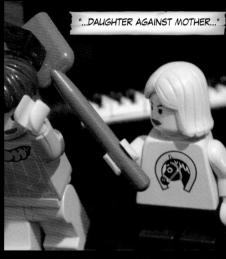

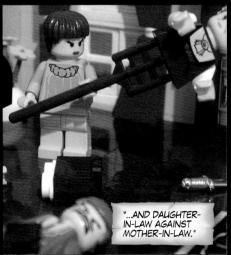

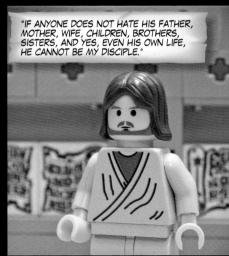

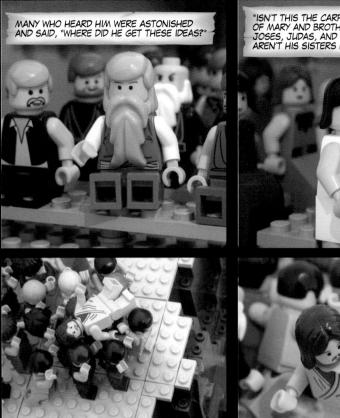

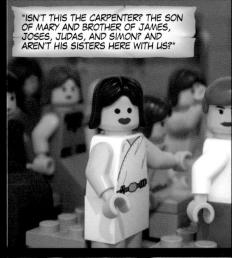

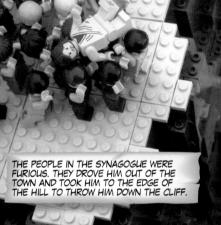

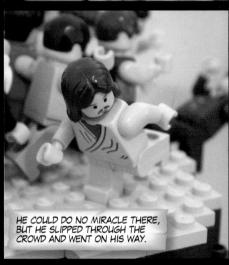

Mk 6:19-20

Mt 11:2

Mk 6:5; Lk 4:30 |

Mk 6:2 | Mk 6:3 | Lk 4:28-29 |

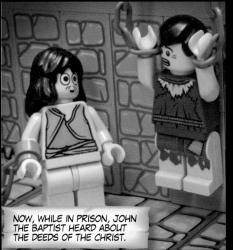

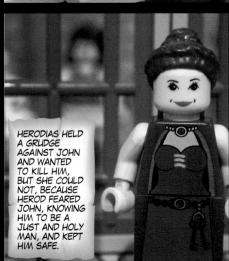

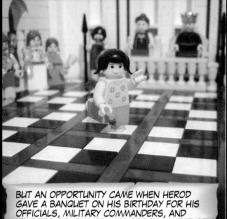

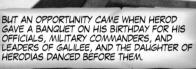

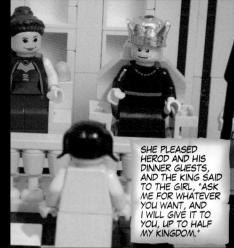

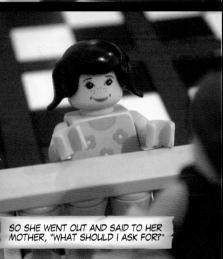

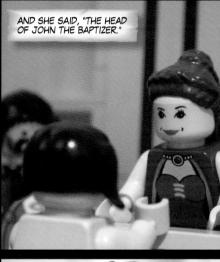

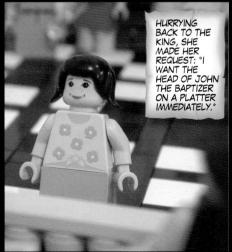

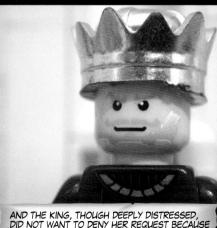

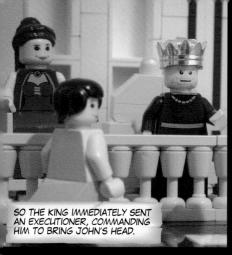

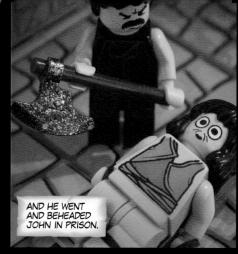

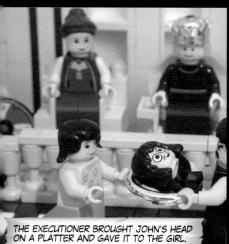

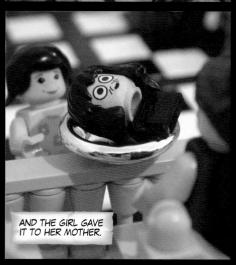

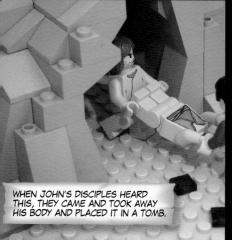

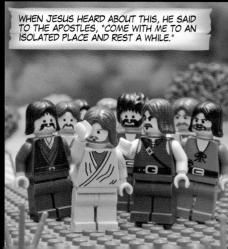

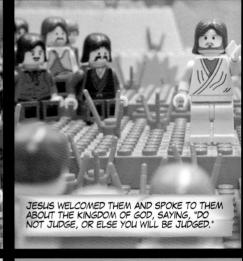

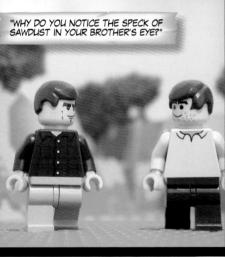

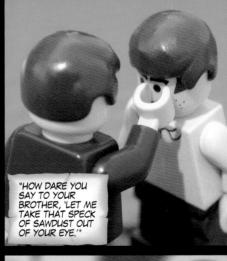

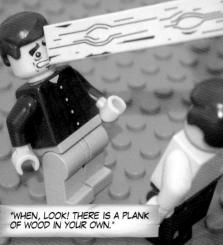

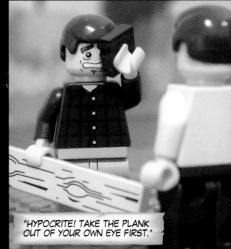

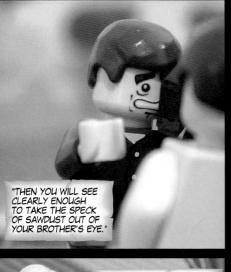

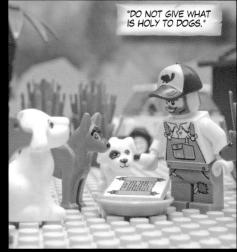

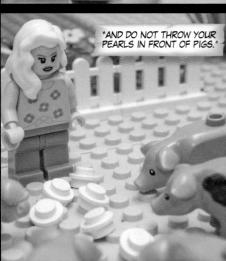

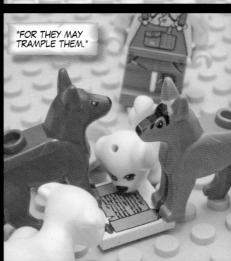

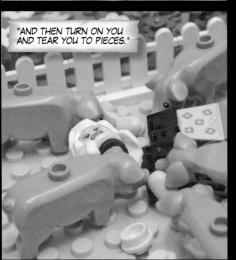

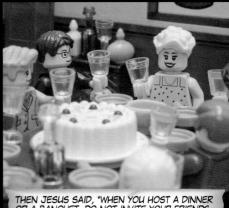

Mt 7:6

Mt 7:5 | Mt 7:6 | Mt 7:6 |

THEN JESUS SAID, "WHEN YOU HOST A DINNER OR A BANQUET, DO NOT INVITE YOUR FRIENDS, YOUR BROTHERS OR SISTERS, YOUR RELATIVES, OR YOUR RICH NEIGHBORS."

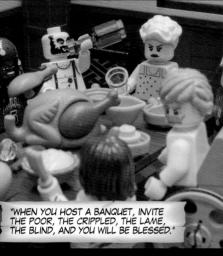

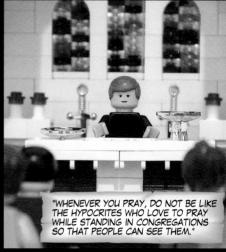

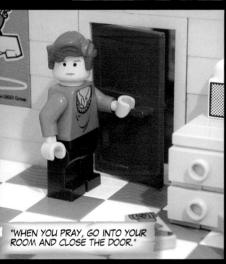

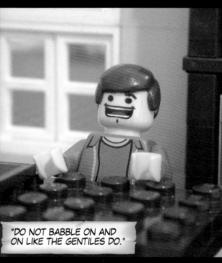

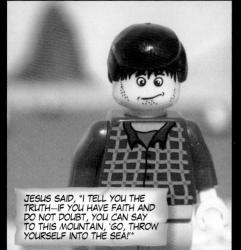

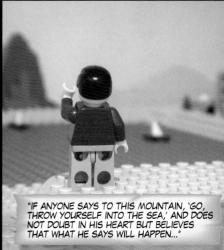

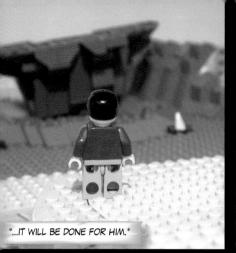

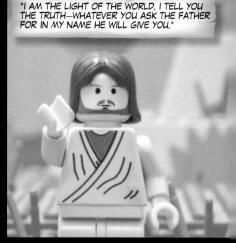

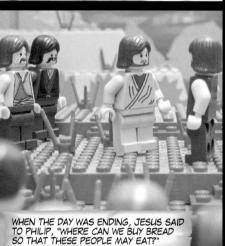

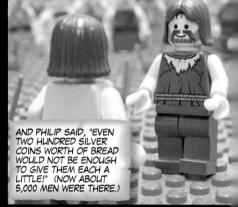

THEN PETER'S BROTHER ANDREW SAID TO JESUS, "THERE'S A BOY HERE WITH FIVE LOAVES AND TWO FISH, BUT WHAT USE IS THAT WITH

ALL THESE PEOPLE?"

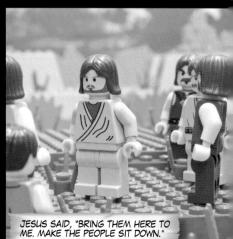

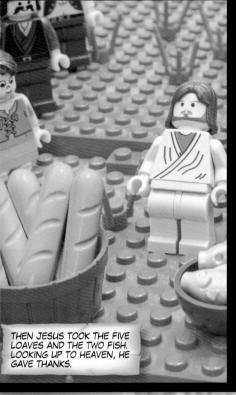

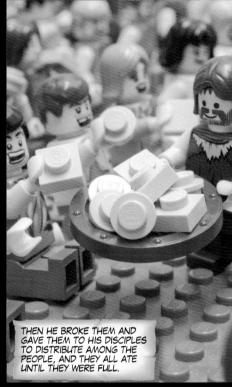

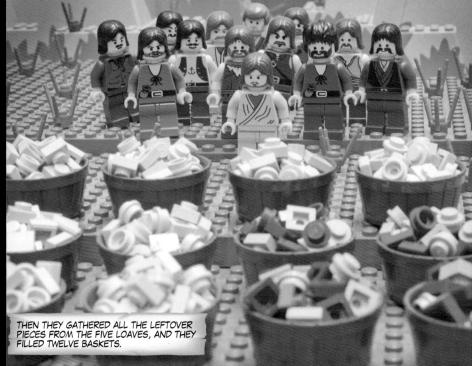

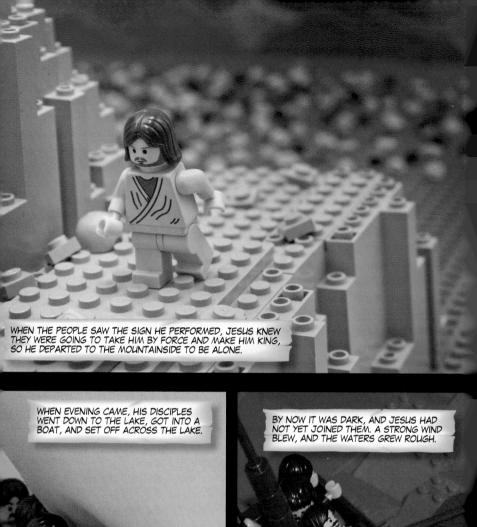

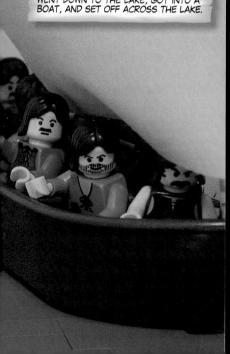

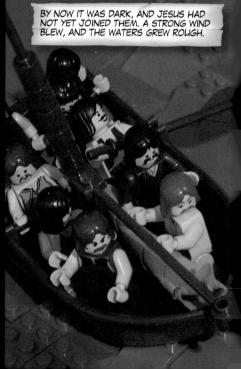

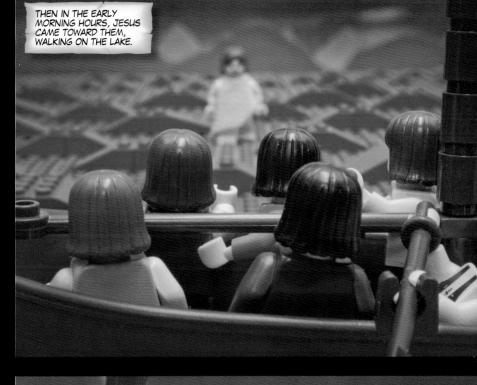

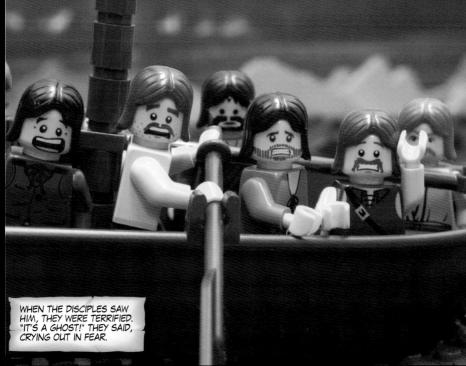

Mt 14:25 | Mt 14:26

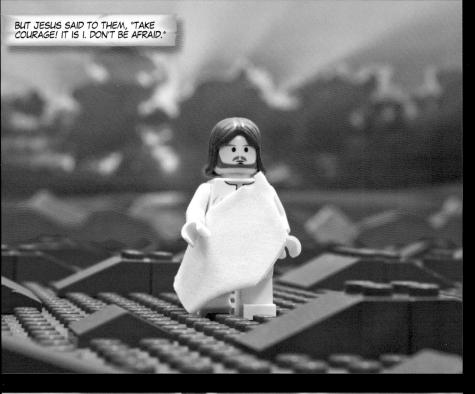

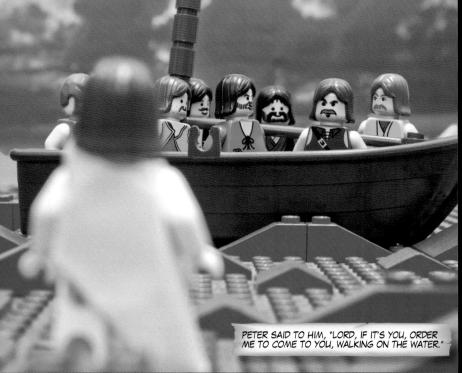

Mt 14:27 | Mt 14:28

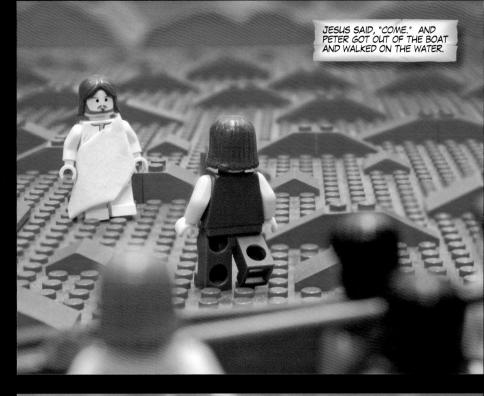

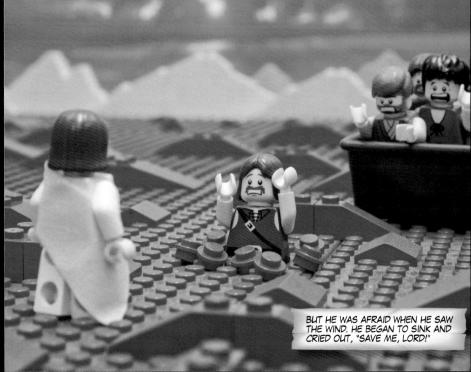

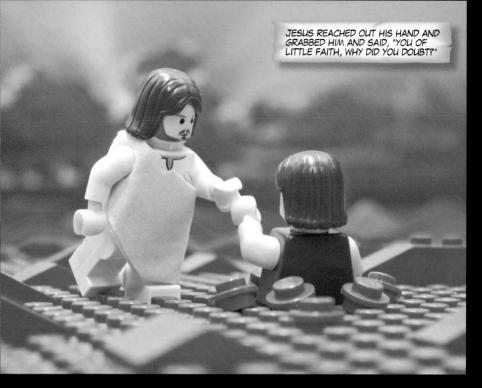

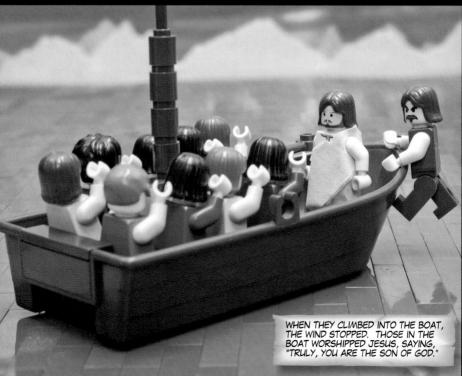

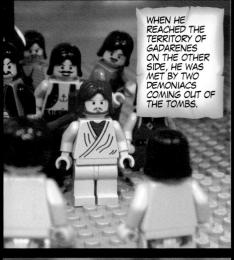

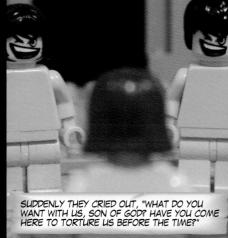

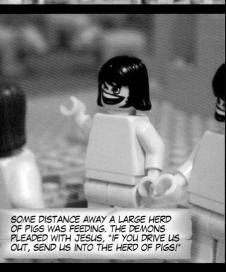

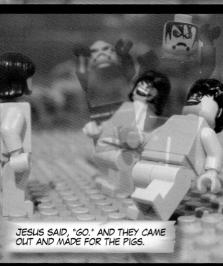

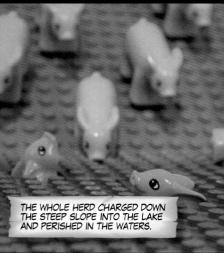

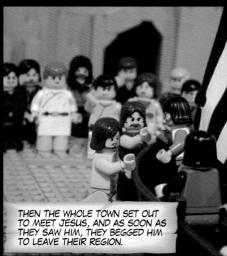

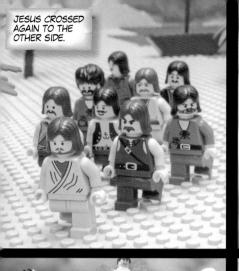

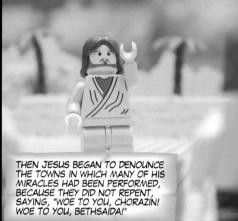

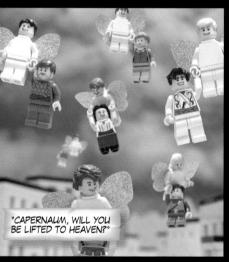

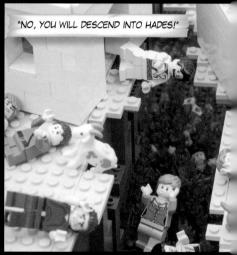

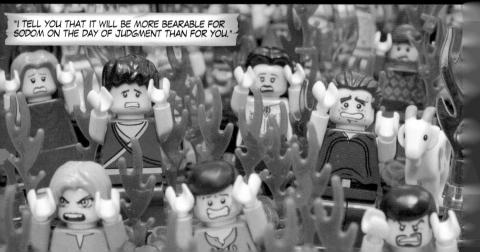

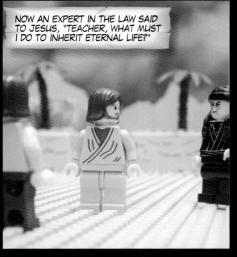

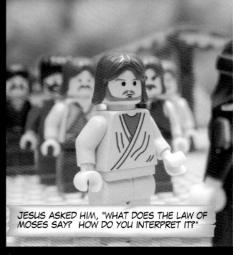

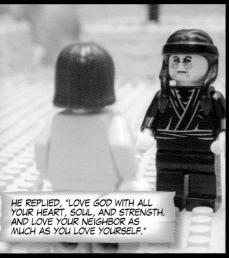

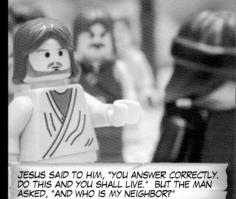

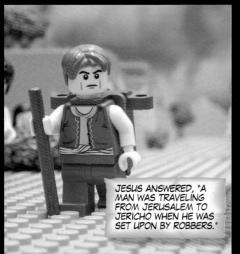

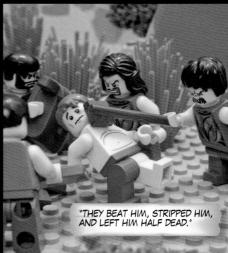

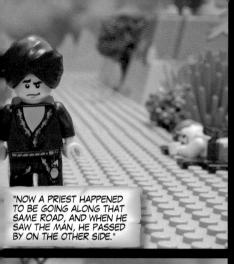

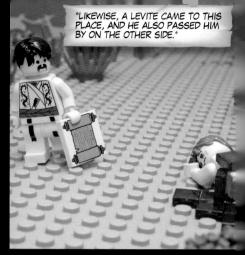

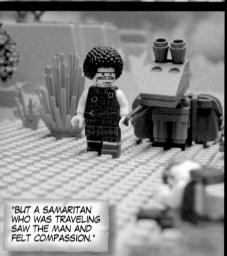

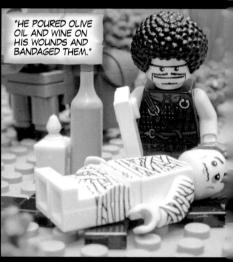

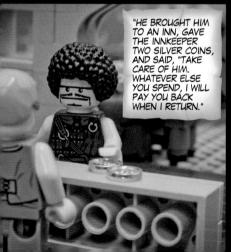

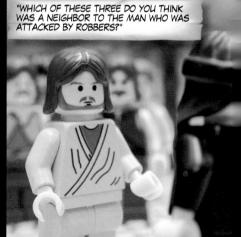

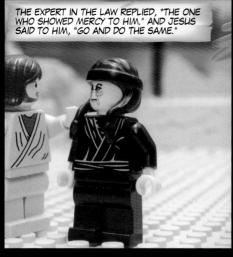

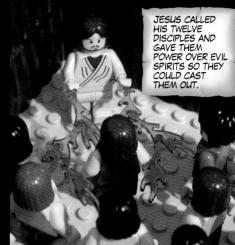

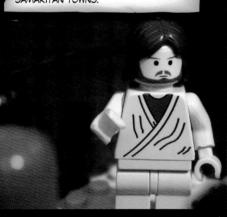

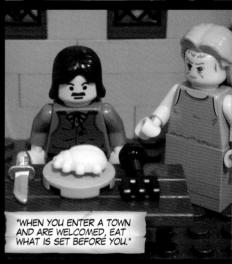

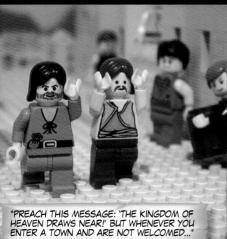

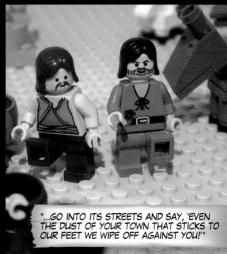

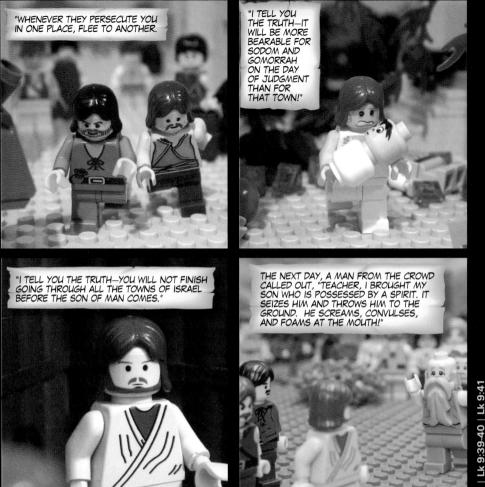

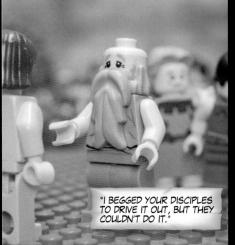

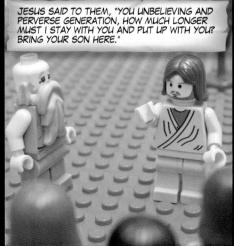

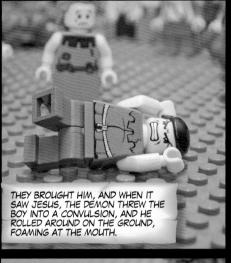

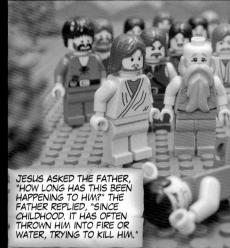

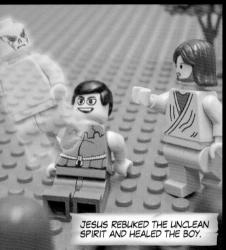

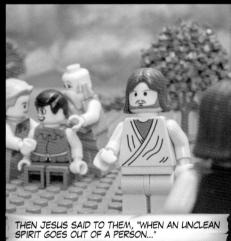

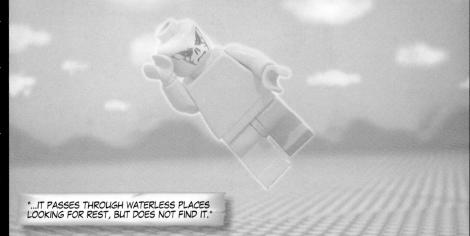

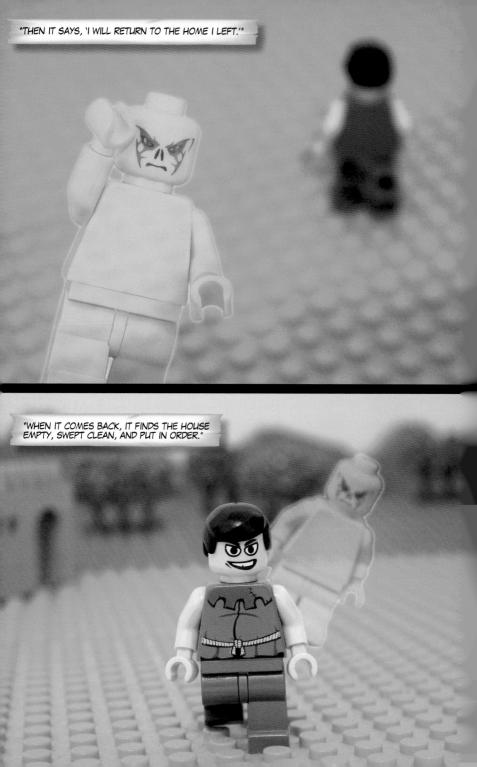

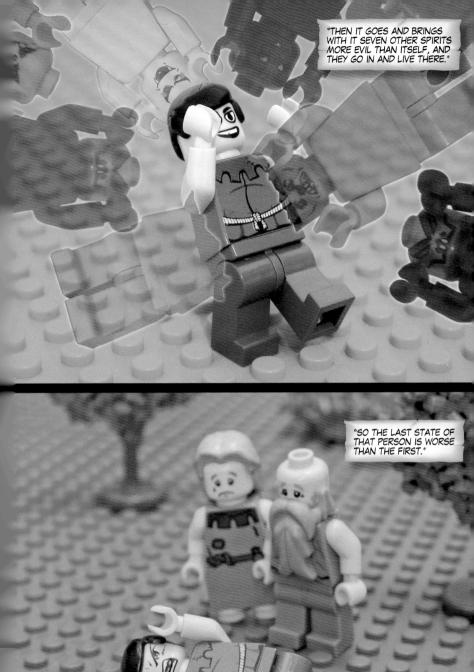

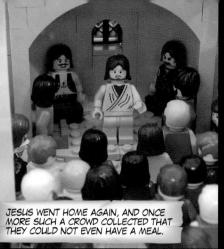

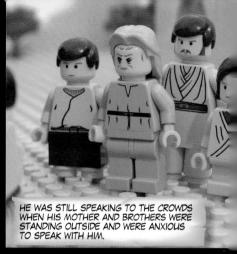

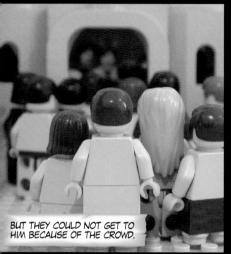

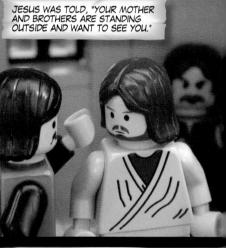

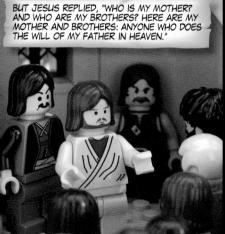

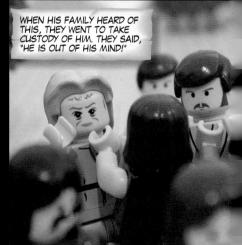

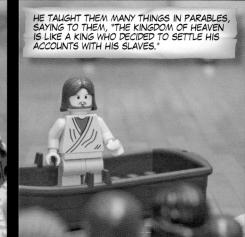

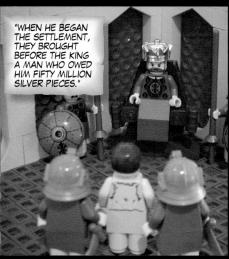

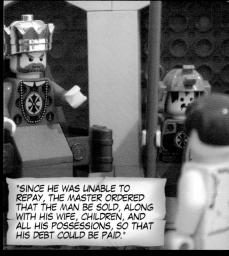

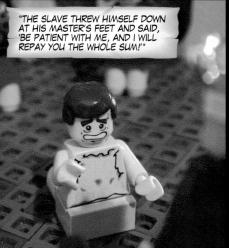

Mk 4:2; Mt 18:23 | Mt 18:24 | Mt 18:25 | Mt 18:26 | Mt 18:27

Mt 13:1-2

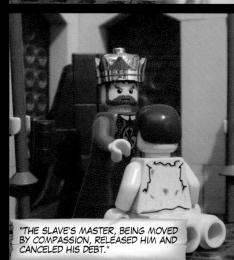

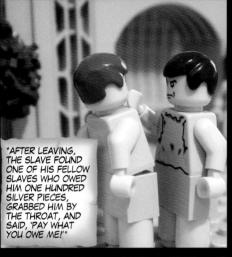

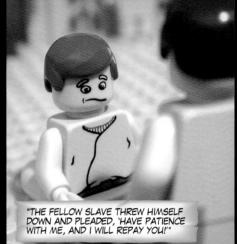

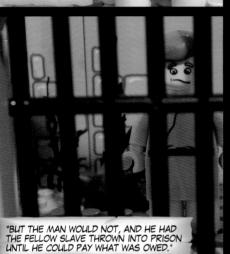

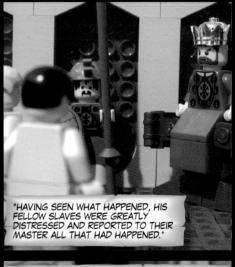

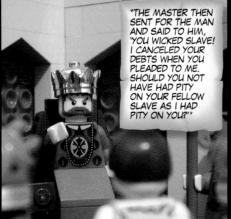

"AND IN HIS ANGER HIS MASTER SENT HIM TO THE TORTURERS UNTIL HE COULD REPAY ALL HE OWED. THAT IS HOW MY HEAVENLY FATHER WILL DEAL WITH YOU UNLESS YOU FORGIVE YOUR BROTHERS FROM YOUR HEART."

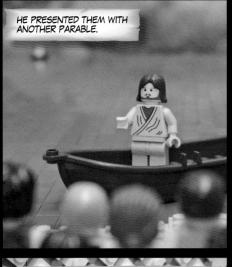

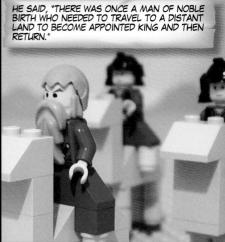

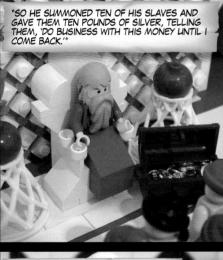

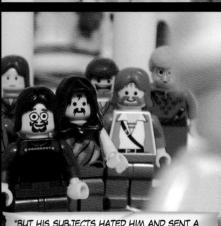

"BUT HIS SUBJECTS HATED HIM AND SENT A DELEGATION AFTER HIM WITH THIS MESSAGE: "WE DON'T WANT THIS MAN TO BE OUR KING!"

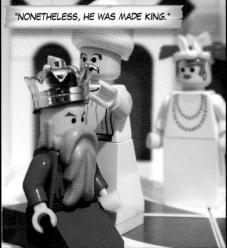

Lk 19:15

Lk 19:14

Lk 19:13

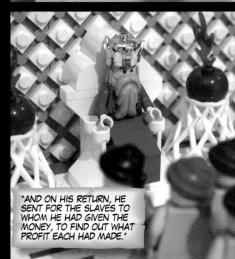

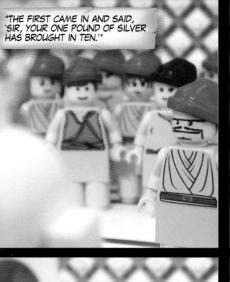

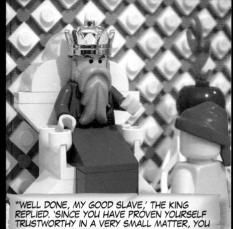

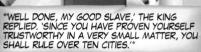

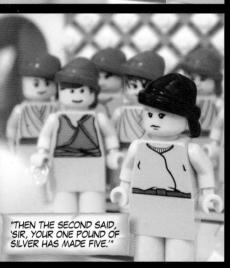

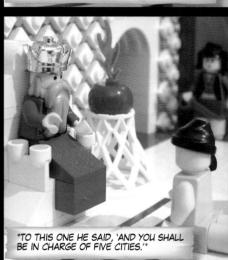

"THEN ANOTHER SLAVE SAID, 'SIR, HERE IS YOUR POUND OF SILVER. I KEPT IT SAFELY HIDDEN AWAY, WRAPPED IN CLOTH BECAUSE I WAS AFRAID OF YOU. YOU ARE A HARSH MAN, TAKING WHAT ISN'T YOURS."

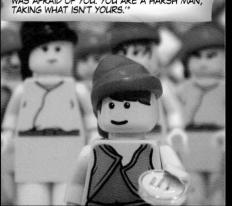

YOU WORTHLESS SLAVE!" SAID THE KING. "YOU KNEW I WAS A HARSH MAN, TAKING WHAT IS NOT MINE. WHY DID YOU NOT PUT MY MONEY IN THE BANK SO THAT I COULD HAVE TAKEN IT OUT WITH INTEREST WHEN I RETURNED?"

19:19

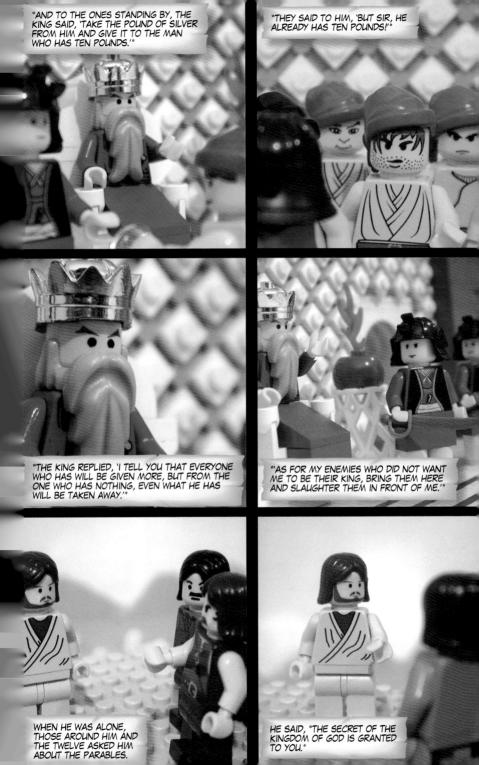

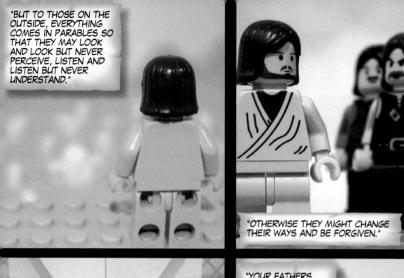

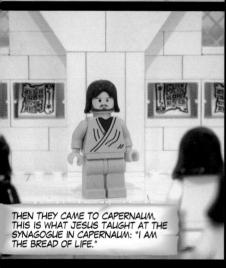

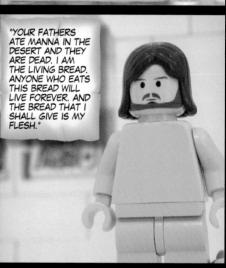

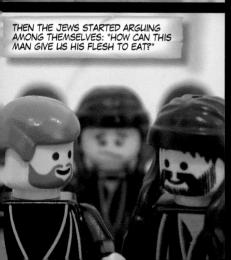

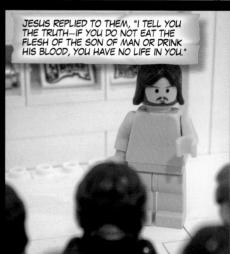

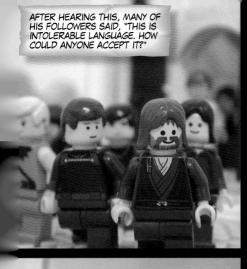

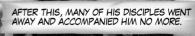

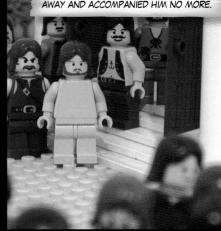

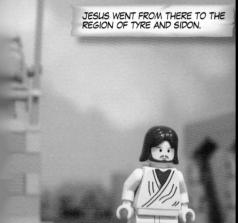

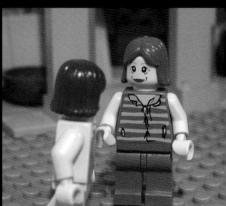

A CANAANITE WOMAN CAME TO HIM AND CRIED OUT, "LORD, SON OF DAVID, HAVE MERCY ON ME! MY DAUGHTER IS TERRIBLY DEMON POSSESSED!"

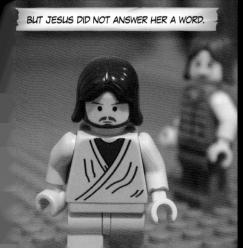

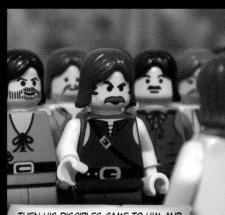

THEN HIS DISCIPLES CAME TO HIM AND URGED HIM, "SEND HER AWAY, FOR SHE KEEPS CRYING OUT AFTER US!"

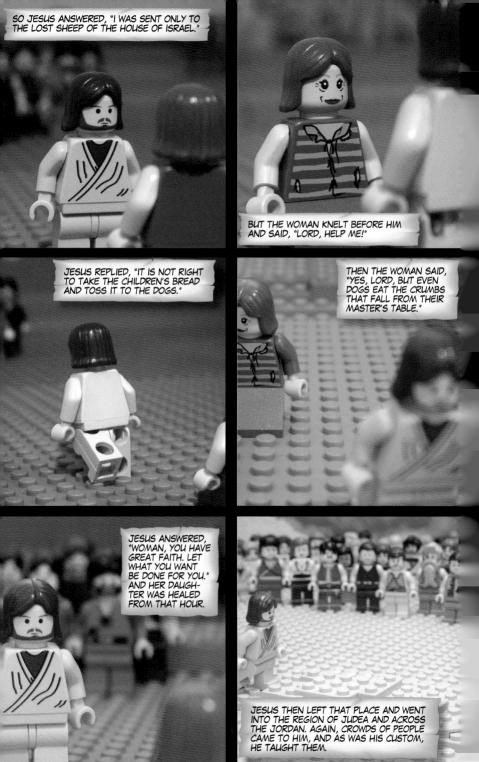

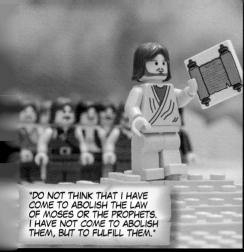

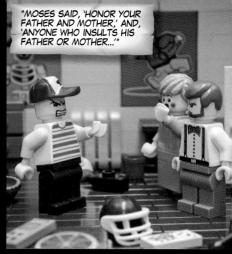

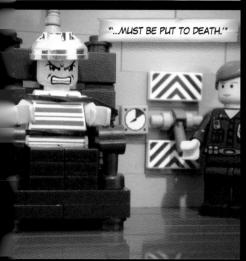

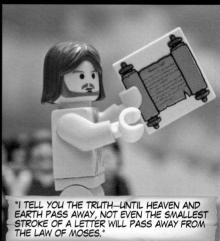

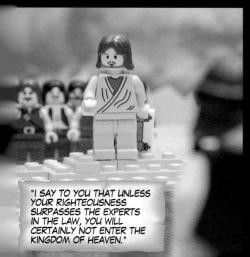

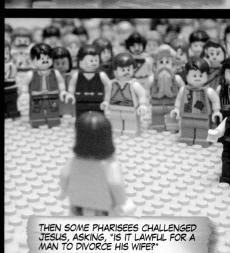

JESUS SAID, "THE TWO BECOME ONE FLESH. THEY ARE NO LONGER TWO, BUT ONE FLESH. SO WHAT GOD HAS JOINED TOGETHER, LET NO ONE SEPARATE."

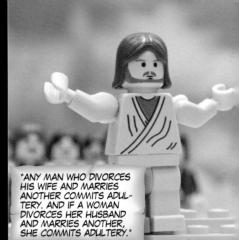

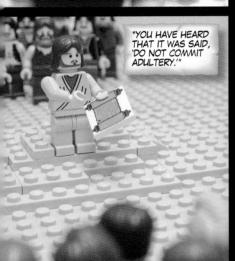

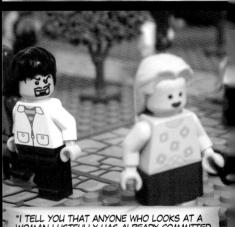

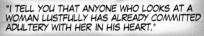

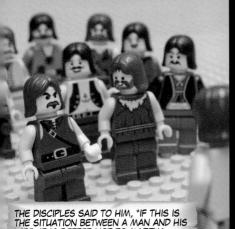

WIFE, IT IS BETTER NOT TO MARRY."

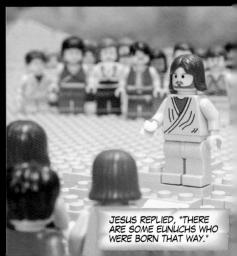

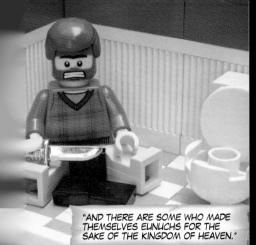

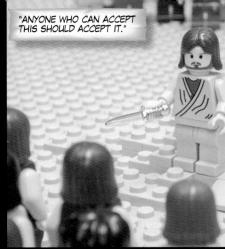

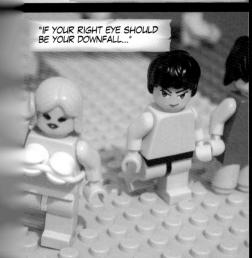

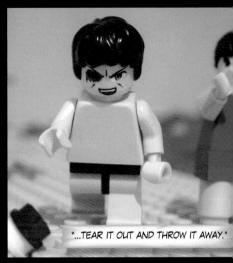

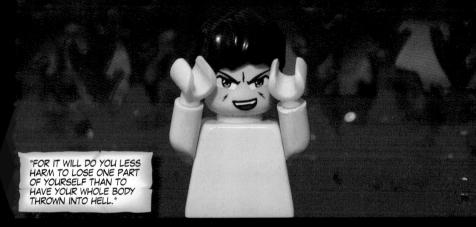

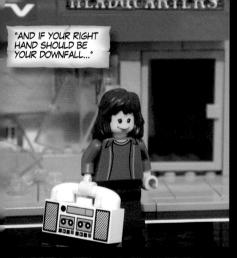

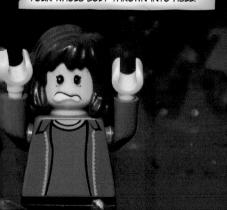

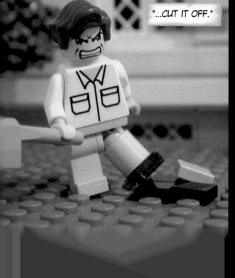

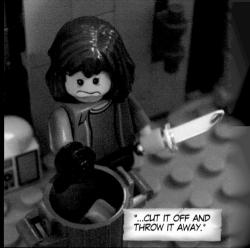

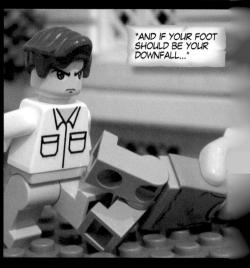

"BETTER FOR YOU TO ENTER INTO LIFE LAME, THAN TO HAVE TWO FEET AND BE THROWN INTO HELL."

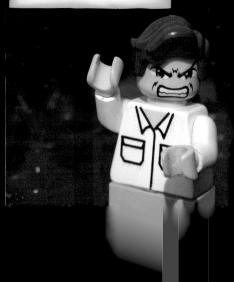

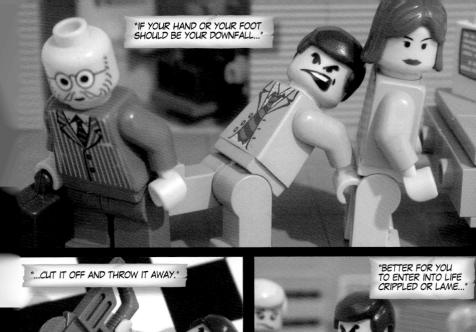

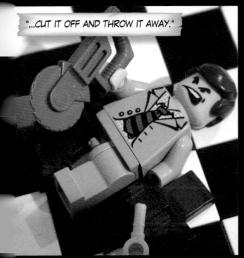

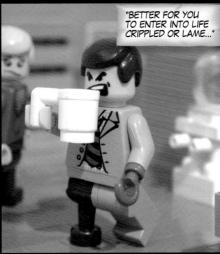

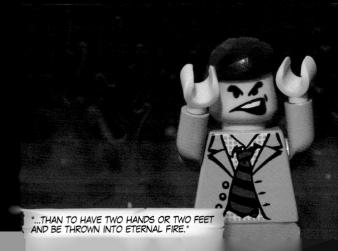

AS JESUS STARTED ON HIS WAY, A MAN RAN UP TO HIM AND FELL ON HIS KNEES BEFORE HIM, SAYING, "GOOD TEACHER, WHAT MUST I DO TO INHERIT ETERNAL LIFE?"

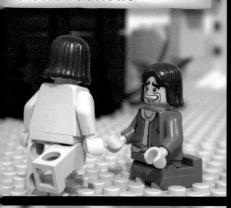

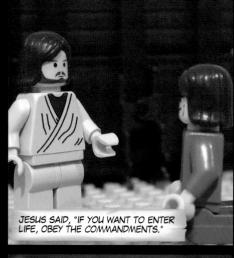

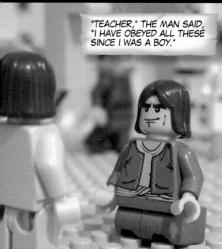

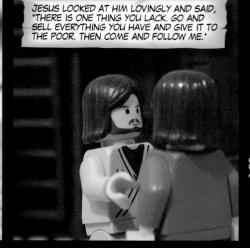

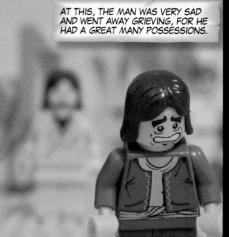

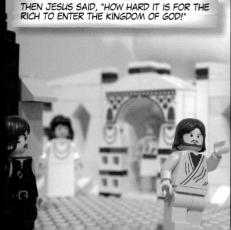

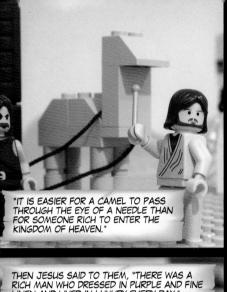

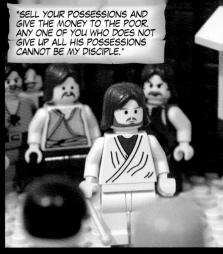

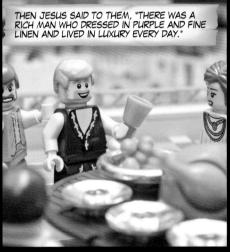

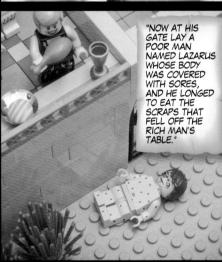

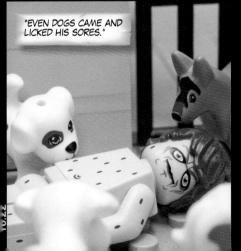

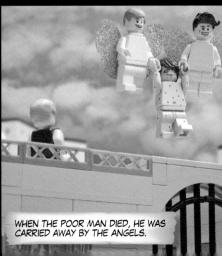

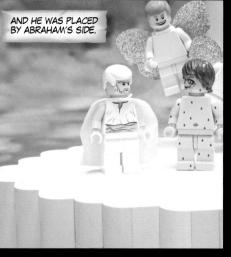

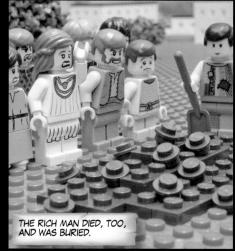

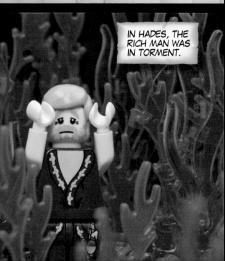

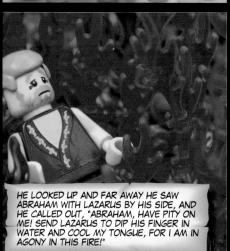

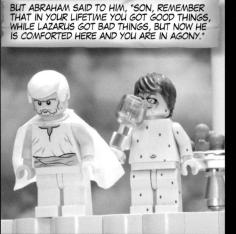

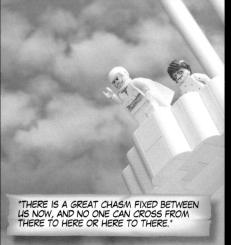

Lk 16:22 | Lk 16:22 | Lk 16:23 | Lk 16:23-24 | Lk 16:25 | Lk 16:26

THE RICH MAN SAID, "THEN I BEG OF YOU, WARN MY FIVE BROTHERS SO THAT THEY WILL NOT END UP IN THIS PLACE OF TORMENT!"

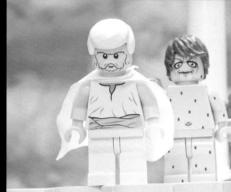

BUT ABRAHAM SAID, "IF THEY DID NOT LISTEN TO MOSES AND THE PROPHETS, THEY WILL NOT BE CONVINCED EVEN IF SOMEONE RISES FROM THE DEAD."

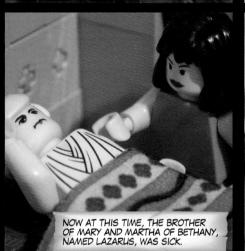

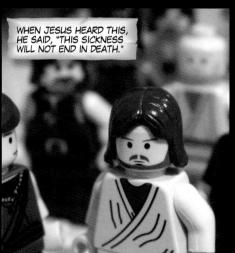

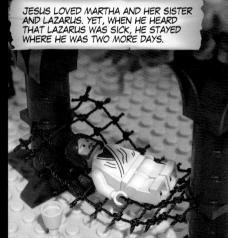

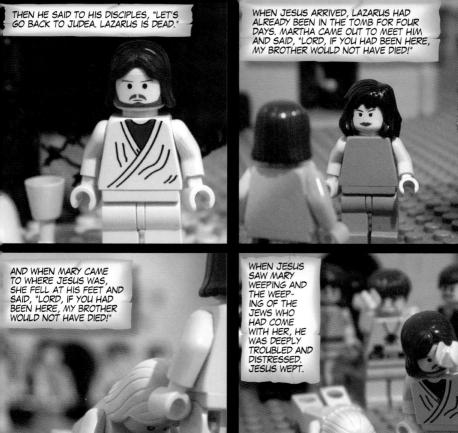

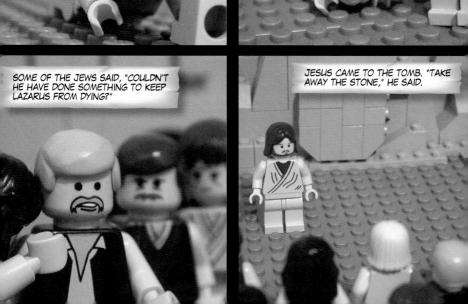

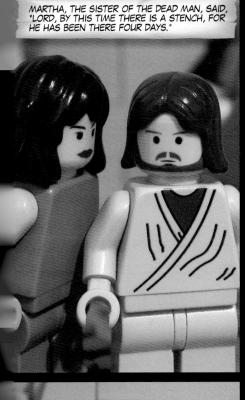

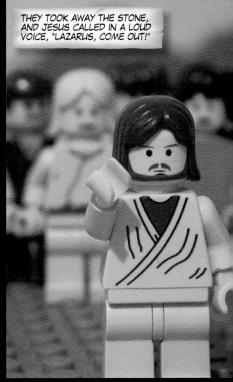

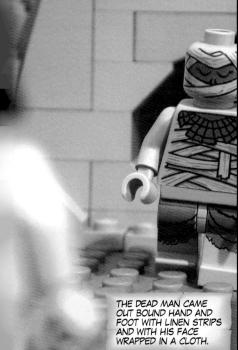

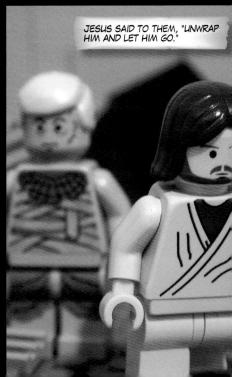

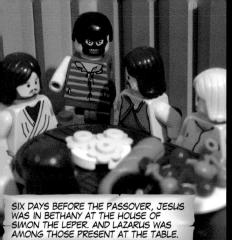

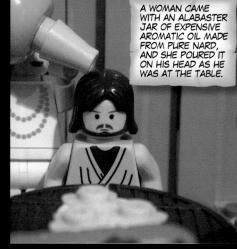

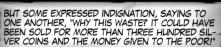

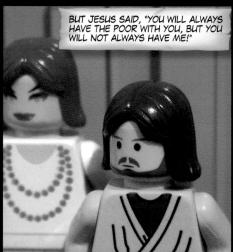

THEN MARY TOOK A POUND OF EXPENSIVE AROMATIC OIL FROM PURE NARD AND ANOINTED THE FEET OF JESUS.

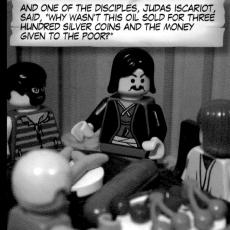

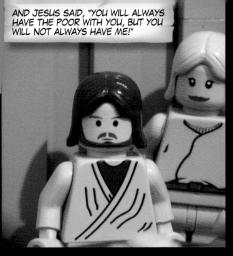

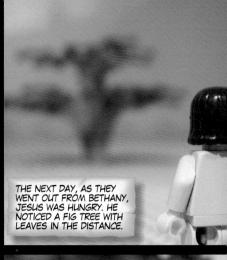

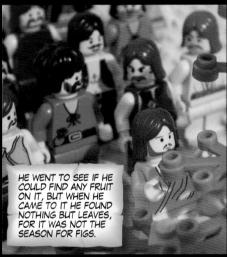

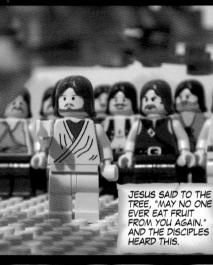

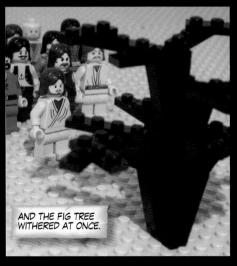

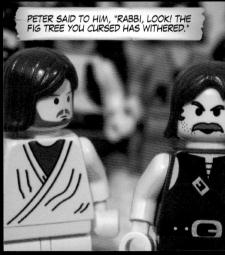

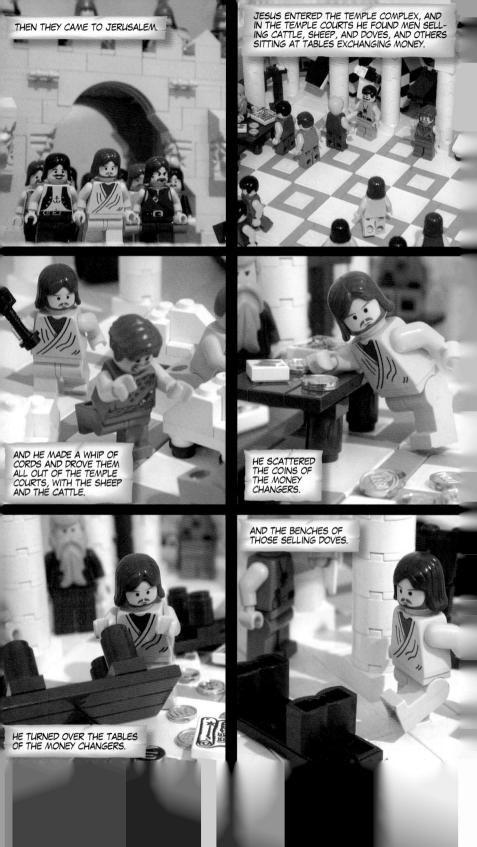

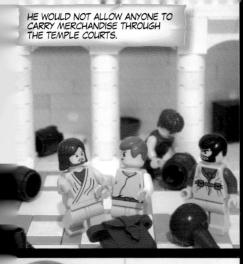

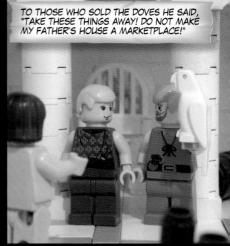

THE CHIEF PRIESTS AND THE SCRIBES HEARD THIS, AND THEY SOUGHT SOME WAY TO KILL JESUS, FOR THEY FEARED HIM.

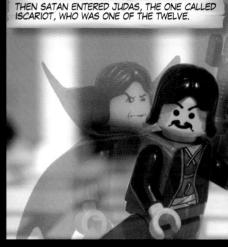

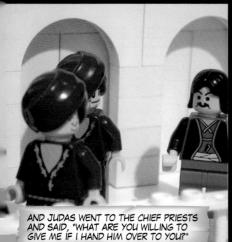

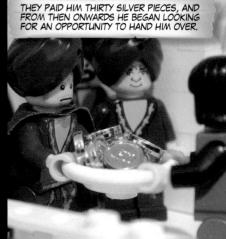

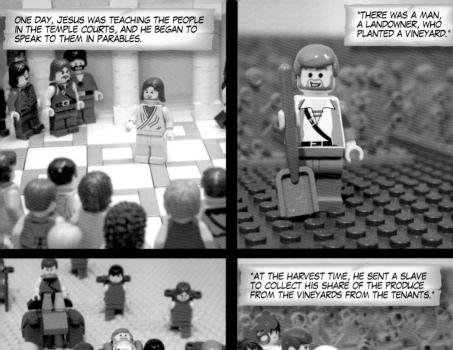

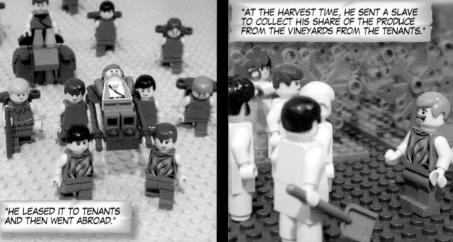

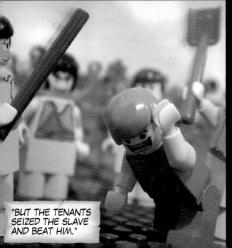

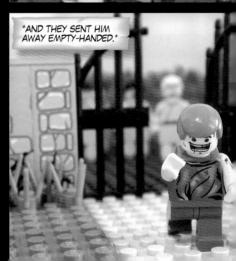

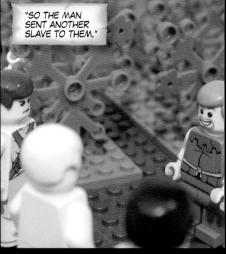

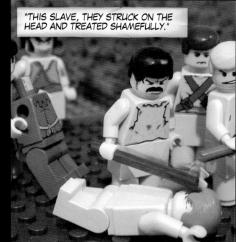

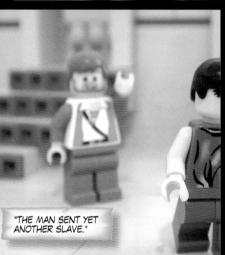

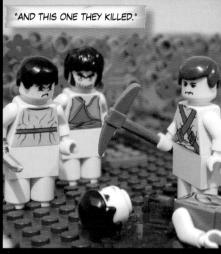

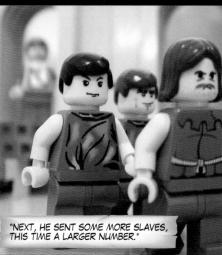

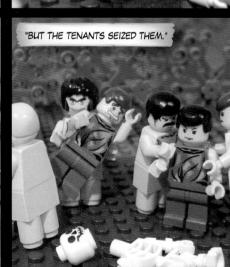

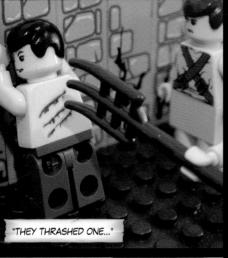

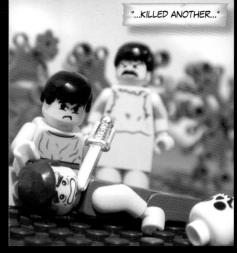

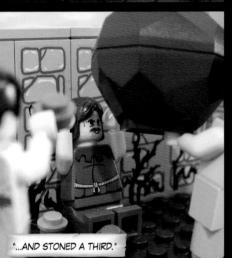

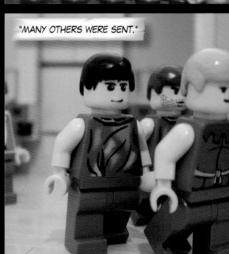

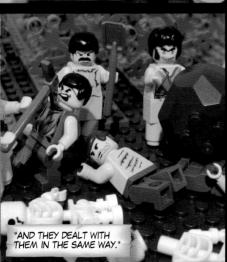

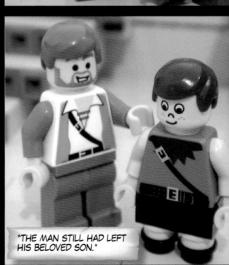

Mt 21:35 | Mt 21:35 | Mt 21:35 | Mk 12:5 | Mt 21:36 |

"FINALLY HE SENT HIS SON TO THEM, THINKING,
"THEY WILL RESPECT MY SON."

"BUT WHEN THE TENANTS SAW HIS
SON, THEY SAID TO ONE ANOTHER,
'THIS IS THE HEIR. COME, LET'S KILL
HIM AND TAKE HIS INHERITANCE."

"AND THEY THREW HIS BODY
OUT OF THE VINEYARD."

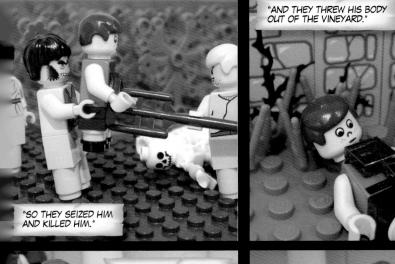

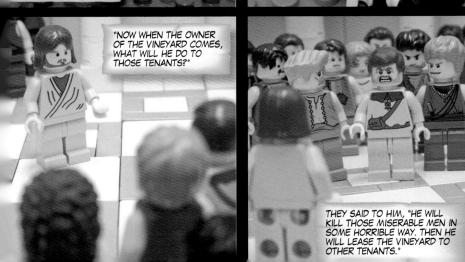

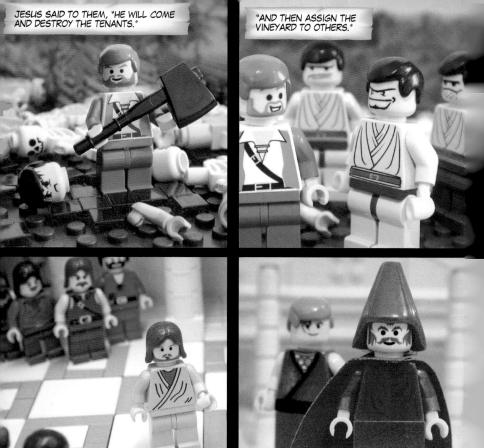

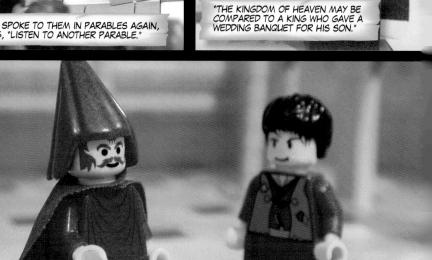

"HE INVITED A LARGE NUMBER OF PEOPLE AND COMMANDED HIS SLAVE TO SAY, LOOK, THE BANQUET IS READY. MY OXEN AND FATTENED CATTLE HAVE BEEN SLAUGHTERED. EVERYTHING IS PREPARED. COME TO THE WEDDING."

"BUT EACH ONE BEGAN TO MAKE EXCUSES. THE FIRST SAID, 'I HAVE BOUGHT A PIECE OF LAND AND MUST GO SEE IT. PLEASE ACCEPT MY APOLOGIES."

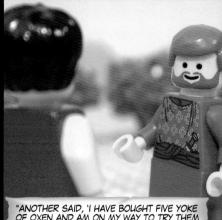

"ANOTHER SAID, "I HAVE BOUGHT FIVE YOKE OF OXEN AND AM ON MY WAY TO TRY THEM OUT. PLEASE ACCEPT MY APOLOGIES."

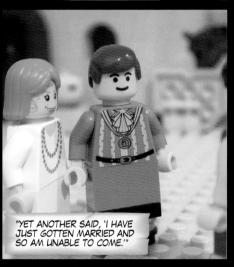

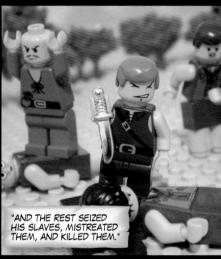

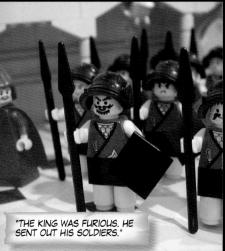

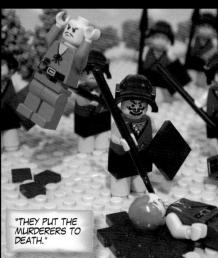

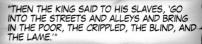

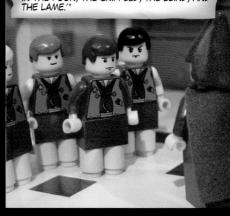

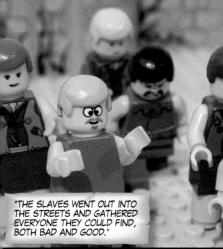

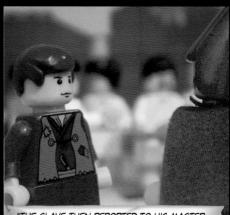

"THE SLAVE THEN REPORTED TO HIS MASTER,
"YOUR INSTRUCTIONS HAVE BEEN CARRIED OUT,
BUT THERE IS STILL ROOM."

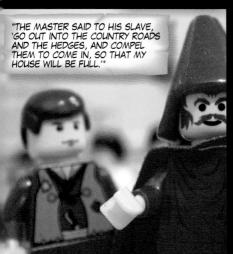

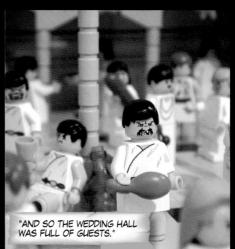

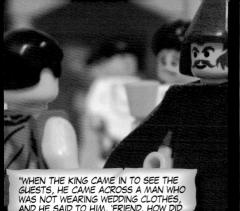

"WHEN THE KING CAME IN TO SEE THE GUESTS, HE CAME ACROSS A MAN WHO WAS NOT WEARING WEDDING CLOTHES, AND HE SAID TO HIM, 'FRIEND, HOW DID YOU COME IN HERE WITHOUT WEDDING CLOTHES?"

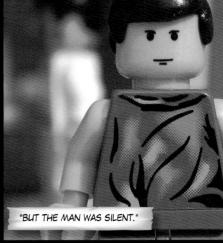

"THE KING THEN SAID TO HIS ATTENDANTS, THE HIS HANDS AND FEET AND THROW HIM INTO THE OUTER DARKNESS WHERE THERE WILL BE WEEPING AND GNASHING OF TEETH!"

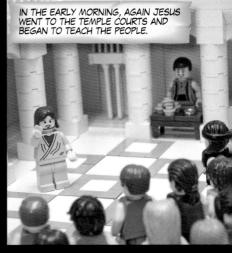

THE EXPERTS IN THE LAW AND THE PHARISEES SAID TO JESUS, "THIS WOMAN WAS CAUGHT IN THE ACT OF ADULTERY. THE LAW OF MOSES COMMANDS US TO STONE SUCH WOMEN TO DEATH. WHAT DO YOU SAY?"

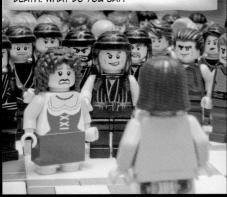

THEY PERSISTED IN ASKING HIM, AND JESUS REPLIED, "LET HE AMONG YOU THAT IS WITHOUT SIN BE THE FIRST TO THROW A STONE AT HER."

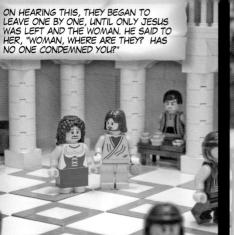

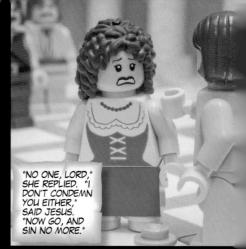

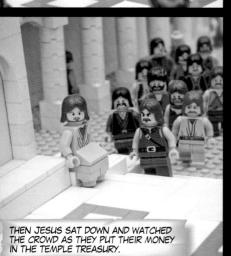

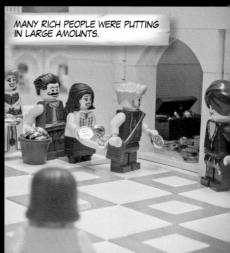

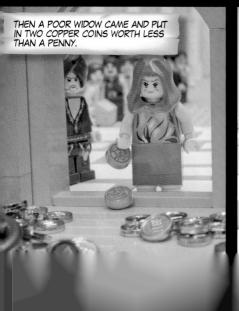

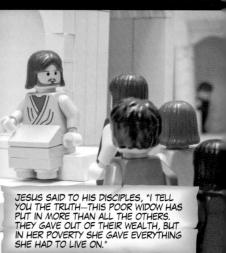

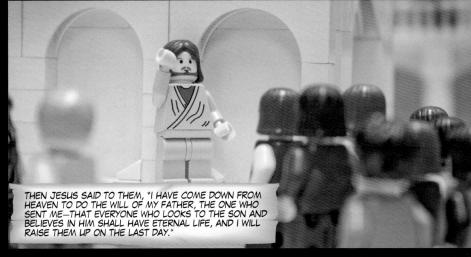

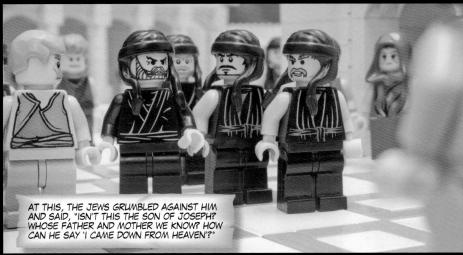

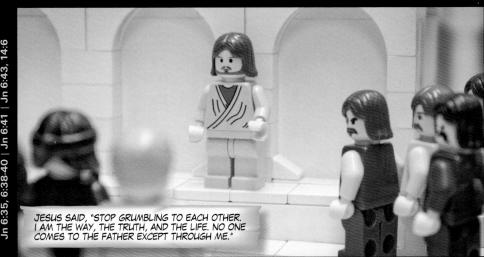

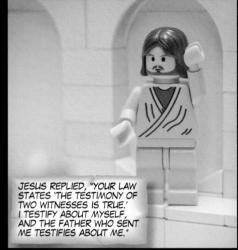

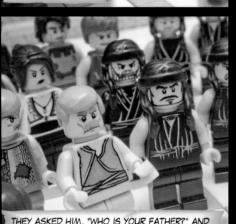

THEY ASKED HIM, "WHO IS YOUR FATHER?" AND JESUS SAID TO THEM, "YOU DON'T KNOW ME OR MY FATHER. IF YOU KNEW ME YOU WOULD KNOW MY FATHER TOO."

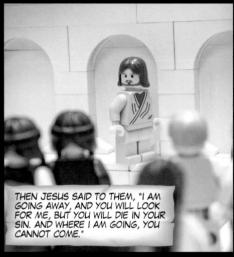

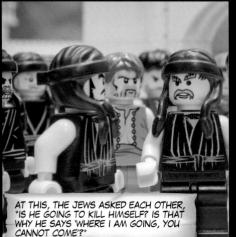

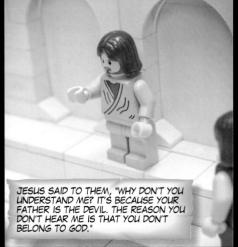

n 8:13

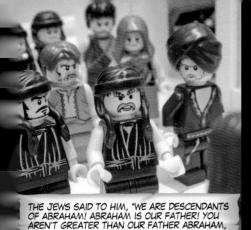

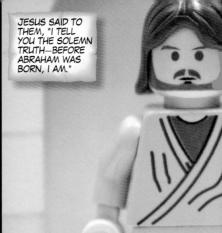

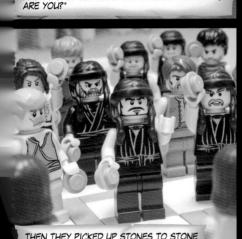

THEN THEY PICKED UP STONES TO STONE HIM, SAYING, "WE ARE GOING TO STONE YOU FOR BLASPHEMY, BECAUSE YOU ARE A MAN CLAIMING TO BE GOD."

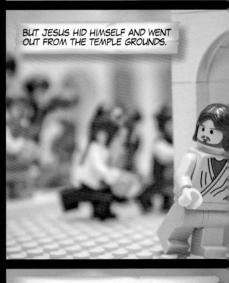

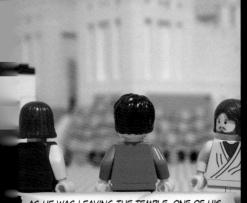

AS HE WAS LEAVING THE TEMPLE, ONE OF HIS DISCIPLES SAID TO HIM, "TEACHER, LOOK! WHAT STONES! WHAT BUILDINGS!"

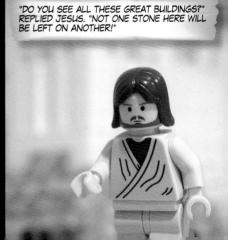

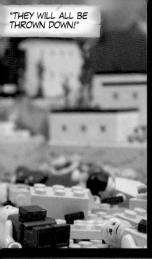

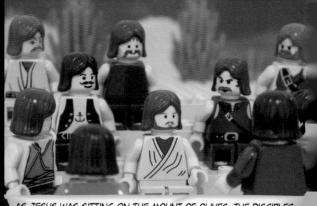

AS JESUS WAS SITTING ON THE MOUNT OF OLIVES, THE DISCIPLES CAME TO HIM PRIVATELY AND SAID, "TELL US WHEN THESE THINGS WILL HAPPEN, AND WHAT WILL BE THE SIGN OF YOUR COMING AND OF THE END OF THIS AGE?"

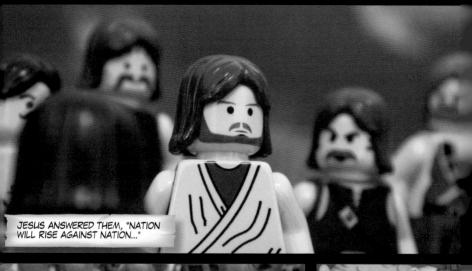

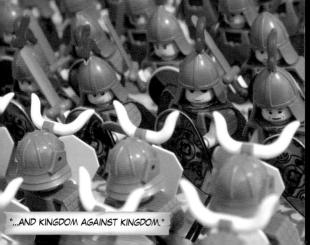

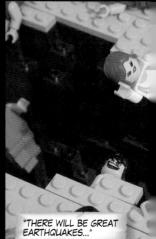

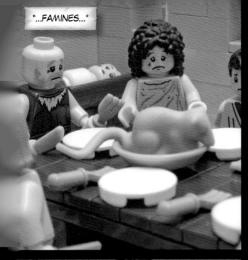

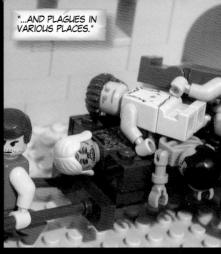

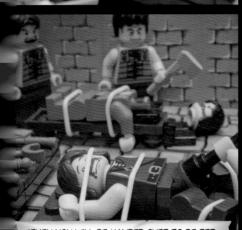

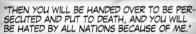

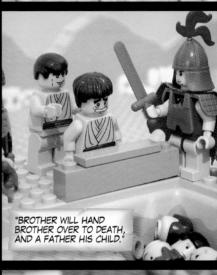

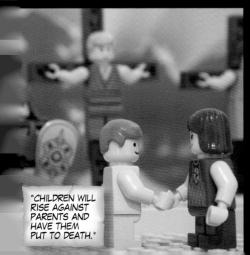

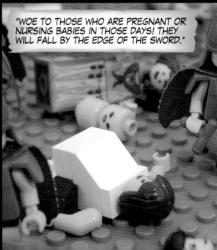

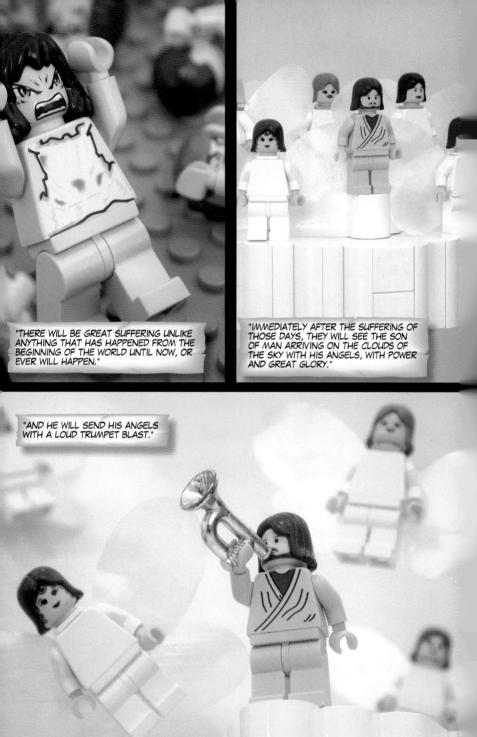

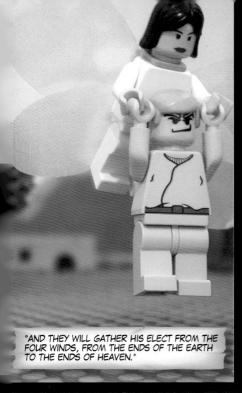

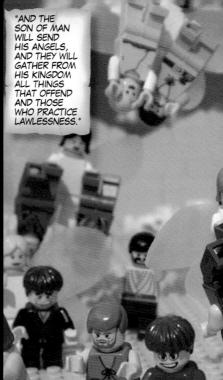

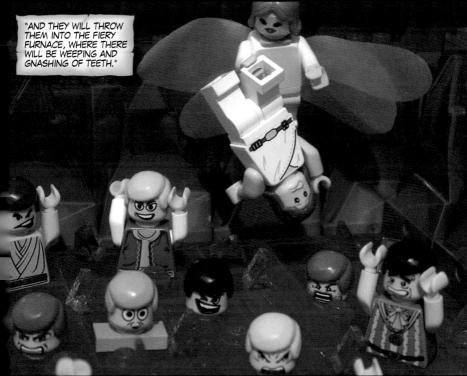

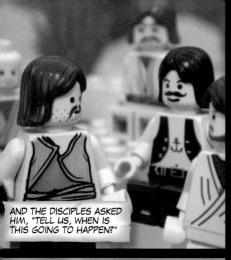

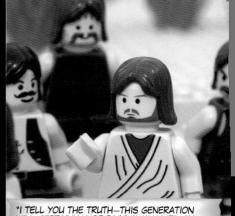

"I TELL YOU THE TRUTH—THIS GENERATION WILL CERTAINLY NOT PASS AWAY UNTIL ALL THESE THINGS HAVE HAPPENED."

"I TELL YOU THE TRUTH—SOME STANDING HERE WILL NOT TASTE DEATH BEFORE THEY SEE THE SON OF MAN COMING IN HIS KINGDOM."

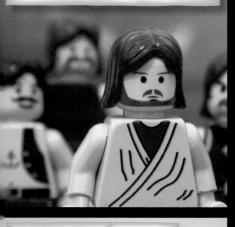

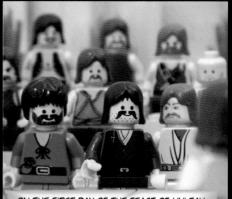

ON THE FIRST DAY OF THE FEAST OF UNLEAV-ENED BREAD, JESUS'S DISCIPLES CAME TO HIM AND SAID, "WHERE DO YOU WANT US TO PREPARE FOR YOU TO EAT THE PASSOVER?"

JESUS SAID, "GO INTO THE CITY TO A CERTAIN MAN AND TELL HIM, "THE TEACHER SAYS, "MY TIME IS NEAR. I WILL OBSERVE THE PASSOVER WITH MY DISCIPLES AT YOUR HOUSE."

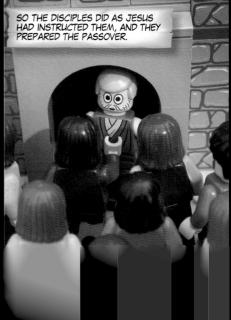

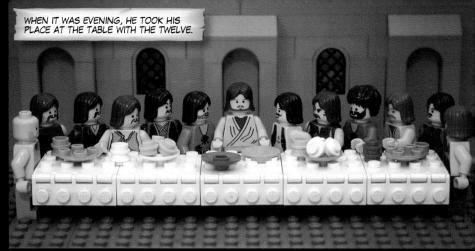

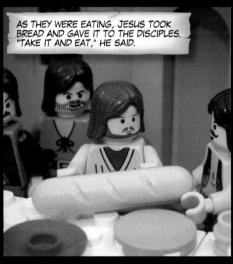

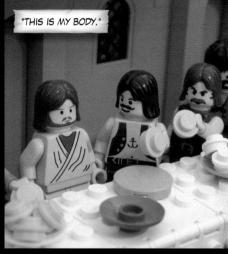

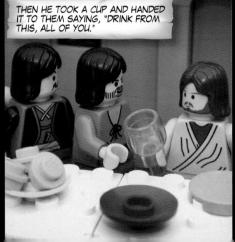

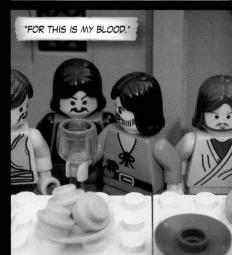

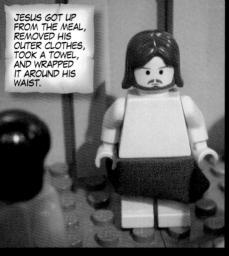

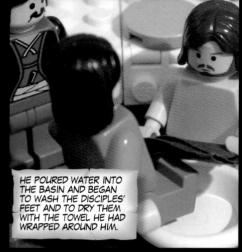

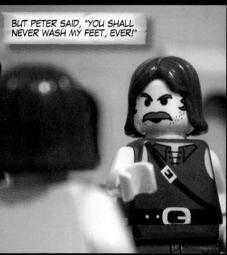

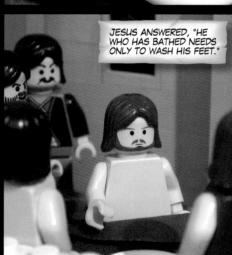

WHEN HE HAD FINISHED WASHING THEIR FEET, HE PUT ON HIS CLOTHES AND RETURNED TO HIS PLACE. "I HAVE SET AN EXAMPLE. YOU SHOULD DO AS I HAVE DONE FOR YOU. YOU SHOULD WASH ONE ANOTHER'S FEET."

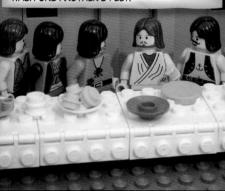

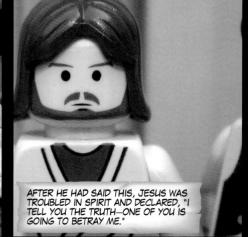

Jn 13:4 | Jn 13:5 | Jn 13:6 | Jn 13:10 | Jn 13:12, 13:15, 13:14 | Jn 13:21

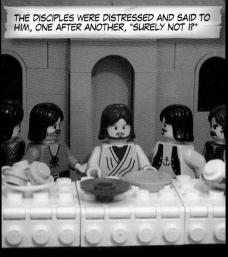

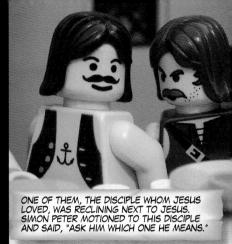

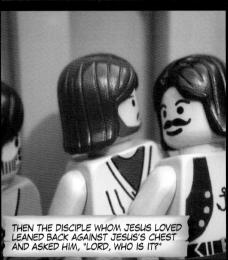

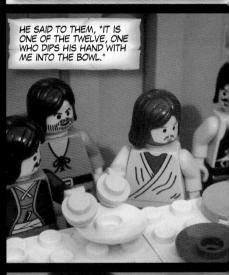

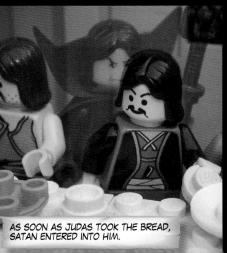

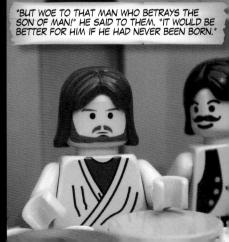

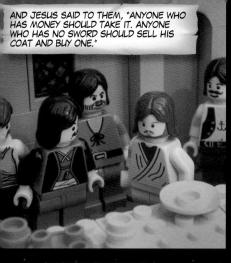

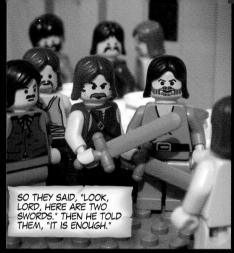

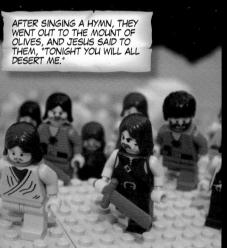

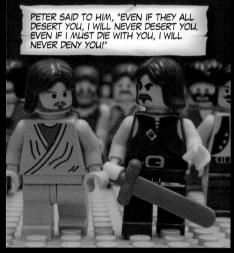

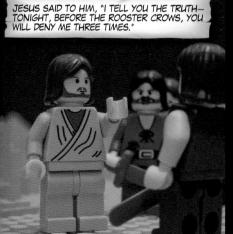

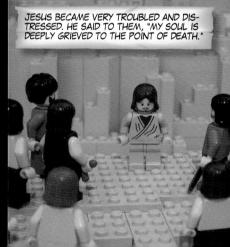

GOING A LITTLE FURTHER, HE THREW HIMSELF TO THE GROUND AND PRAYED THAT IF IT WERE POSSIBLE THE HOUR WOULD PASS FROM HIM. HE SAID, "FATHER, EVERYTHING IS POSSIBLE FOR YOU. TAKE THIS CUP FROM ME. LET THIS CUP PASS FROM ME!"

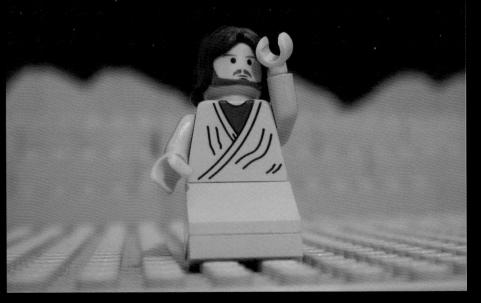

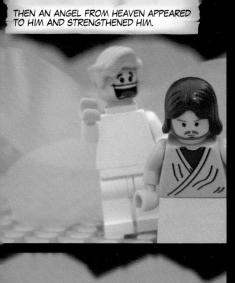

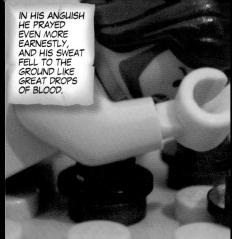

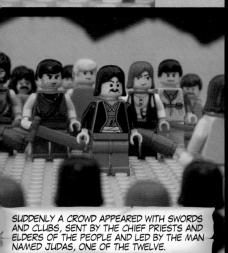

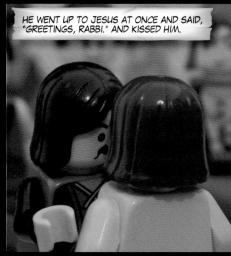

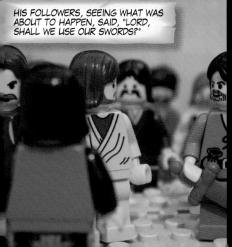

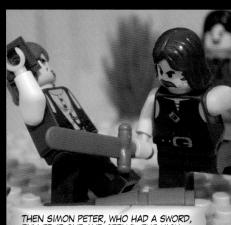

THEN SIMON PETER, WHO HAD A SWORD, PULLED IT OUT AND STRUCK THE HIGH PRIEST'S SLAVE, CUTTING OFF HIS RIGHT EAR. THE SLAVE'S NAME WAS MALCHUS.

٦

BUT JESUS SAID TO PETER, "PUT YOUR SWORD BACK INTO ITS SHEATH! OR DO YOU THINK THAT I CANNOT CALL ON MY FATHER AND THAT HE WOULD SEND ME MORE THAN TWELVE LEGIONS OF ANGELS RIGHT NOW?"

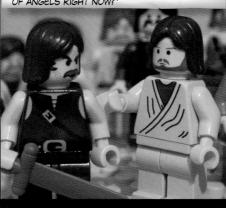

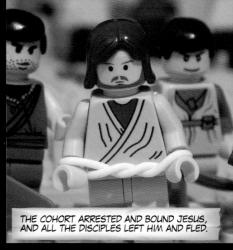

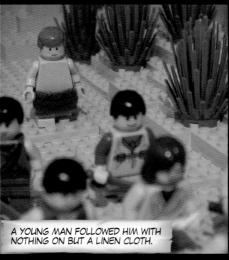

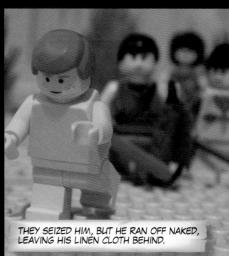

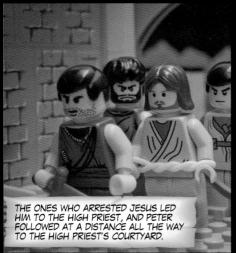

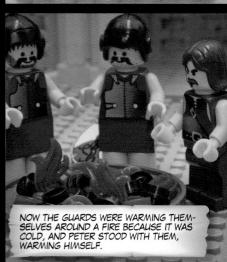

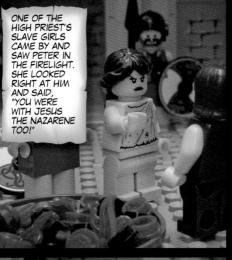

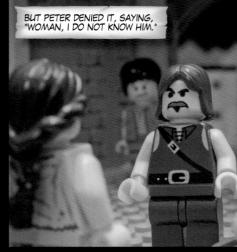

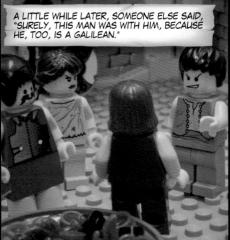

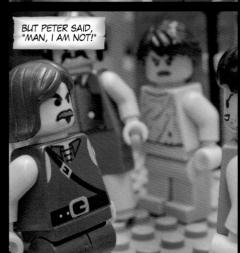

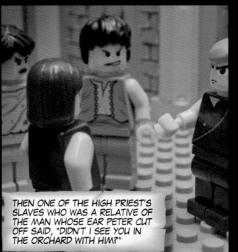

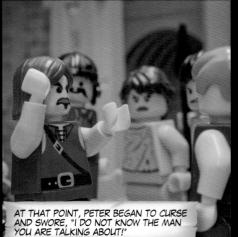

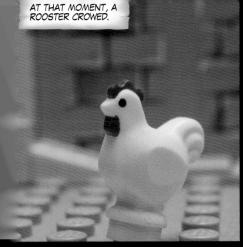

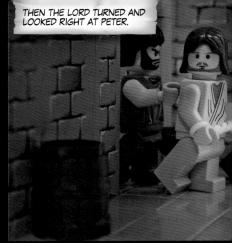

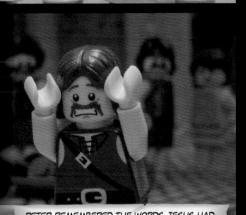

PETER REMEMBERED THE WORDS JESUS HAD SAID TO HIM: "BEFORE THE ROOSTER CROWS, YOU WILL DENY ME THREE TIMES." AND HE WENT OUTSIDE AND WEPT BITTERLY.

THEY TOOK JESUS FIRST TO ANNAS, BECAUSE ANNAS WAS THE FATHER-IN-LAW OF CAIAPHAS WHO WAS THE HIGH PRIEST THAT YEAR. THE HIGH PRIEST QUESTIONED HIM ABOUT HIS DISCIPLES AND HIS TEACHING.

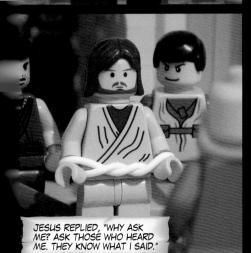

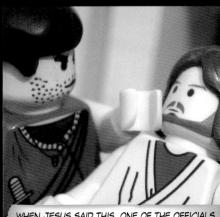

WHEN JESUS SAID THIS, ONE OF THE OFFICIALS NEARBY STRUCK HIM IN THE FACE, SAYING, "IS THIS THE WAY YOU ANSWER THE HIGH PRIEST?"

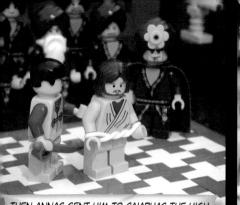

THEN ANNAS SENT HIM TO CAIAPHAS THE HIGH PRIEST, IN WHOSE HOUSE THE EXPERTS IN THE LAW AND THE ELDERS HAD GATHERED.

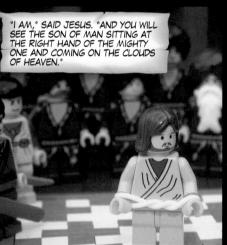

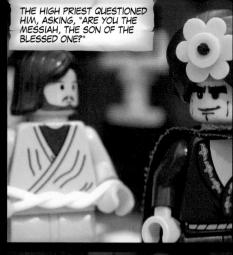

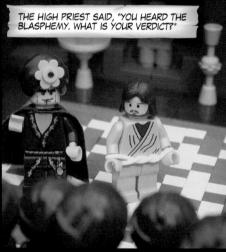

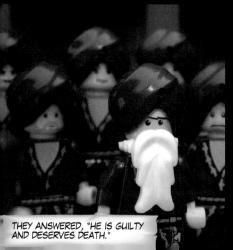

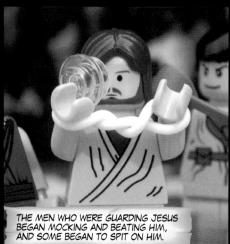

THEY BLINDFOLDED HIM AND STRUCK HIM WITH THEIR FISTS, SAYING, "PROPHESY! WHICH ONE OF US HIT YOU?" AND THEY SAID MANY OTHER INSULTING THINGS TO HIM.

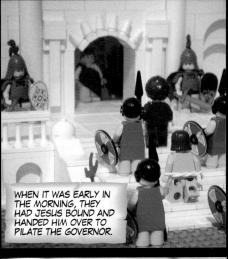

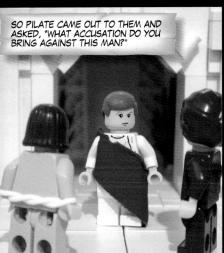

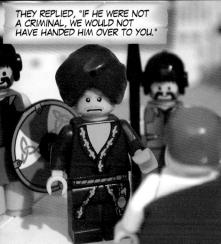

THEN PILATE SAID TO THEM, "TAKE HIM AND JUDGE HIM ACCORDING TO YOUR OWN LAW!" WHEN HE LEARNED JESUS WAS A GALILEAN FROM HEROD'S JURISDICTION, HE SENT HIM TO HEROD, WHO ALSO HAPPENED TO BE IN JERUSALEM AT THAT TIME.

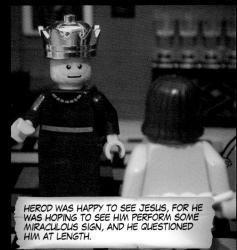

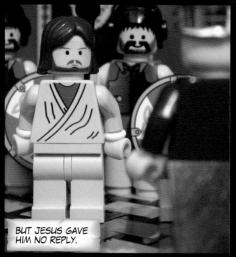

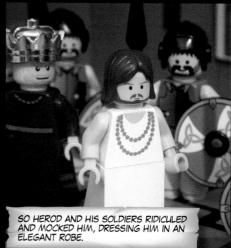

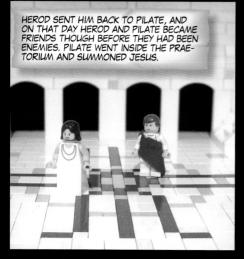

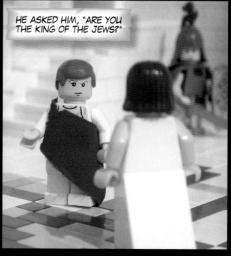

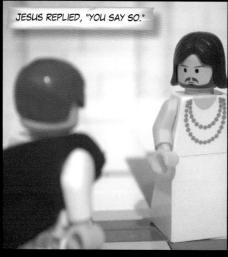

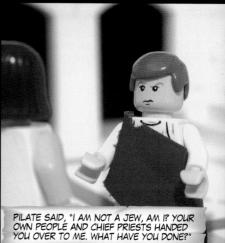

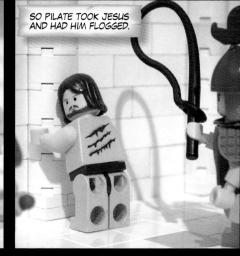

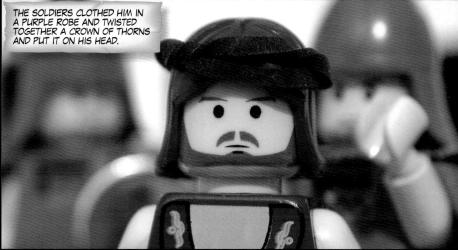

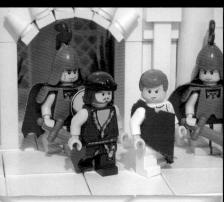

Jn 19:11

Jn 19:5, 19:10

Jn 19:2

Jn 19:1

Mt 27:14

SO JESUS CAME OUTSIDE, WEARING THE CROWN OF THORNS AND THE PURPLE ROBE, AND PILATE SAID, "DO YOU REFUSE TO SPEAK TO ME? DON'T YOU KNOW! HAVE THE AUTHORITY TO RELEASE YOU OR TO CRUCIFY YOU?"

JESUS REPLIED, "YOU WOULD HAVE NO AUTHORITY OVER ME AT ALL, UNLESS IT WAS GIVEN TO YOU FROM ABOVE. THEREFORE THE ONE WHO HANDED ME OVER TO YOU IS GUILTY OF GREATER SIN."

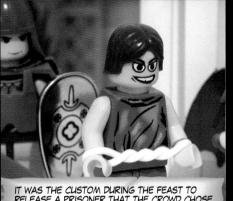

IT WAS THE CUSTOM DURING THE FEAST TO RELEASE A PRISONER THAT THE CROWD CHOSE. THEY HAD IN CLISTODY A NOTORIOLIS PRISONER NAMED JESUS BARABBAS, WHO HAD BEEN THROWN IN PRISON FOR STARTING A RIOT IN THE CITY AND FOR MURDER.

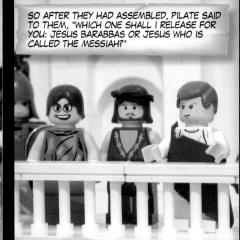

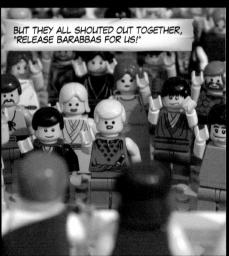

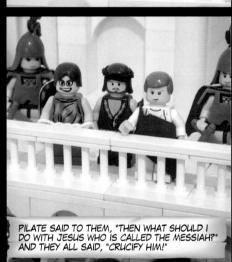

Jn 19:7

Jn 19:6 |

6: Lk 23:19

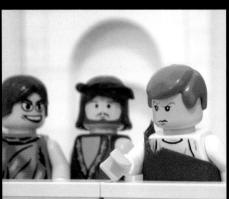

PILATE SAID, "YOU TAKE HIM AND CRUCIFY HIM!"

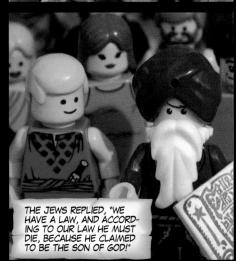

SO PILATE HANDED HIM OVER TO BE CRUCIFIED, AND THEY TOOK JESUS AWAY.

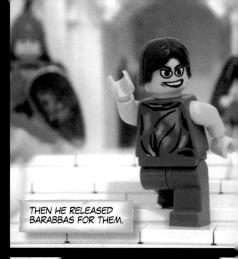

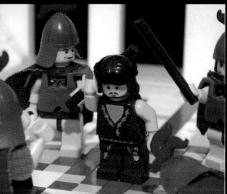

THEN THE GOVERNOR'S SOLDIERS TOOK JESUS INTO THE PRAETORIUM AND MOCKED HIM, SAYING, "HAIL, KING OF THE JEWS!" AND STRUCK HIM REPEATEDLY ON THE HEAD.

AFTER THEY HAD MOCKED HIM, THEY STRIPPED HIM OF THE ROBE AND PUT HIS OWN CLOTHES BACK ON HIM, AND THEY LED HIM AWAY TO CRUCIFY HIM. TWO OTHER CRIMINALS WERE ALSO TO BE EXECUTED WITH HIM.

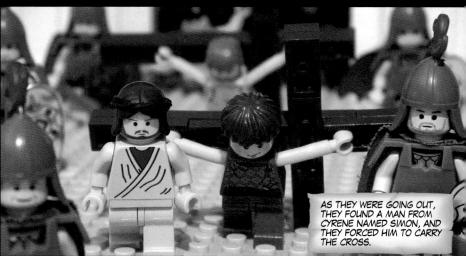

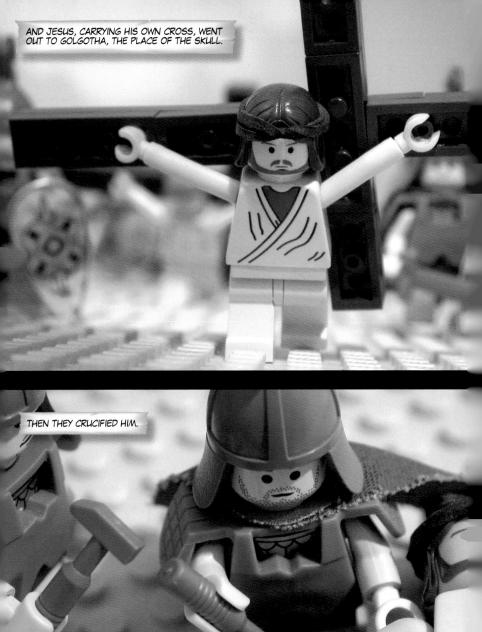

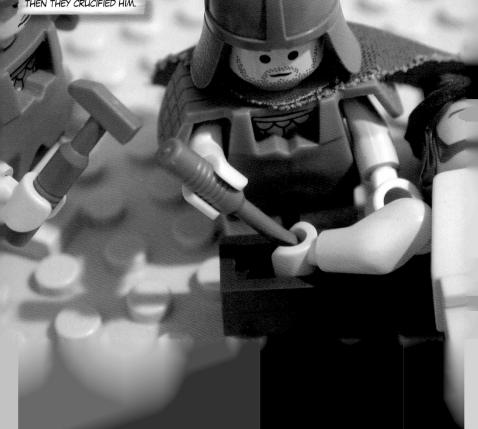

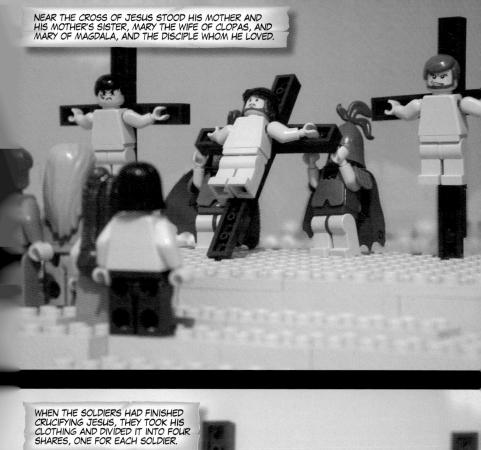

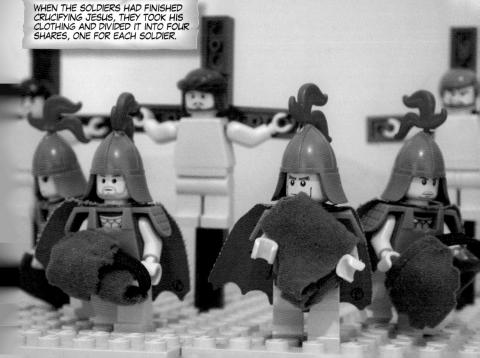

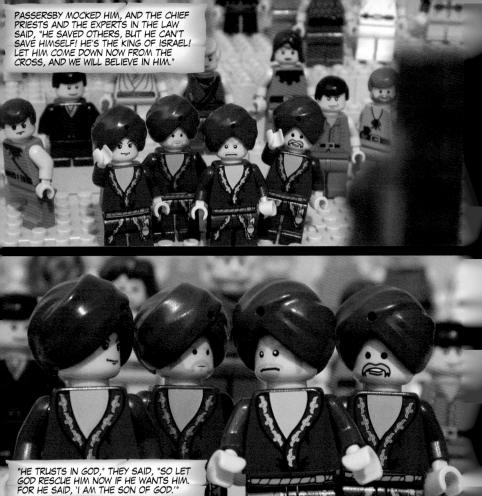

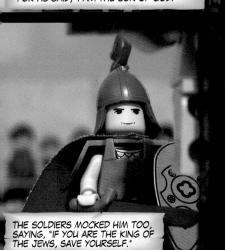

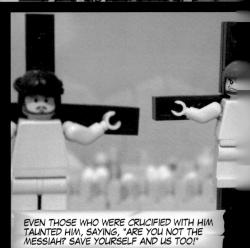

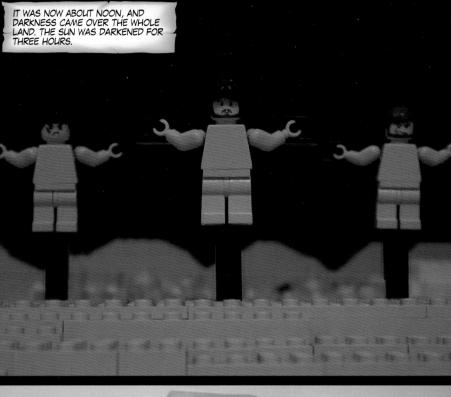

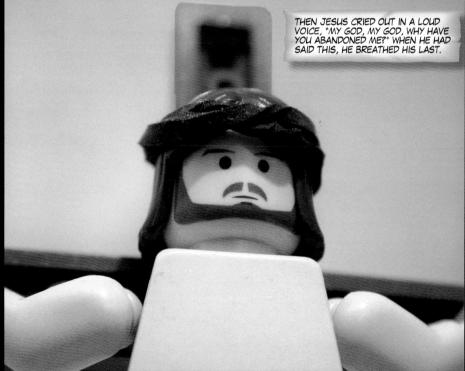

Lk 23:44-45 | Mk 15:34; Lk 23:46

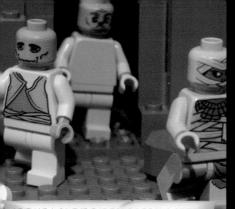

AT THAT MOMENT THE TOMBS BROKE OPEN AND THE BODIES OF MANY HOLY PEOPLE WHO HAD DIED WERE RAISED TO LIFE.

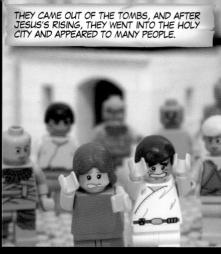

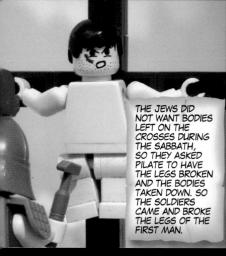

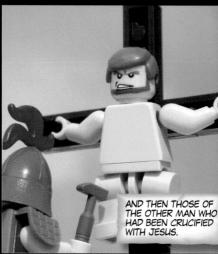

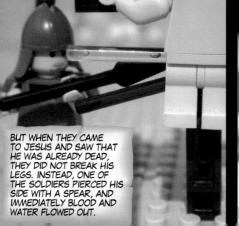

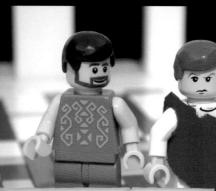

AFTER THIS, JOSEPH OF ARIMATHEA, A RICH MAN WHO WAS A DISCIPLE OF JESUS, ASKED PILATE IF HE COULD REMOVE THE BODY OF JESUS. PILATE, SURPRISED THAT JESUS WAS ALREADY DEAD, GAVE HIM PERMISSION.

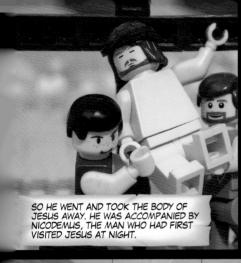

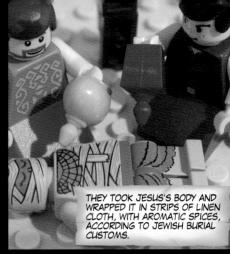

NEARBY WAS A NEW TOMB IN WHICH NO ONE HAD YET BEEN BURIED. THEY LAID JESUS THERE. AND MARY MAGDALENE AND MARY THE MOTHER OF JOSES SAW WHERE HE WAS LAID.

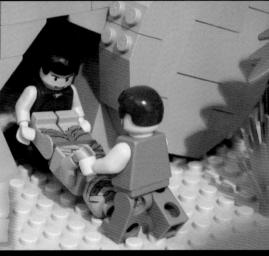

THE NEXT DAY, THE CHIEF PRIESTS AND THE PHARISEES CAME BEFORE PILATE AND SAID, "GIVE ORDERS TO GUARD THE TOMB, STEAL HIS BODY AND SAY TO THE PEOPLE, 'HE HAS BEEN RAISED FROM THE DEAD!"

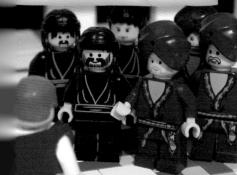

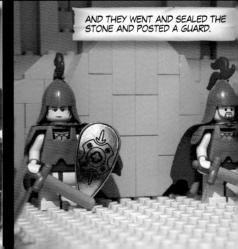

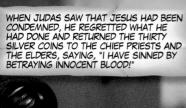

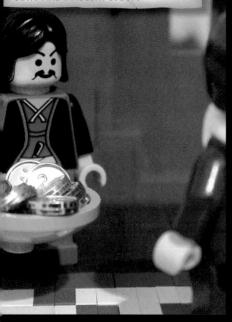

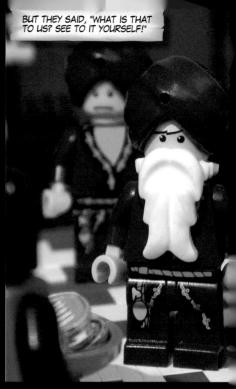

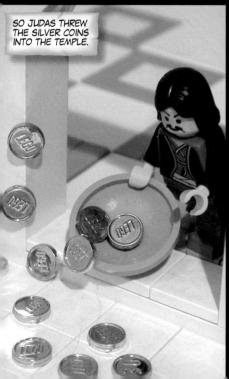

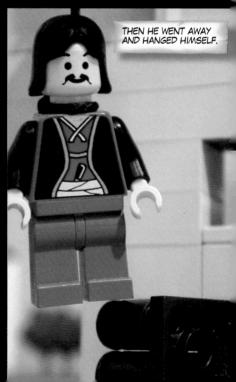

AT SUNRISE, MARY MAGDALENE, MARY THE MOTHER OF JAMES, AND SALOME WENT TO THE TOMB WITH AROMATIC SPICES TO ANOINT JESUS'S BODY, AND THEY WERE ASKING EACH OTHER, "WHO WILL ROLL AWAY THE STONE FOR US FROM THE ENTRANCE TO THE TOMB?"

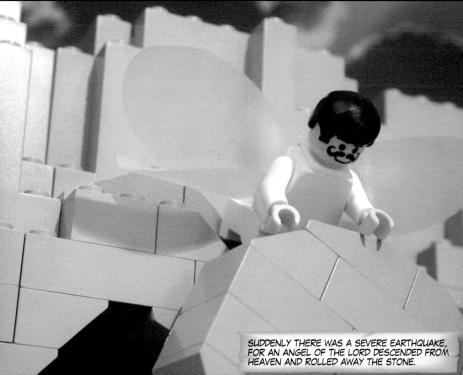

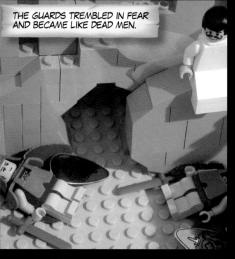

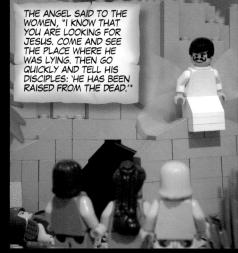

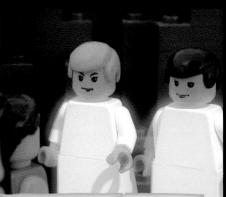

THEY WENT INTO THE TOMB AND SUDDENLY

TWO MEN IN GLEAMING CLOTHES STOOD BESIDE THEM AND SAID, "WHY DO YOU LOOK FOR THE LIVING AMONG THE DEAD? HE IS NOT HERE, HE HAS RISEN!"

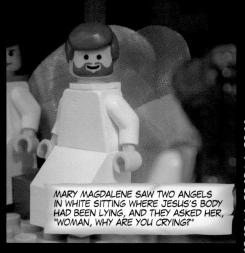

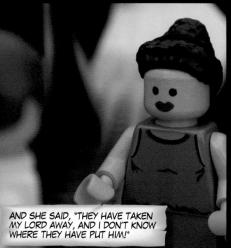

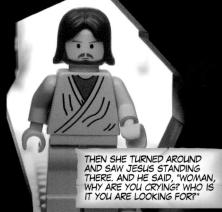

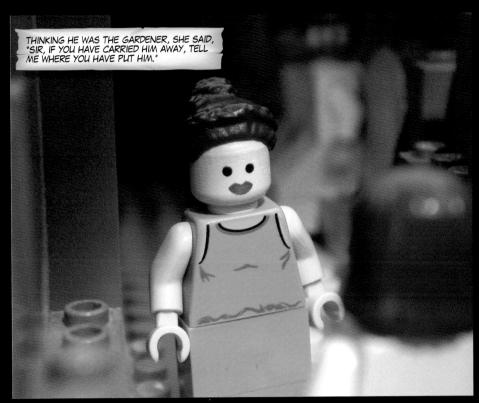

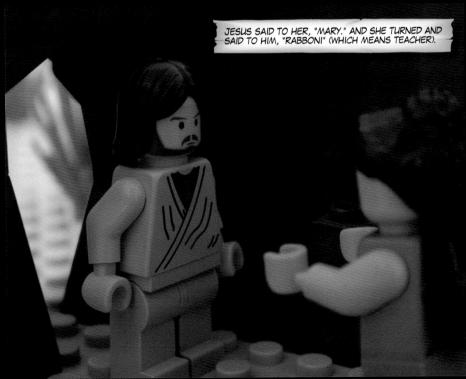

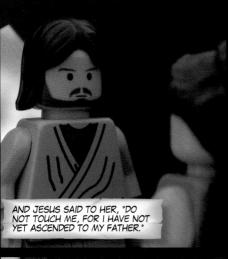

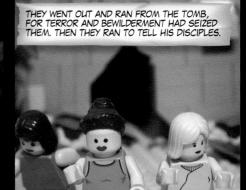

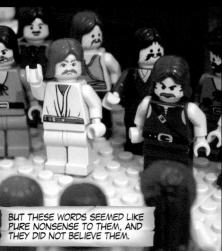

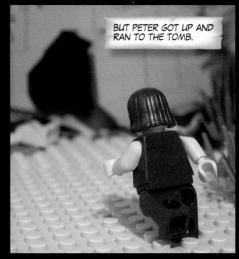

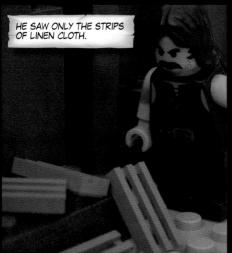

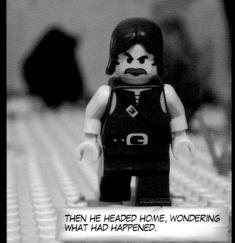

Jn 20:17 | Mk 16:18: Mt 28:8 | Lk 24:10 | Lk 24:12 | Lk 24:12 | Lk 24:12

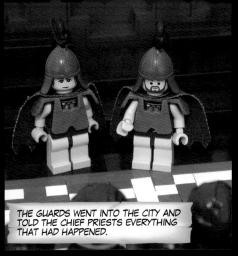

THEY FORMED A PLAN, GIVING THE SOLDIERS A LARGE SUM OF MONEY AND TELLING THEM, "YOU -ARE TO SAY, 'HIS DISCIPLES CAME AT NIGHT AND STOLE HIS BODY WHILE WE WERE ASLEEP."

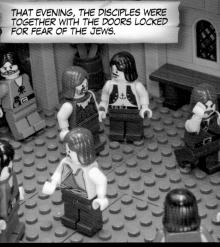

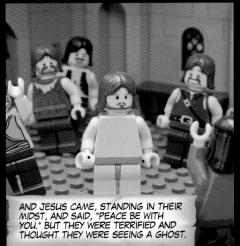

JESUS SAID, "WHY ARE YOU AFRAID. WHY DO YOU DOUBT? LOOK AT MY HANDS. TOUCH ME AND SEE! A GHOST DOES NOT HAVE FLESH AND BONES AS I HAVE."

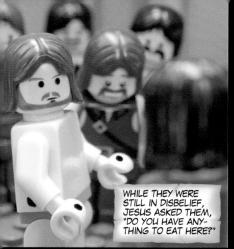

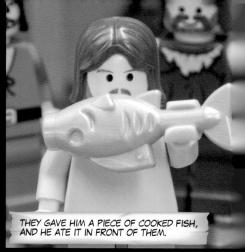

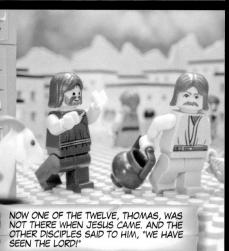

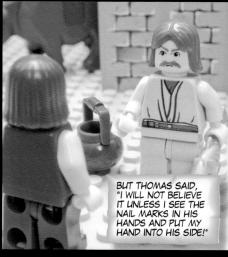

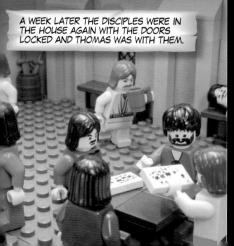

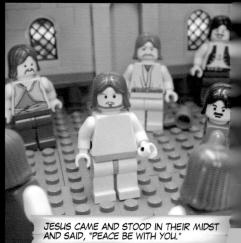

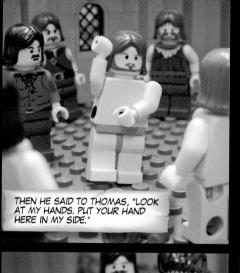

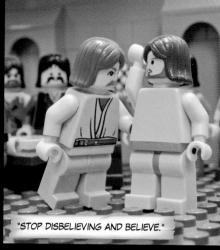

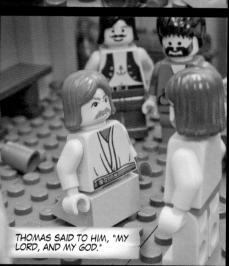

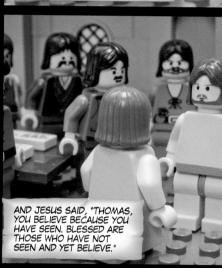

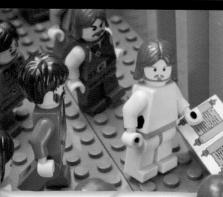

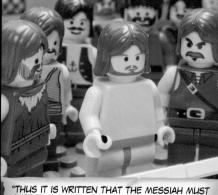

THEN HE OPENED THEIR MINDS SO THEY COULD UNDERSTAND THE SCRIPTURES, SAYING, "EVERYTHING WRITTEN ABOUT ME IN THE LAW OF MOSES, THE PROPHETS, AND THE PSALMS MUST BE FULFILLED."

"THUS IT IS WRITTEN THAT THE MESSIAH MUST SUFFER AND AFTER THREE DAYS RISE FROM THE DEAD. THE REPENTANCE FOR THE FORGIVENESS OF SINS MUST BE PREACHED TO ALL NATIONS, STARTING IN JERUSALEM."

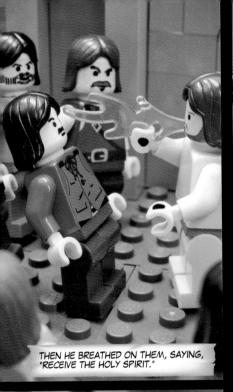

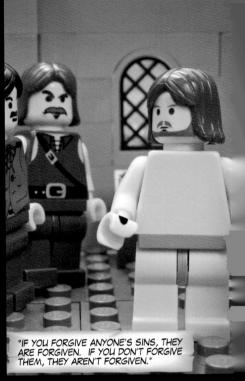

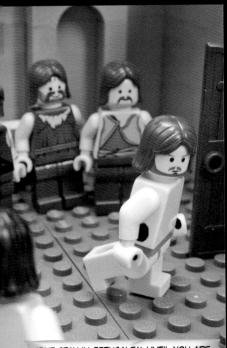

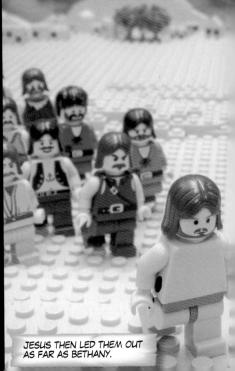

"BUT STAY IN JERUSALEM UNTIL YOU ARE CLOTHED WITH POWER FROM ON HIGH."

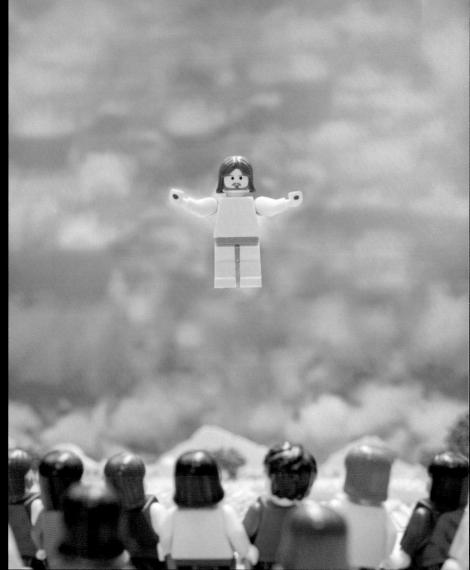

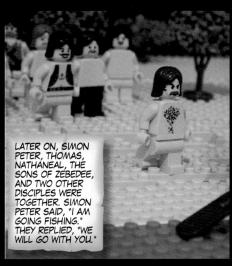

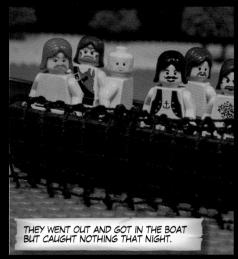

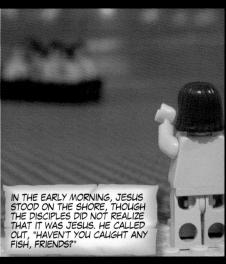

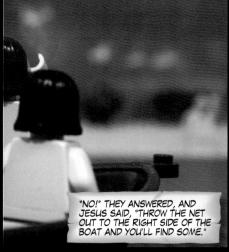

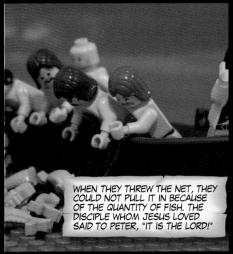

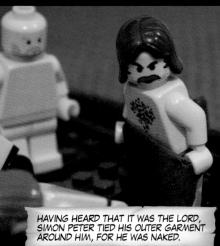

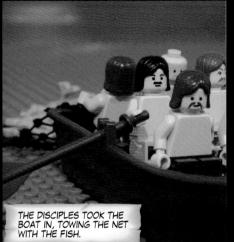

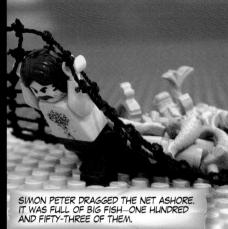

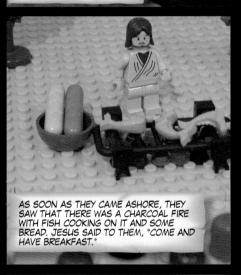

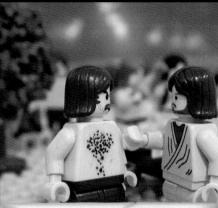

WHEN THEY HAD EATEN, JESUS SAID TO SIMON PETER, "SIMON, SON OF JOHN, DO YOU LOVE ME MORE THAN THESE OTHERS DO?"

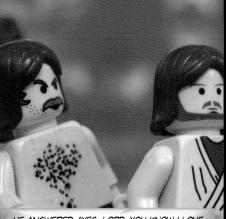

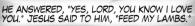

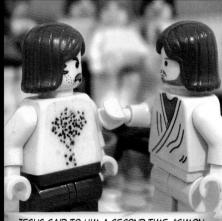

JESUS SAID TO HIM A SECOND TIME, "SIMON SON OF JOHN, DO YOU LOVE ME?"

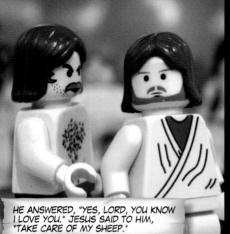

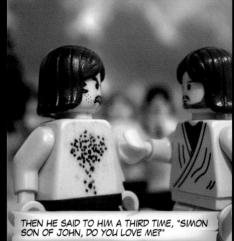

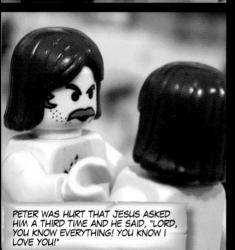

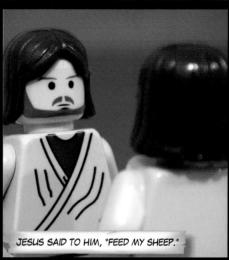

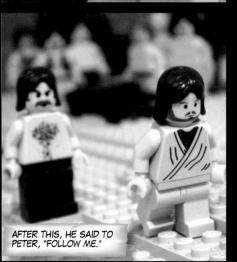

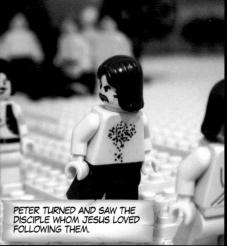

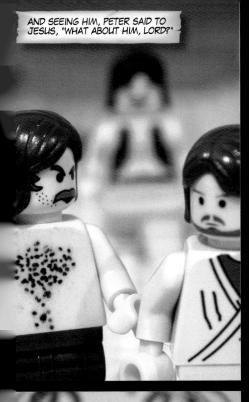

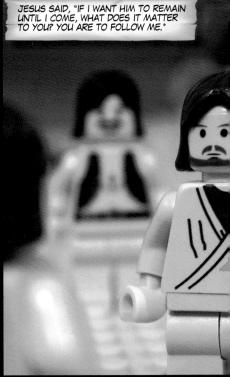

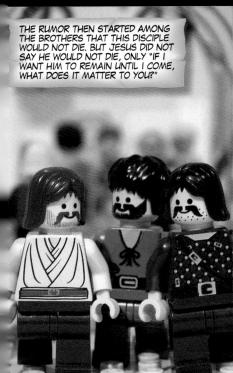

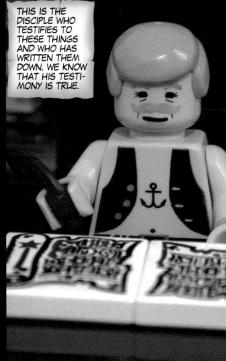

PART II. ACTS OF THE APOSTLES

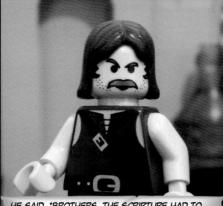

HE SAID, "BROTHERS, THE SCRIPTURE HAD TO BE FULFILLED CONCERNING JUDAS, WHO SERVED AS GUIDE TO THOSE WHO ARRESTED JESUS."

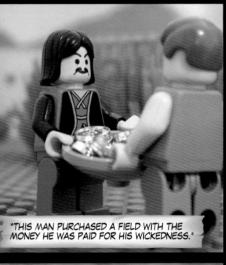

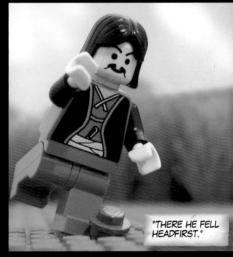

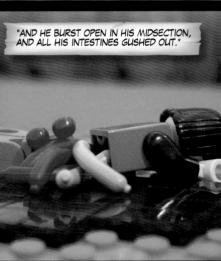

Acts 1:15 | Acts 1:16 | Acts 1:18 |

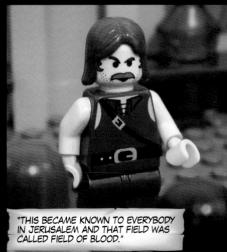

PETER SAID, "IN THE BOOK OF PSALMS IT SAYS, "LET ANOTHER TAKE OVER HIS OFFICE." SO ONE OF THE MEN WHO HAS BEEN WITH US SINCE THE TIME OF JOHN'S BAPTISM MUST BECOME A WITNESS WITH US."

THEY PROPOSED TWO MEN: JOSEPH KNOWN AS BARSABBAS WHOSE SURNAME WAS JUSTUS, AND MATTHIAS.

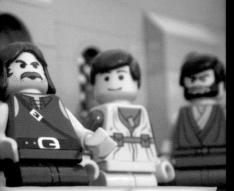

THEN THEY PRAYED, "LORD, SHOW US WHICH OF THESE TWO YOU HAVE CHOSEN TO TAKE THE PLACE OF THE APOSTLESHIP JUDAS LEFT TO GO TO HIS PROPER PLACE."

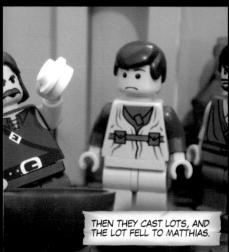

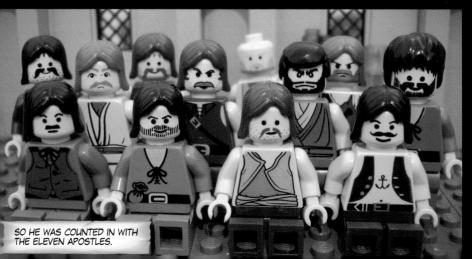

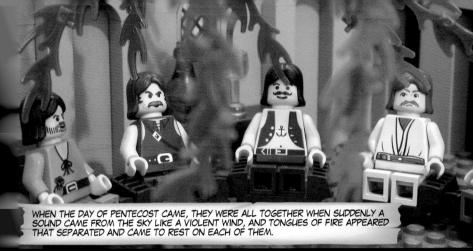

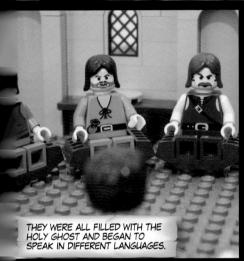

IN JERUSALEM THERE WERE GOD-FEARING MEN FROM EVERY NATION, AND AT THIS SOUND THEY ASSEMBLED IN CONFUSION, BECAUSE EACH ONE HEARD THEM SPEAKING IN HIS OWN LANGUAGE.

BEWILDERED, THEY SAID, "AREN'T THESE MEN SPEAKING ALL GALILEANS? HOW IS IT THAT EACH ONE OF US HEARS THEM IN HIS OWN NATIVE LANGUAGE?" AMAZED AND CONFUSED, THEY SAID TO ONE ANOTHER, "WHAT DOES THIS MEAN?"

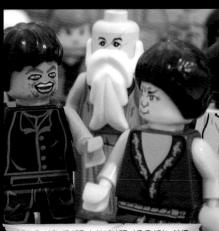

SOME, HOWEVER, LAUGHED AT THEM AND SAID, "THEY HAVE HAD TOO MUCH WINE!"

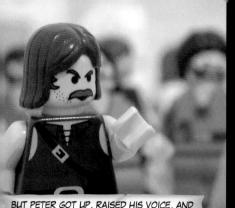

BUT PETER GOT UP, RAISED HIS VOICE, AND DECLARED TO THEM, "THESE MEN ARE NOT DRUNK! IT IS ONLY NINE O'CLOCK IN THE MORNING!"

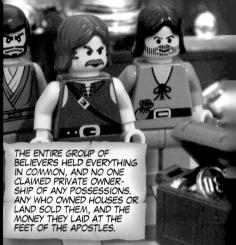

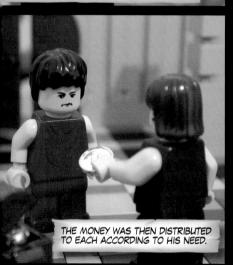

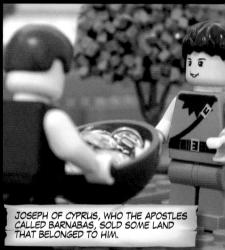

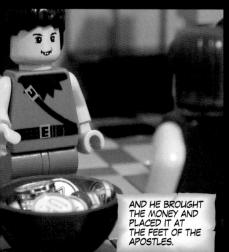

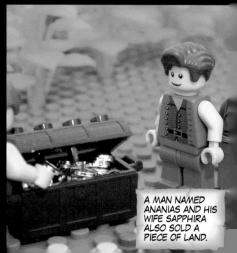

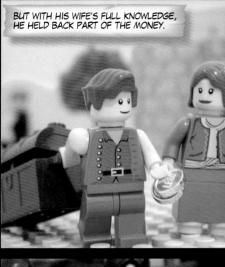

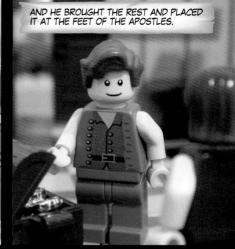

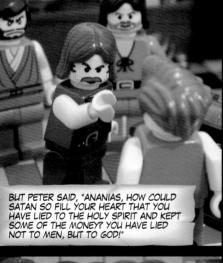

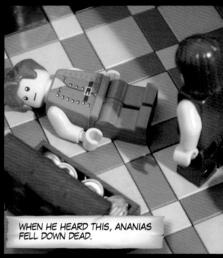

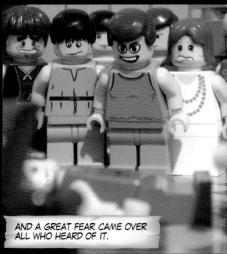

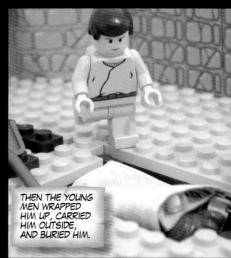

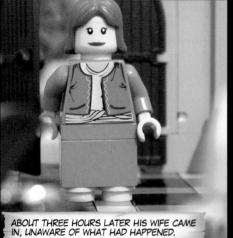

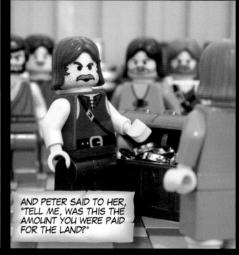

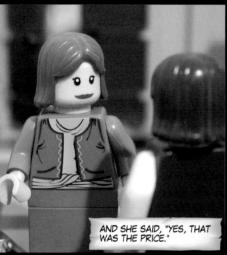

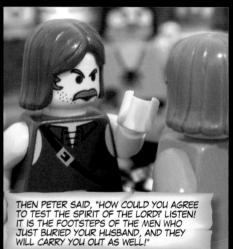

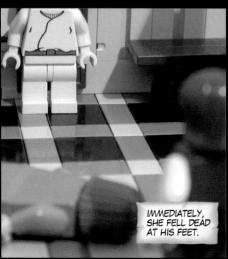

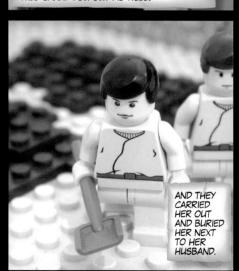

Acts 5:7 | Acts 5:8 | Acts 5:8 | Acts 5:9 | Acts 5:10 | Acts 5:10

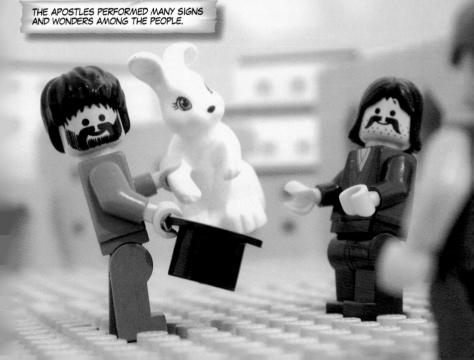

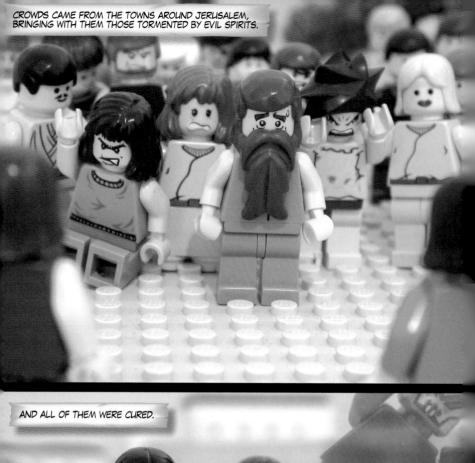

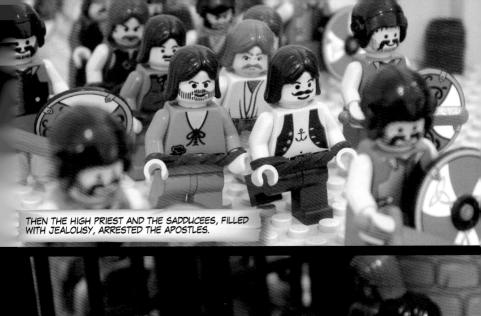

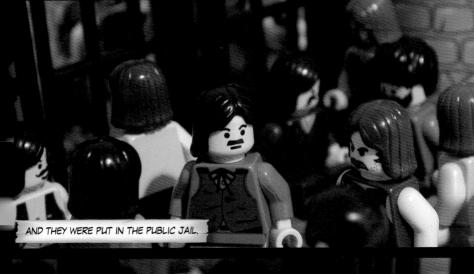

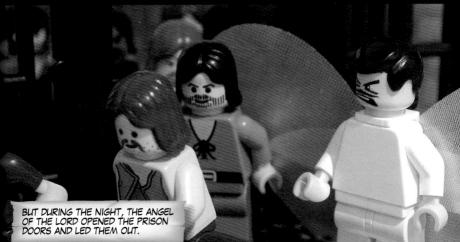

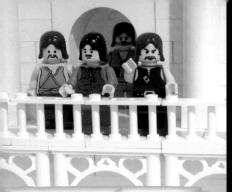

AT DAWN THEY WENT TO THE TEMPLE AND BEGAN TO PREACH. PETER SAID, "THE SUN WILL BE CHANGED TO DARKNESS AND THE MOON TO BLOOD BEFORE THE GREAT AND GLORIOUS DAY OF THE LORD COMES."

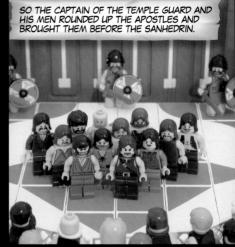

THEY WERE FURIOUS AND WANTED TO PUT THEM TO DEATH, BUT A PHARISEE NAMED GAMALIEL SPOKE UP AND SAID, "MEN OF ISRAEL, BE CAUTIOUS WITH WHAT YOU DO TO THESE MEN."

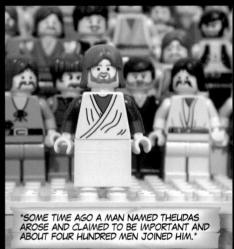

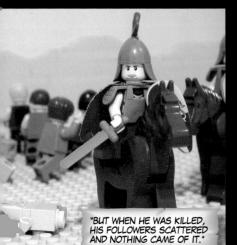

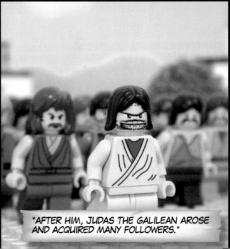

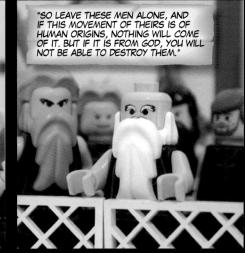

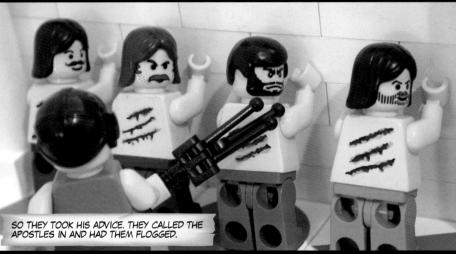

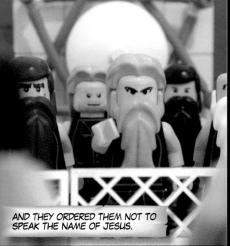

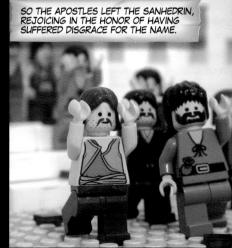

Acts 5:37 | Acts 5:38-39 | Acts 5:40 | Acts 5:40 | Acts 5:41

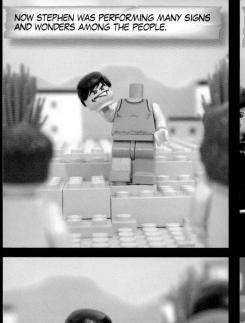

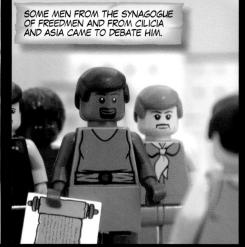

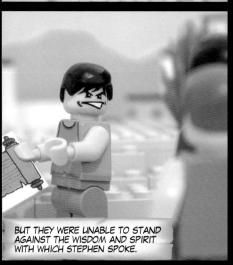

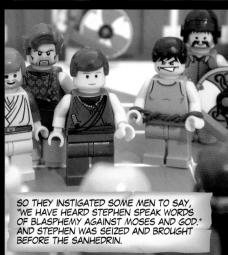

Acts 7:2, 7:51-52

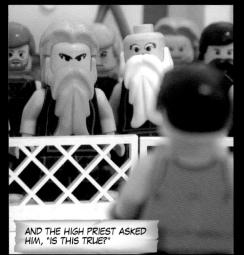

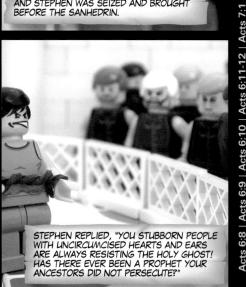

"THEY KILLED THOSE WHO PREDICTED THE COMING OF THE RIGHTEOUS ONE WHOM YOU HAVE NOW BETRAYED AND MURDERED. YOU WERE GIVEN THE LAW THROUGH ANGELS, BUT YOU HAVE NOT OBEYED IT!"

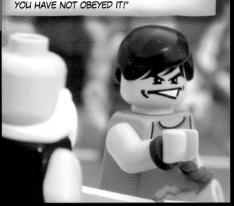

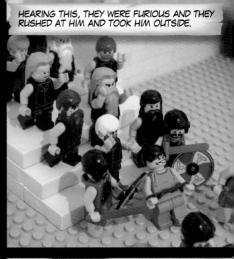

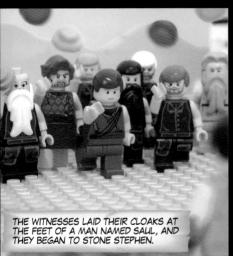

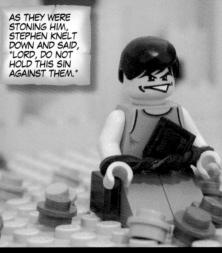

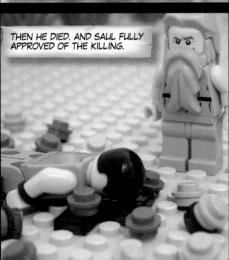

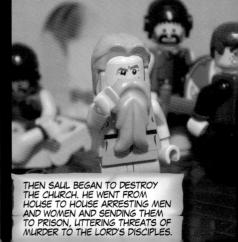

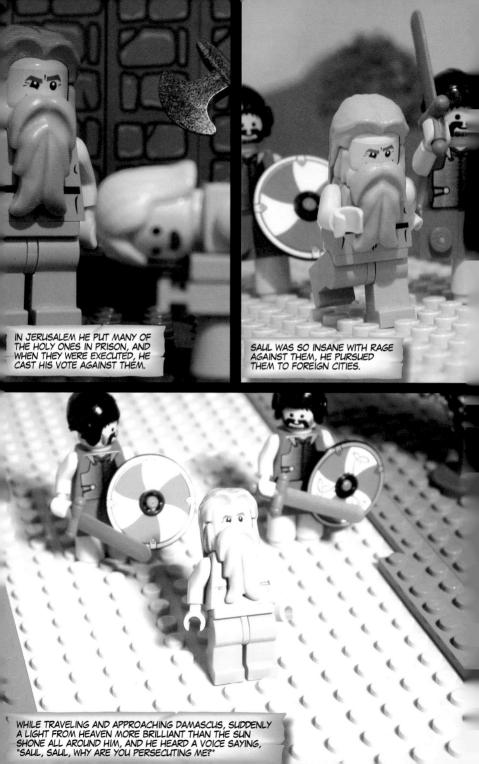

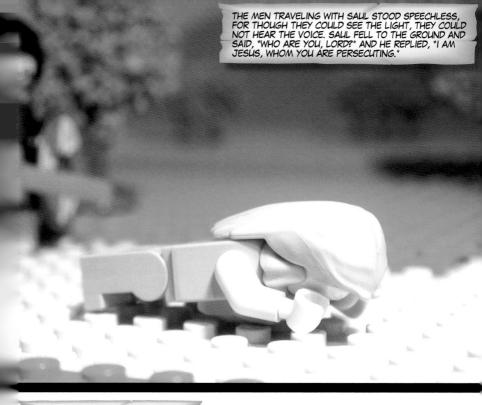

"NOW GET UP AND GO INTO THE CITY, AND YOU WILL BE TOLD WHAT TO DO."

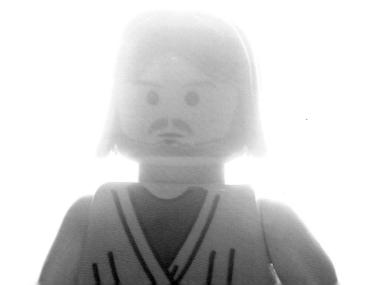

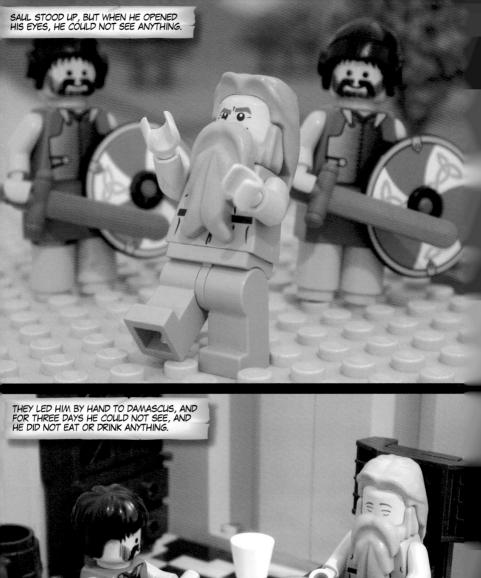

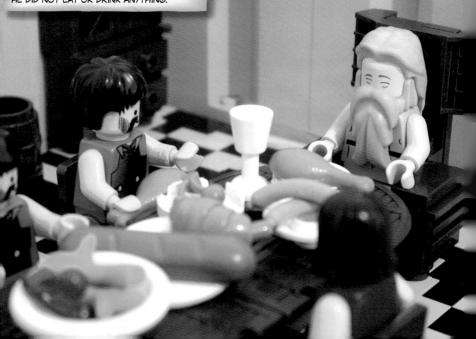

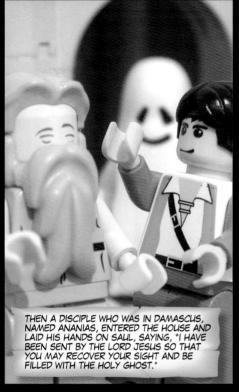

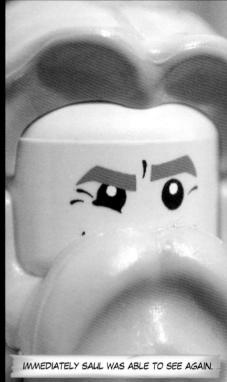

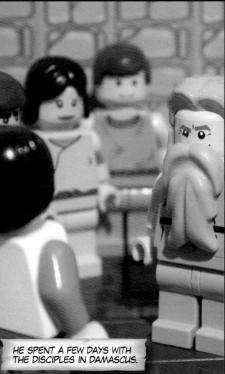

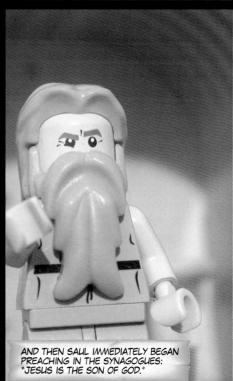

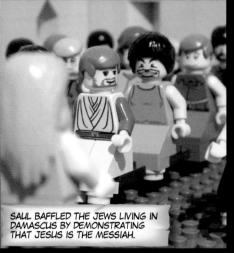

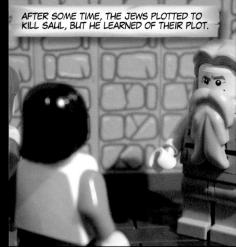

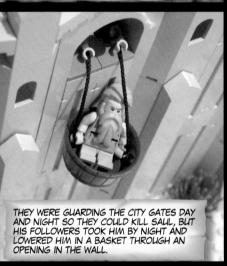

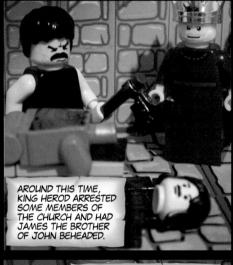

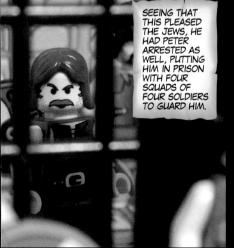

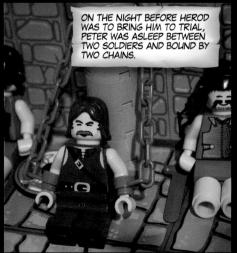

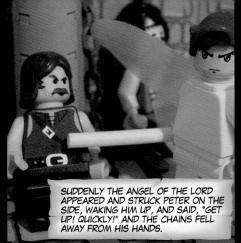

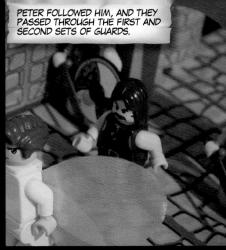

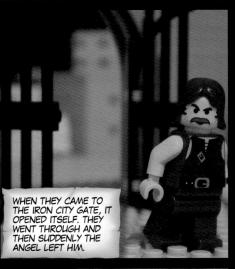

Accs 12:13-14

Acto

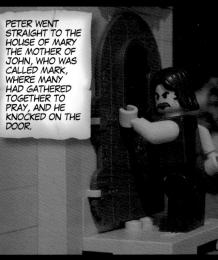

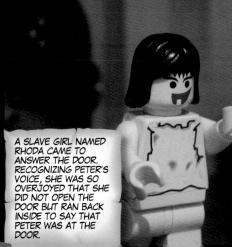

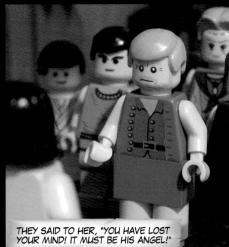

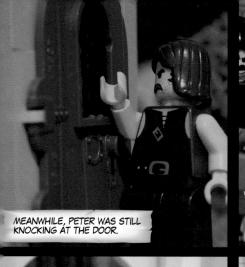

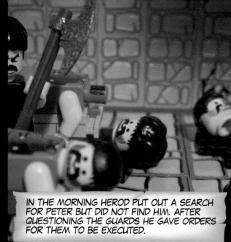

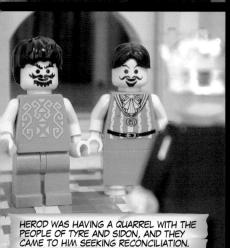

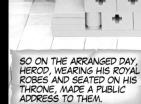

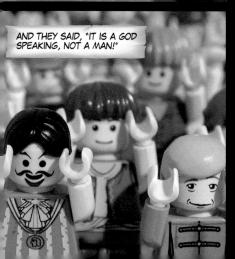

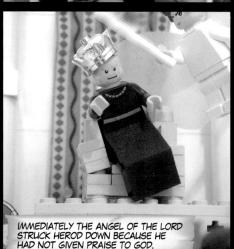

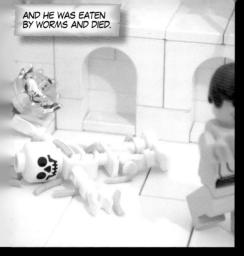

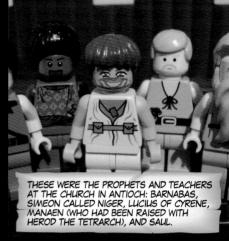

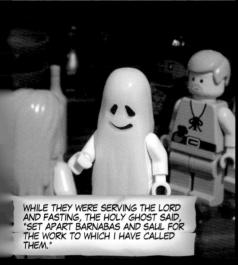

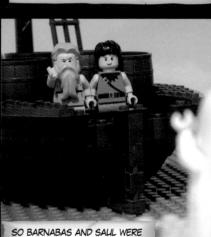

SENT BY THE HOLY GHOST, AND THEY SET SAIL FOR CYPRUS.

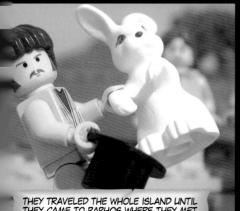

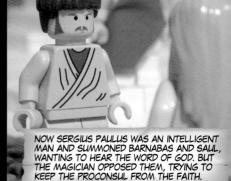

THEY TRAVELED THE WHOLE ISLAND UNTIL THEY CAME TO PAPHOS WHERE THEY MET A JEWISH MAGICIAN AND FALSE PROPHET NAMED SON-OF-JESUS, AN ATTENDANT OF THE PROCONSUL SERGIUS PAULUS.

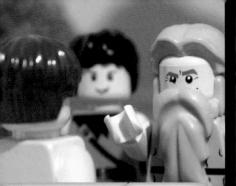

FILLED WITH THE HOLY GHOST, SAUL, WHO WAS ALSO CALLED PAUL, STARED RIGHT AT HIM AND SAID, "SON OF THE DEVIL, FULL OF DECEIT AND TRICKERY! WILL YOU NEVER STOP TWISTING THE WAYS OF THE LORD?"

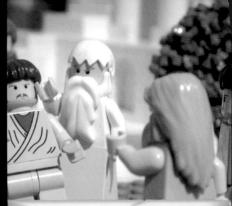

"NOW LOOK! THE HAND OF GOD IS AGAINST YOU, AND YOU WILL BE BLIND FOR A TIME, UNABLE TO SEE BY THE SUN!"

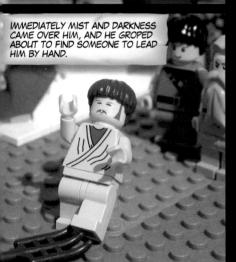

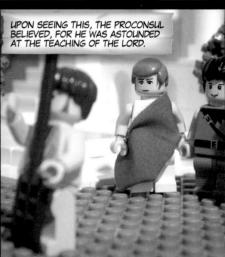

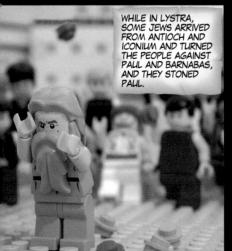

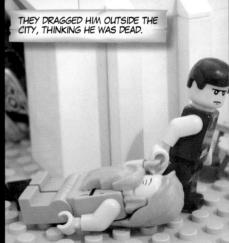

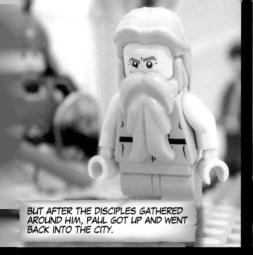

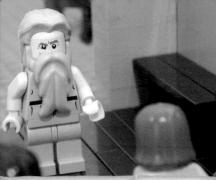

THE NEXT DAY, HE AND BARNABAS LEFT FOR DERBE. THEY PROCLAIMED THE GOOD NEWS IN LYSTRA, ICONIUM, AND ANTIOCH, ENCOURAGING THE DISCIPLES, SAYING, "WE MUST SUFFER MANY HARDSHIPS TO ENTER THE KINGDOM OF GOD."

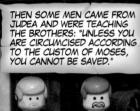

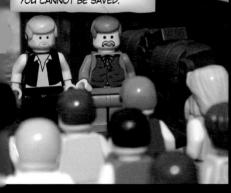

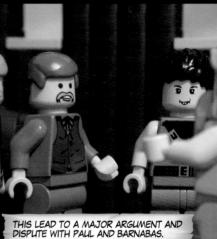

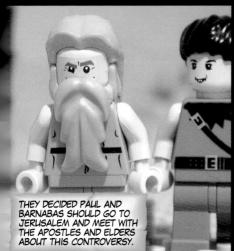

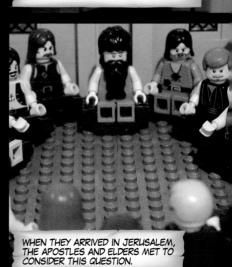

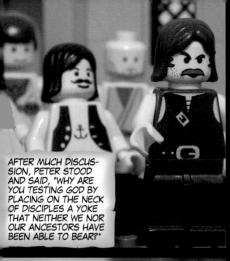

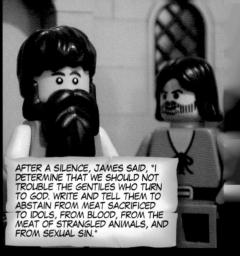

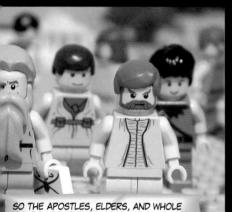

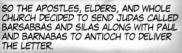

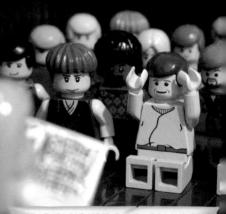

WHEN THEY GATHERED THE CHURCH AND READ THE LETTER ALOUD, THE PEOPLE REJOICED AT ITS ENCOURAGING MESSAGE.

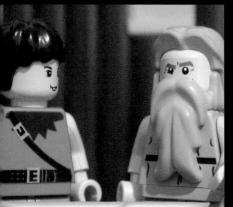

AFTER A FEW DAYS PAUL SAID TO BARNABAS, "LET'S GO BACK AND VISIT THE BROTHERS IN ALL THE TOWNS WHERE WE PREACHED AND SEE HOW THEY ARE."

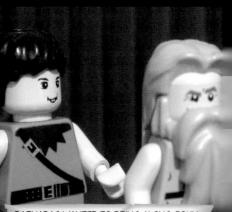

BARNABAS WANTED TO BRING ALONG JOHN CALLED MARK, BLIT PAUL INSISTED THEY NOT TAKE HIM BECAUSE HE HAD DESERTED THEM IN PAMPHYLIA.

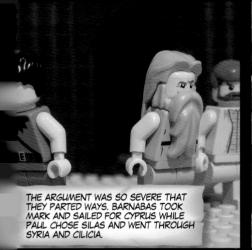

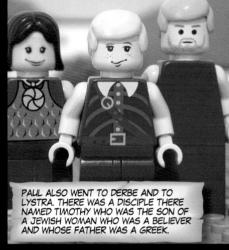

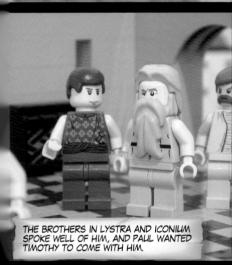

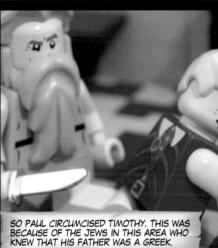

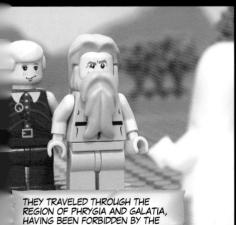

HOLY GHOST FROM PREACHING THE WORD IN THE PROVINCE OF ASIA.

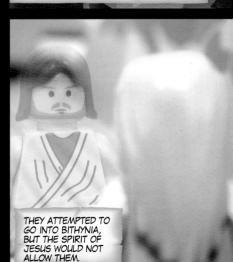

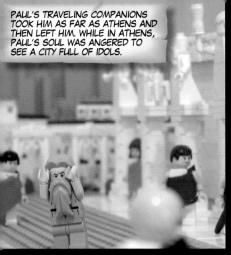

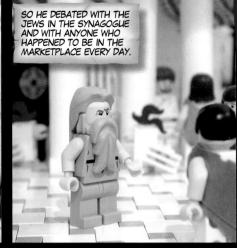

SOME EPICUREAN AND STOIC PHILOSOPHERS ARGUED WITH HIM, SOME SAYING, "WHAT IS THIS FOOLISH BABBLER TRYING TO SAY?" AND OTHERS SAYING, "HE SEEMS TO BE ADVOCATING SOME SORT OF STRANGE DEITIES."

THEY BROUGHT PAUL TO THE AREOPAGUS, SAYING, "TELL US THIS NEW DOCTRINE YOU ARE TEACHING. YOUR IDEAS ARE STRANGE, AND WE WANT TO KNOW THEIR MEANING."

PAUL SAID AT THE AREOPAGUS, "MEN OF ATHENS, GOD HAS SET A DAY ON WHICH THE WORLD WILL BE JUDGED IN RIGHTEOUSNESS BY A MAN HE HAS APPOINTED. AND GOD HAS PROVED THIS TO ALL MEN BY RAISING HIM FROM THE DEAD."

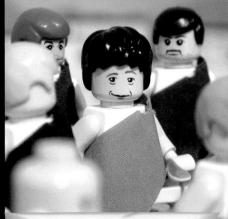

WHEN THEY HEARD ABOUT THE RESURRECTION FROM THE DEAD, SOME LAUGHED AT HIM.

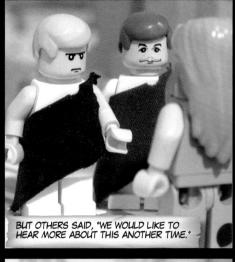

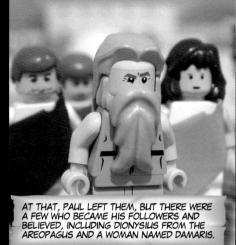

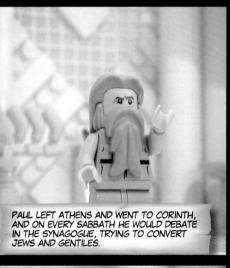

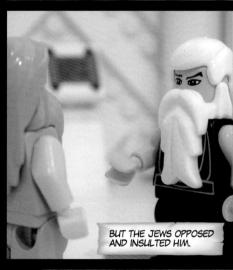

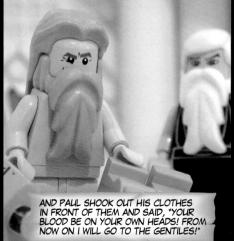

ONE NIGHT, THE LORD SAID TO PAUL IN A VISION, "SPEAK OUT AND DO NOT BE AFRAID. I AR WITH YOU AND NO ONE WILL ASSAULT OR WARM YOU BECAUSE I HAVE MANY PEOPLE IN THIS CITY."

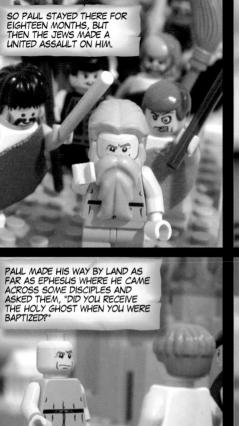

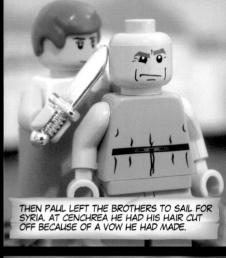

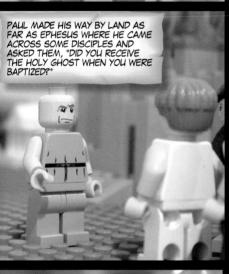

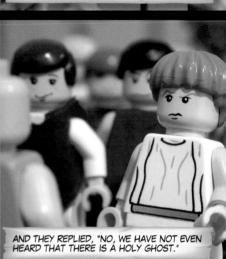

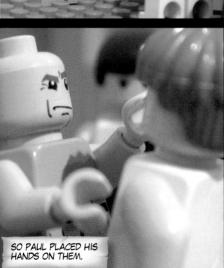

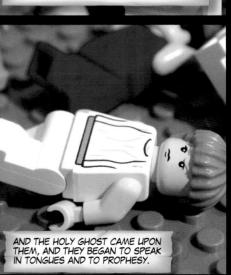

Acts 18:11 | Acts 18:18 | Acts 19:1-2 | Acts 19:2-3 | Acts 19:6 | Acts 19:6-7

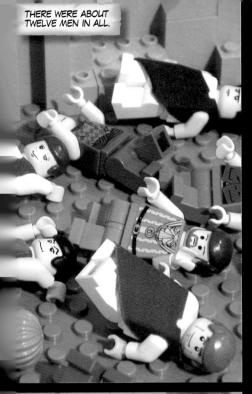

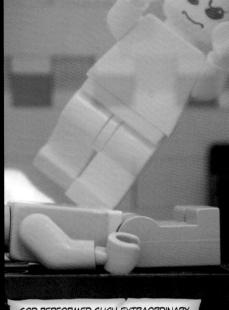

GOD PERFORMED SUCH EXTRAORDINARY MIRACLES THROUGH PAUL THAT EVEN HANDKERCHIEFS OR APRONS THAT HAD TOCHED HIM WERE BROUGHT TO THE SICK, AND THE EVIL SPIRITS WENT OUT OF THEM.

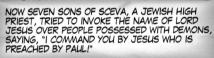

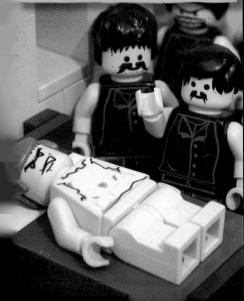

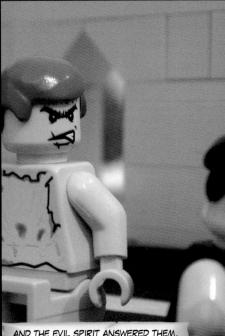

AND THE EVIL SPIRIT ANSWERED THEM, "I KNOW OF JESUS, AND I'VE HEARD OF PAUL, BUT WHO ARE YOU?"

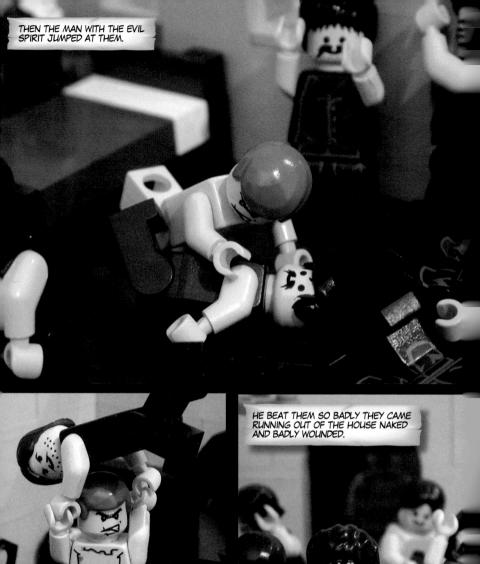

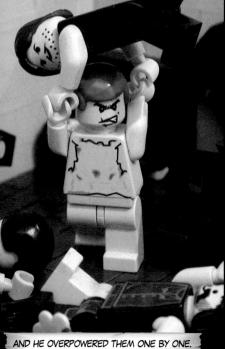

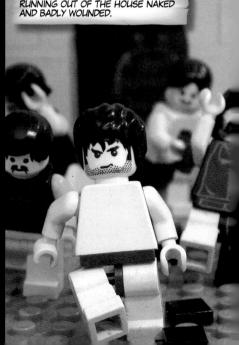

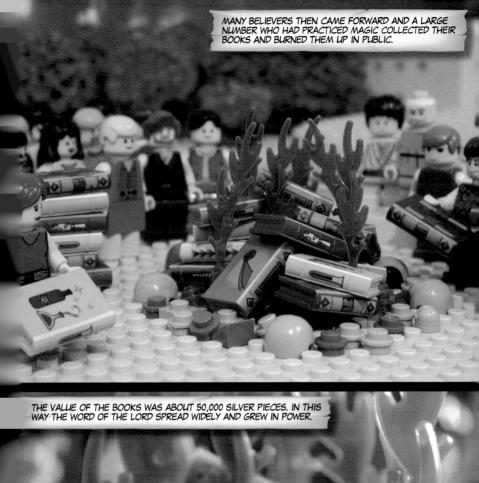

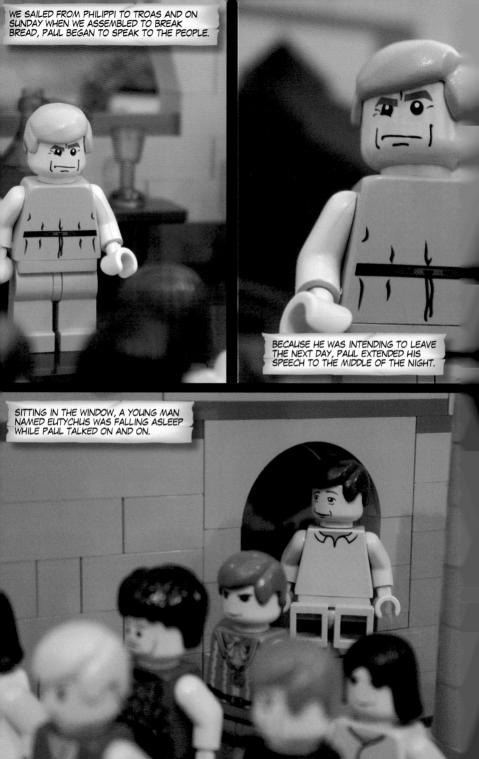

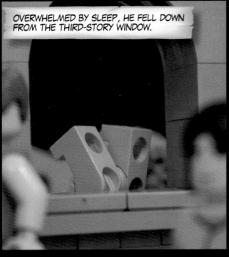

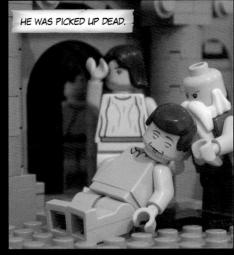

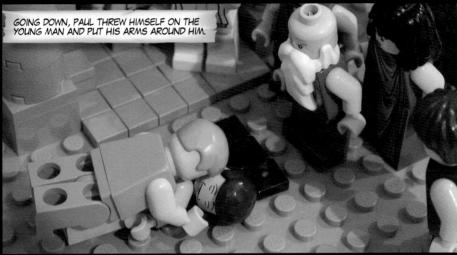

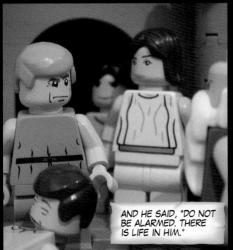

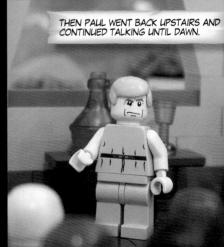

PART III. REVELATION OF JOHN

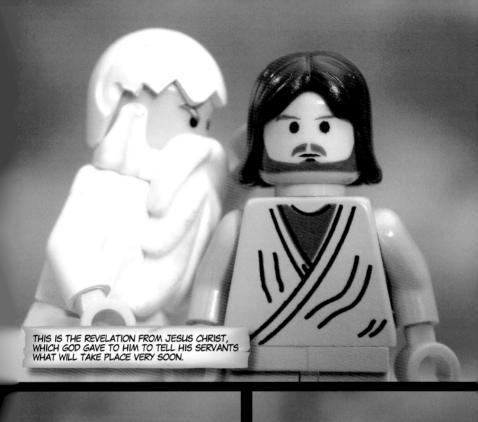

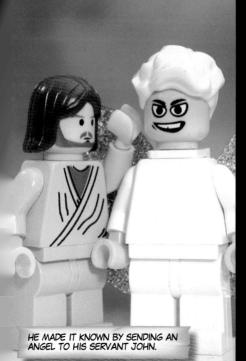

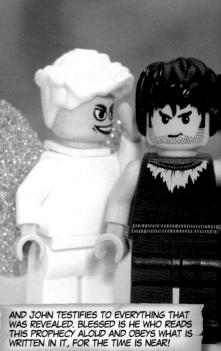

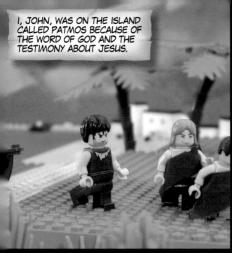

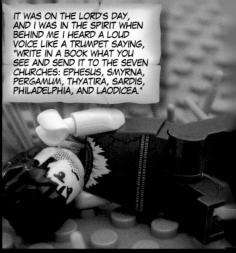

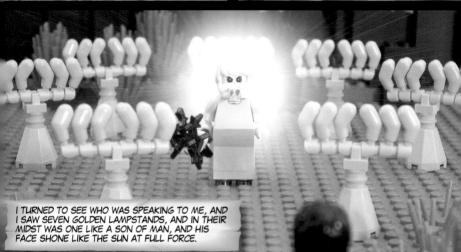

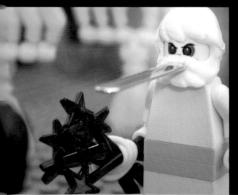

HIS EYES WERE LIKE BLAZING FIRE. OUT OF HIS MOUTH CAME A SHARP DOUBLE-EDGED SWORD. HE WAS DRESSED IN A LONG ROBE WITH A GOLDEN BELT, AND IN HIS RIGHT HAND WERE HELD SEVEN STARS.

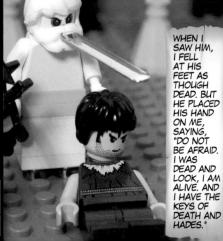

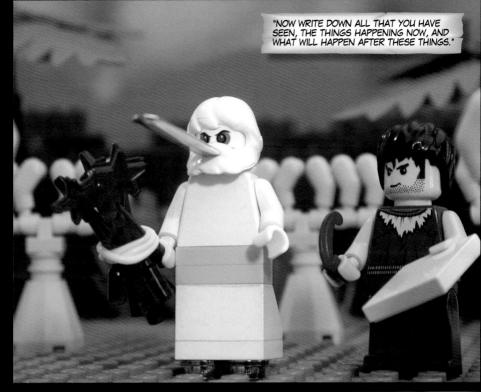

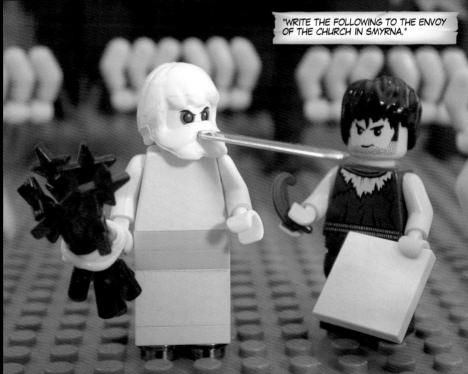

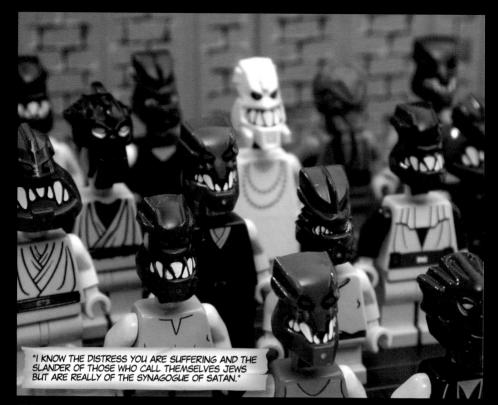

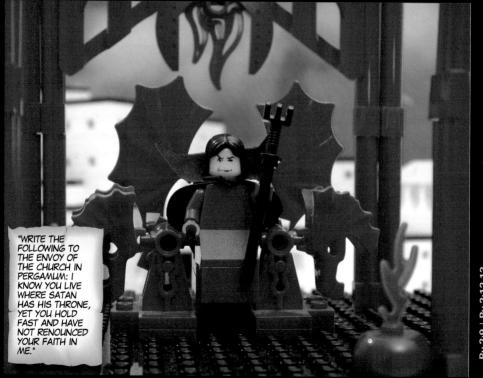

"BUT THERE ARE SOME AMONG YOU WHO HOLD TO THE TEACHINGS OF BALAAM WHO INSTRUCTED BALAK TO CALISE THE PEOPLE OF ISRAEL TO SIN BY EATING FOOD SACRIFICED TO IDOLS."

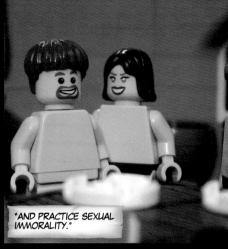

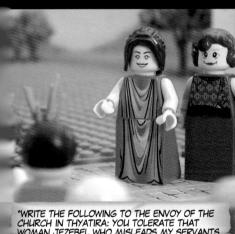

"WRITE THE FOLLOWING TO THE ENVOY OF THE CHURCH IN THYATIRA: YOU TOLERATE THAT WOMAN JEZEBEL WHO MISLEADS MY SERVANTS INTO SEXUAL IMMORALITY."

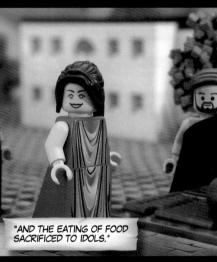

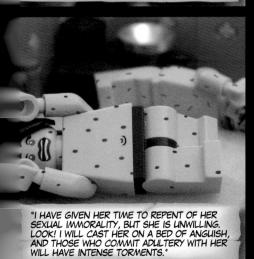

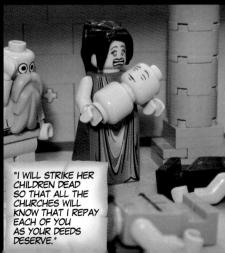

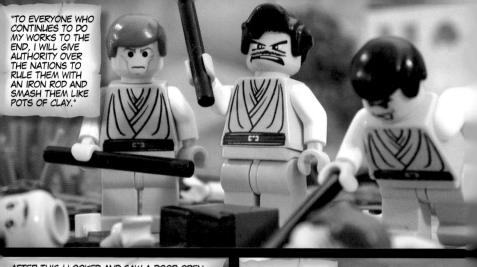

AFTER THIS I LOOKED AND SAW A DOOR OPEN IN THE SKY AND HEARD THE SAME VOICE LIKE A TRUMPET, SAYING, "COME UP HERE, AND I WILL SHOW YOU WHAT MUST TAKE PLACE AFTER THIS."

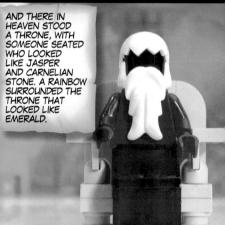

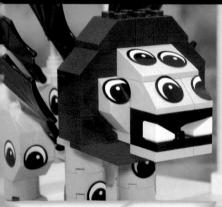

AROUND THE THRONE WERE FOUR LIVING CREATURES, COVERED WITH EYES, EACH WITH SIX WINGS. THE FIRST LIVING CREATURE WAS LIKE A LION.

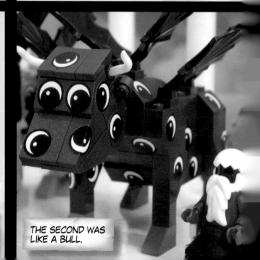

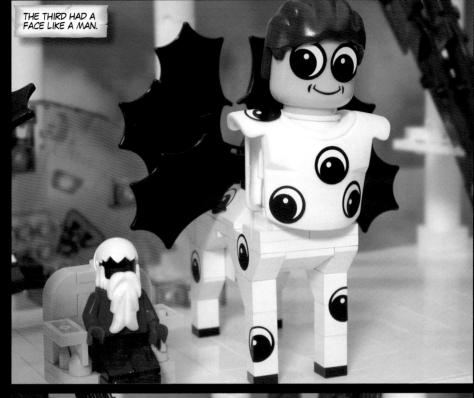

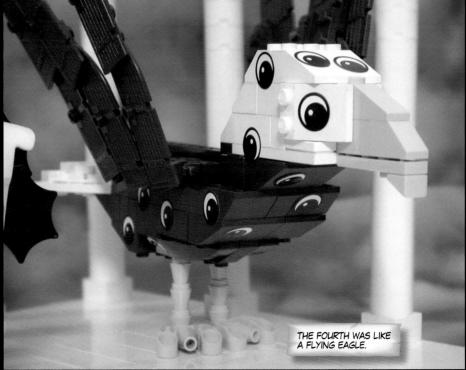

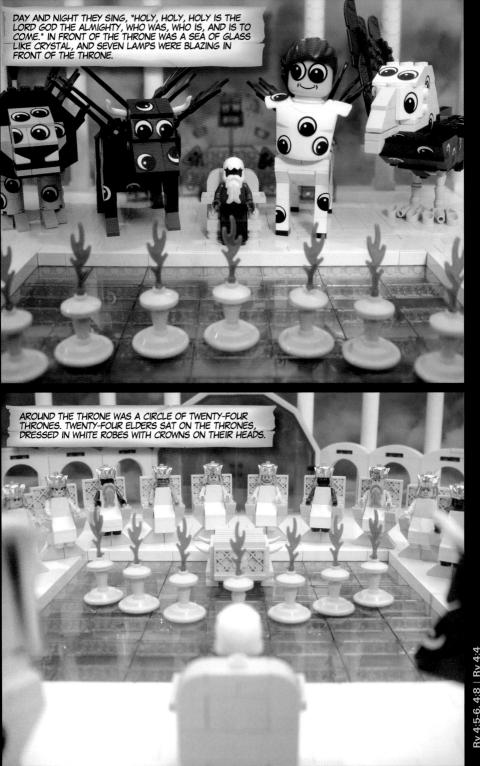

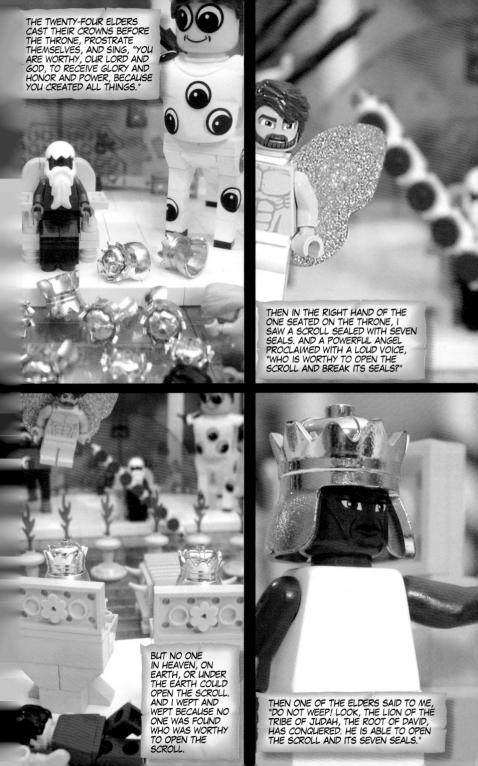

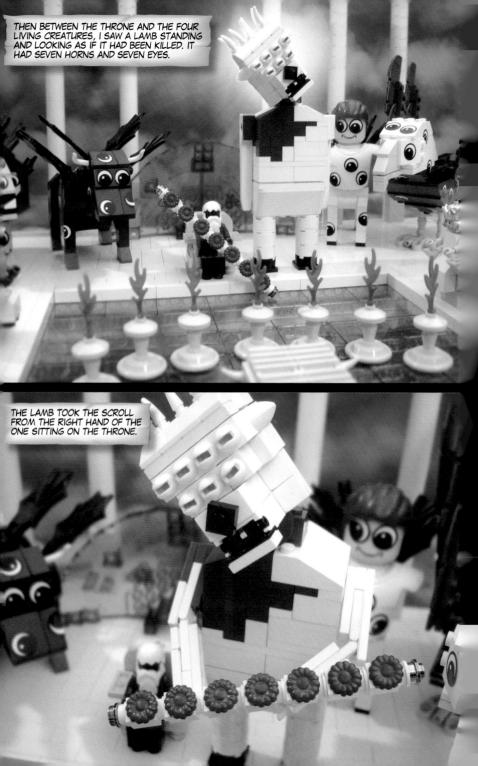

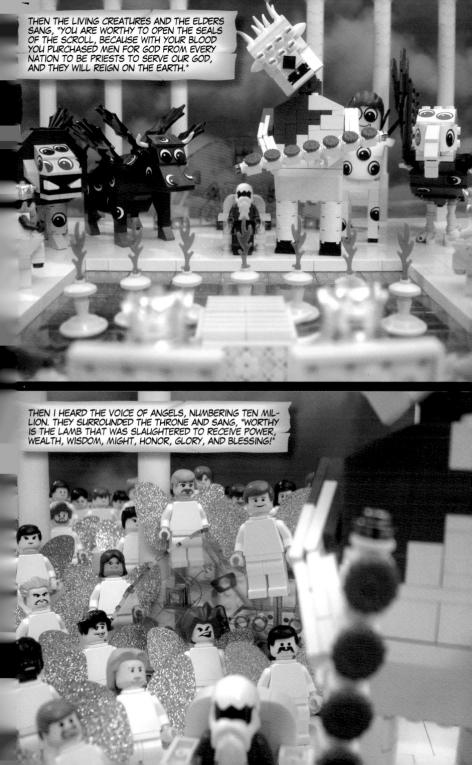

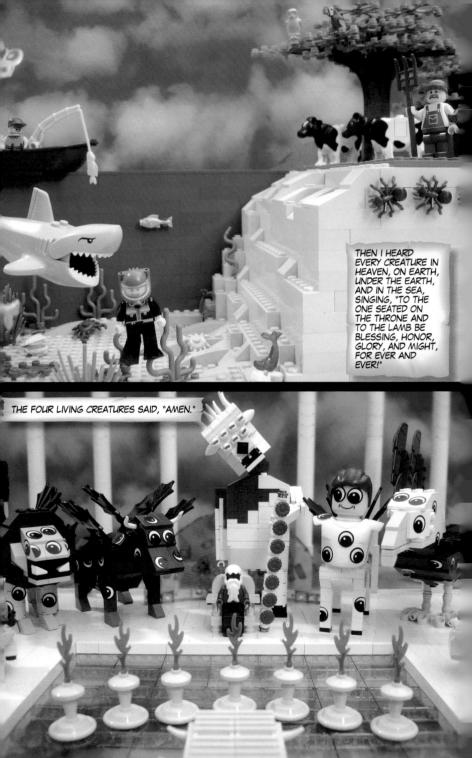

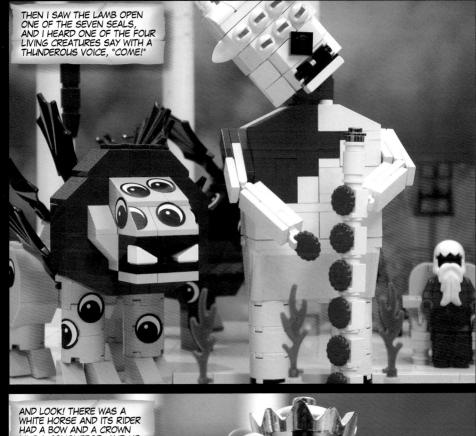

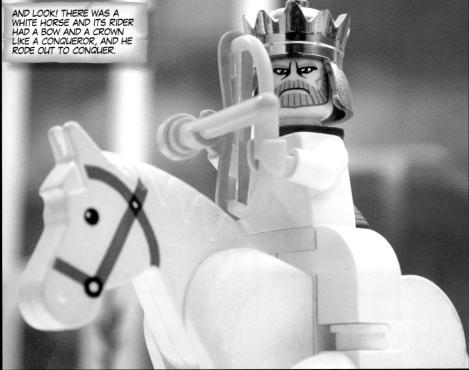

Rv 6:1

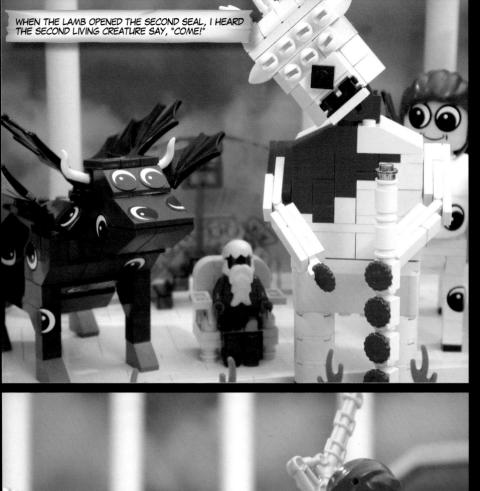

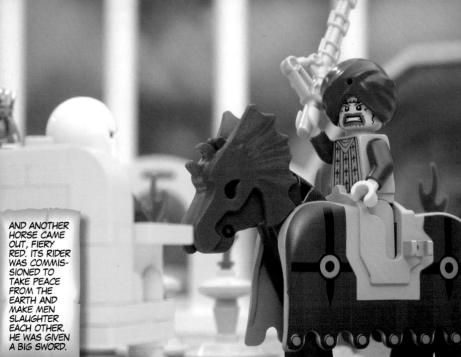

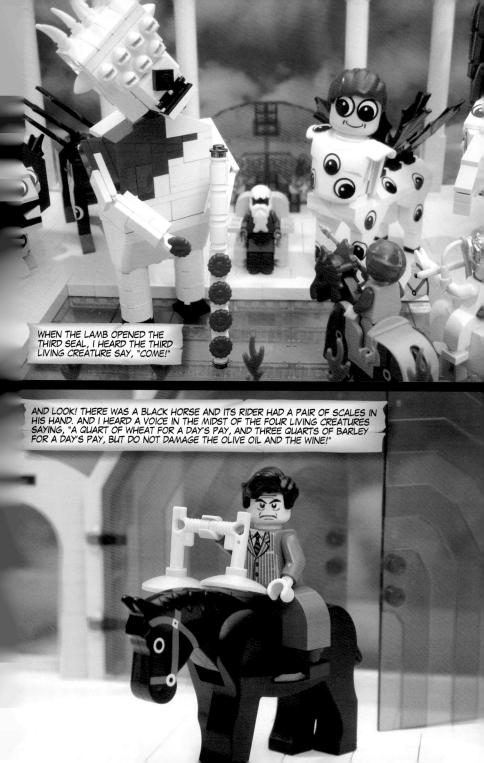

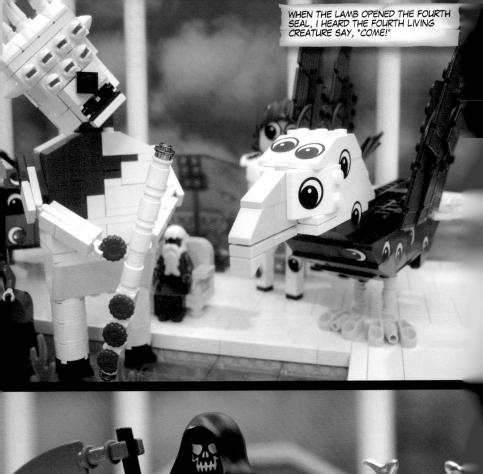

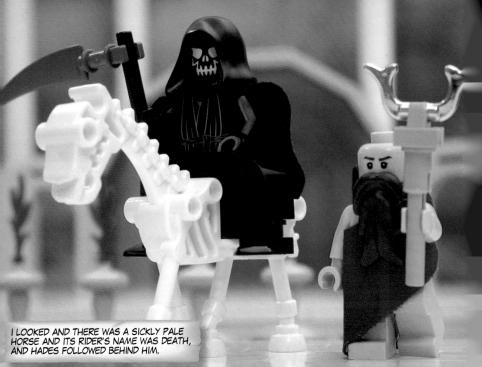

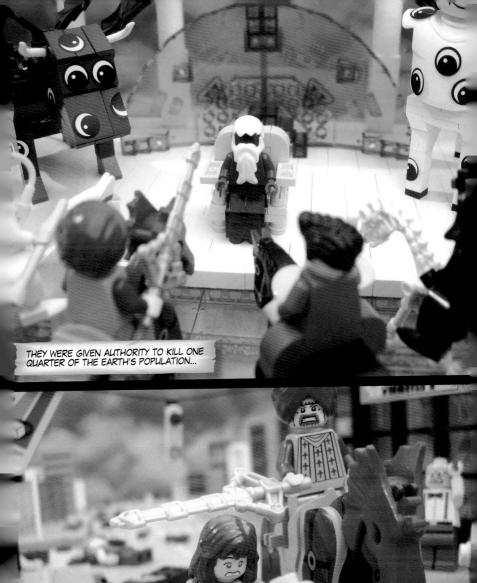

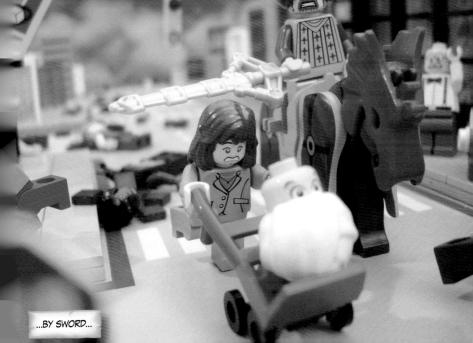

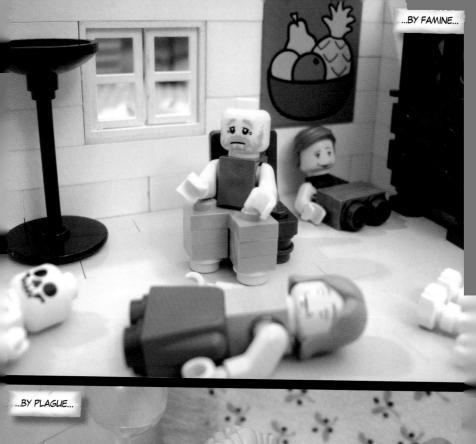

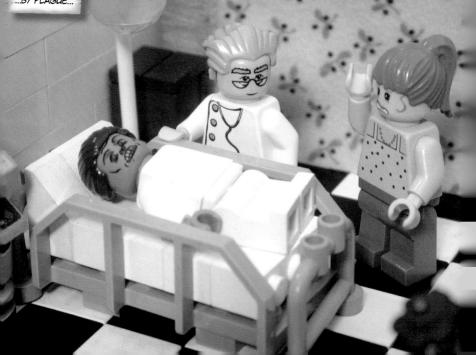

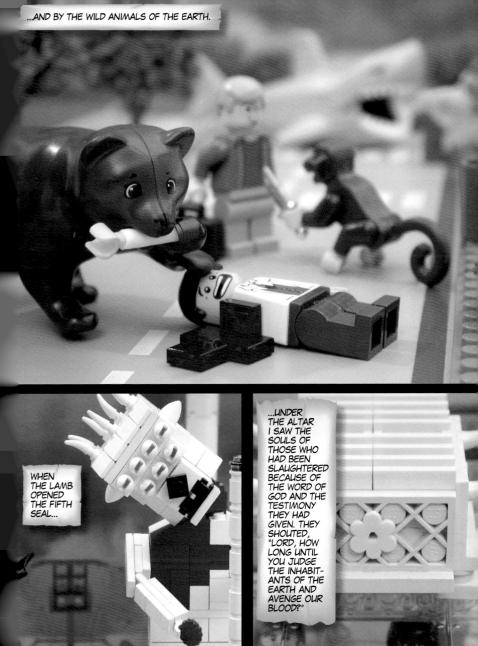

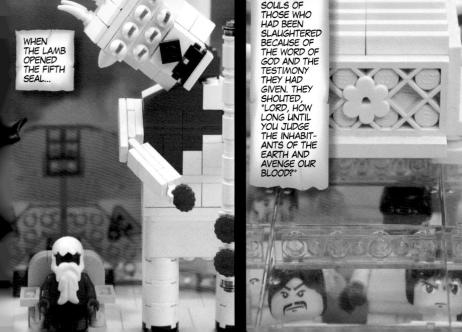

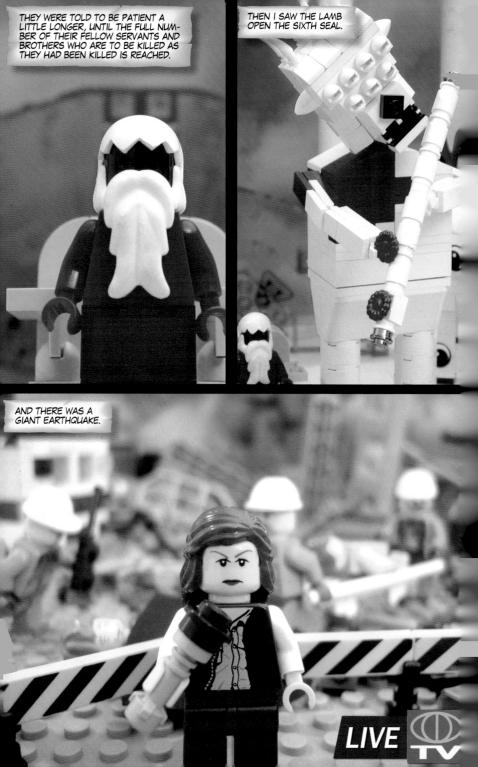

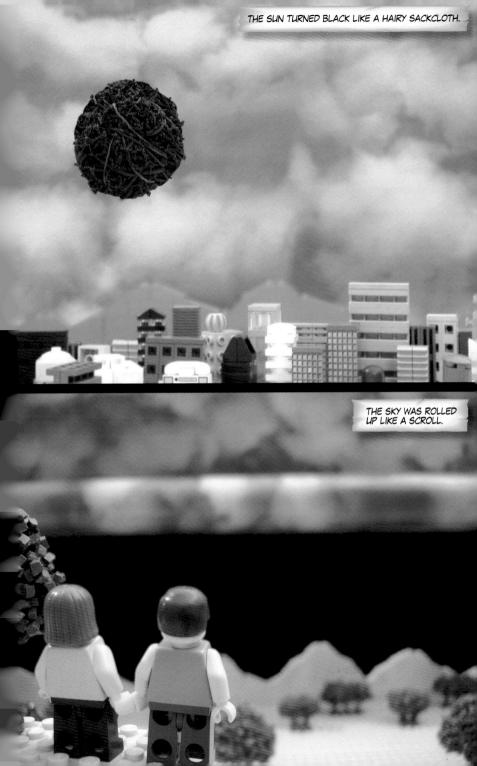

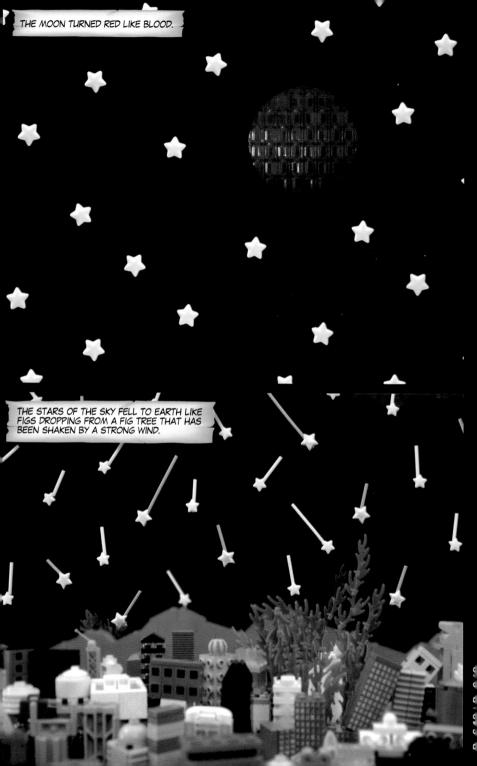

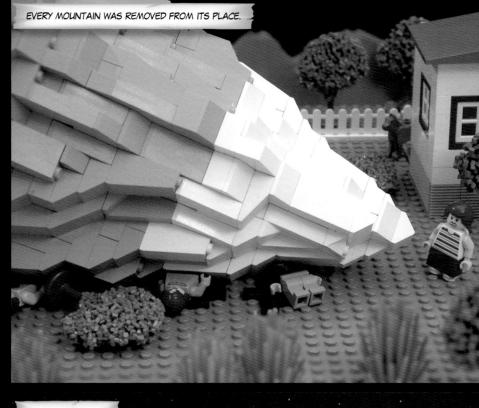

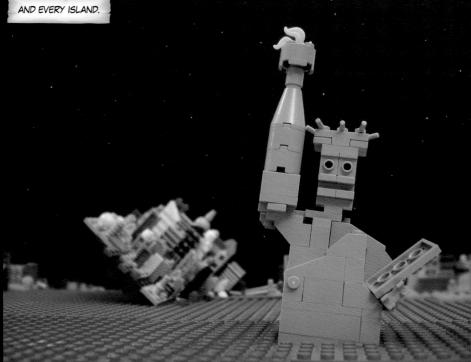

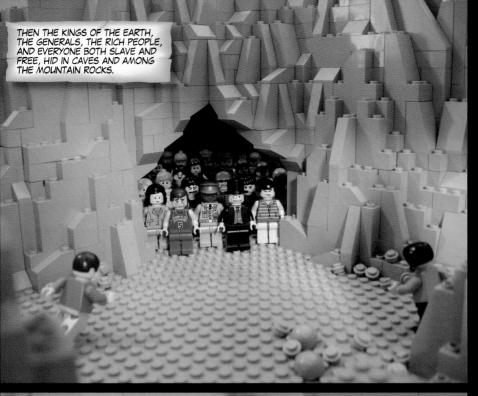

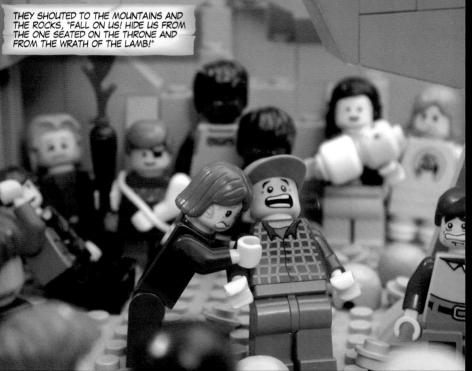

6.15 | Rv 6.16

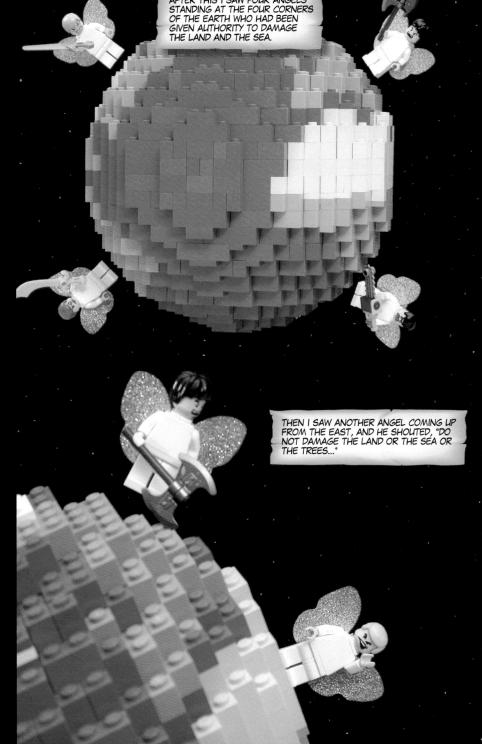

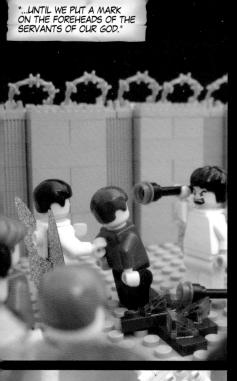

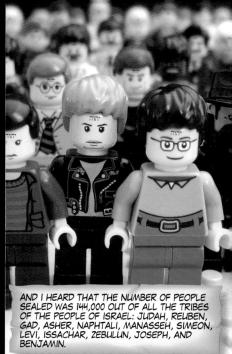

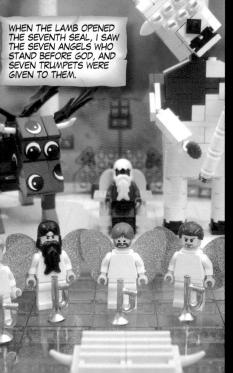

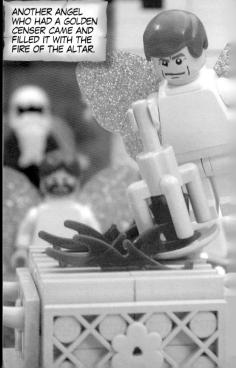

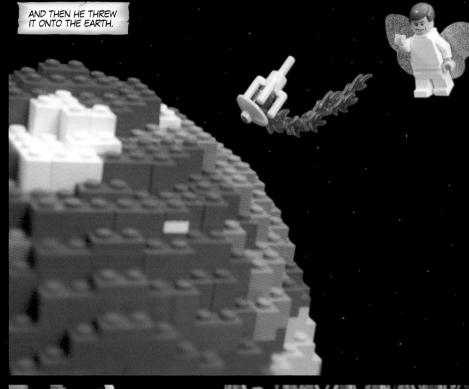

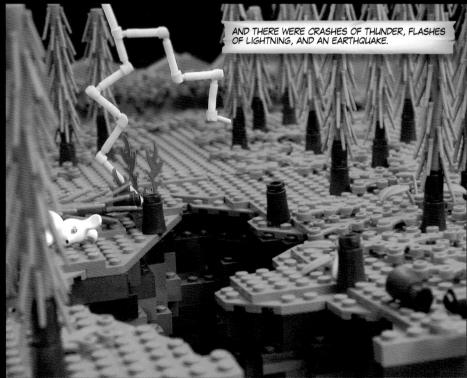

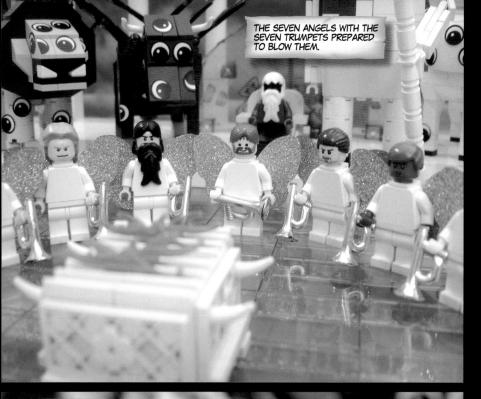

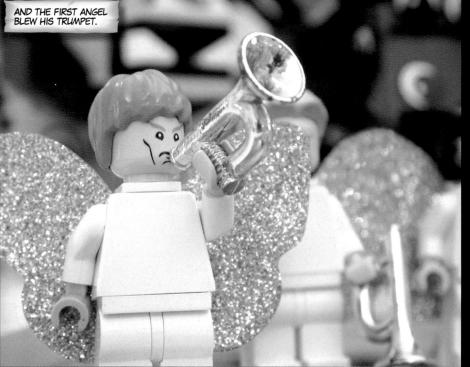

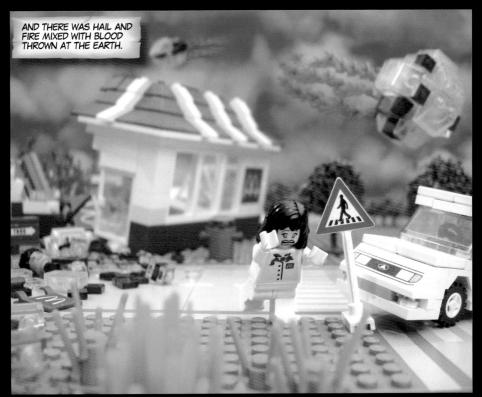

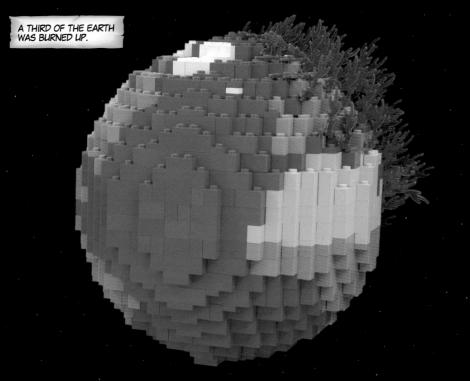

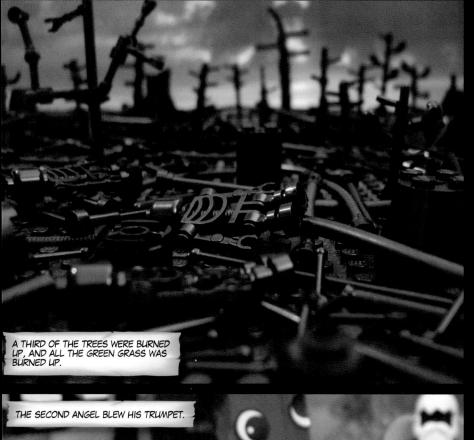

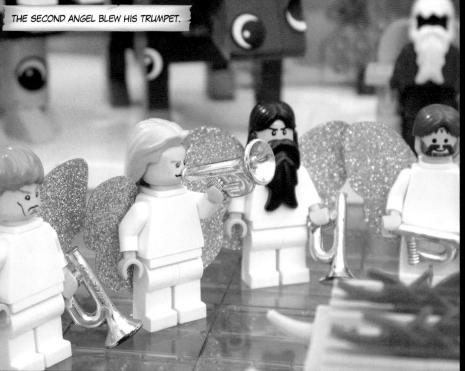

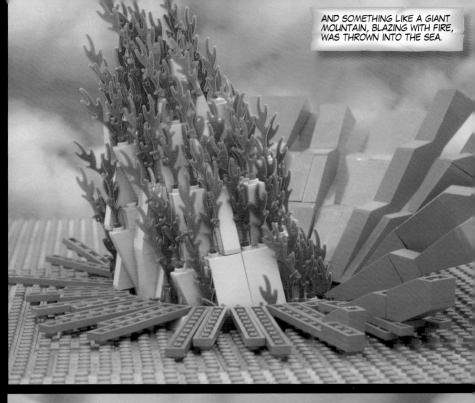

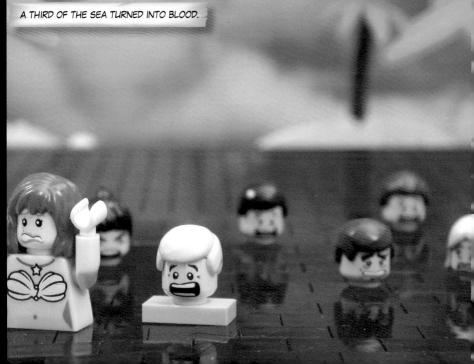

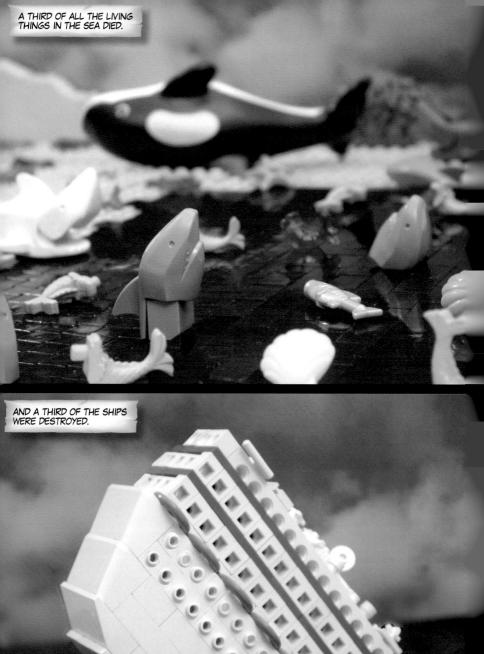

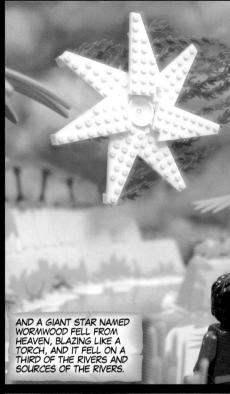

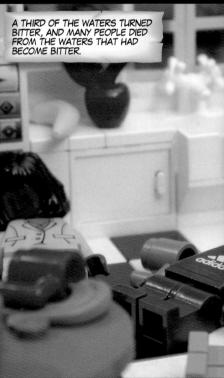

Rv 8:10 | Rv 8:10-11 | Rv 8:11 | Rv 8:12

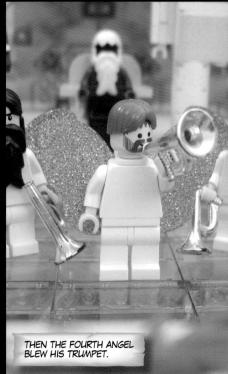

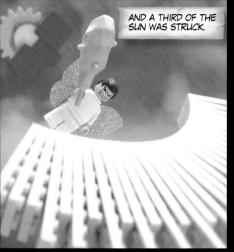

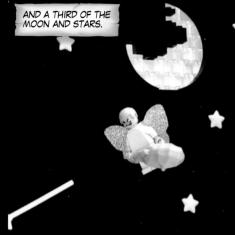

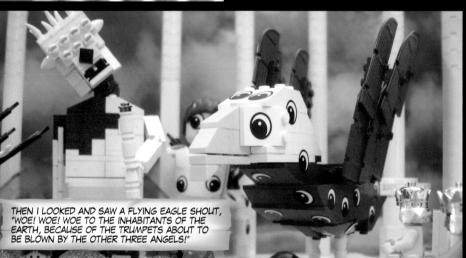

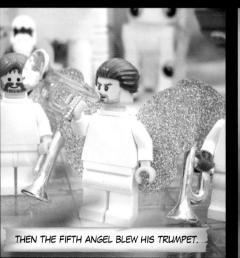

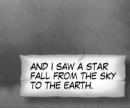

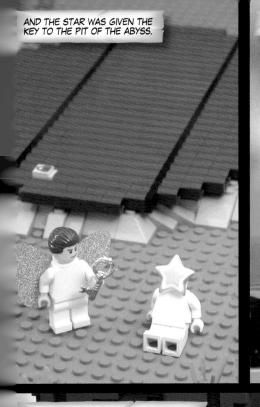

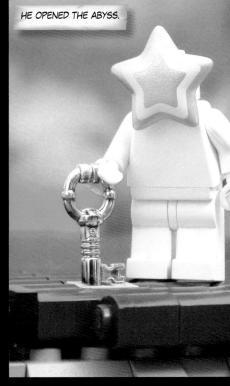

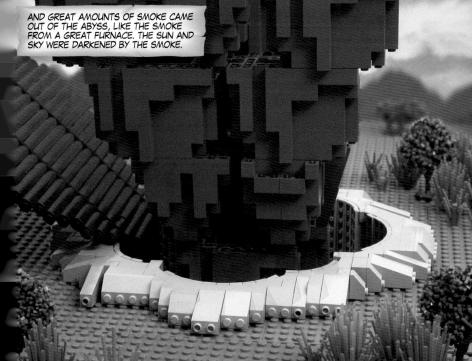

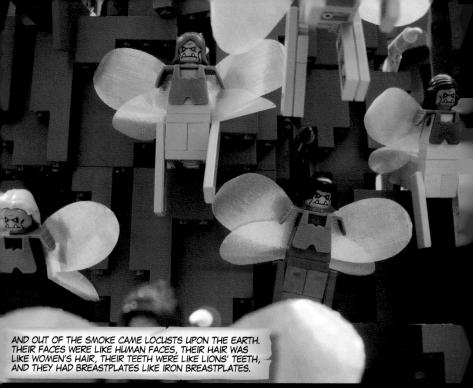

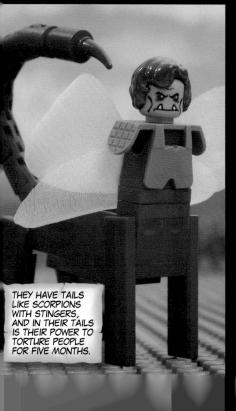

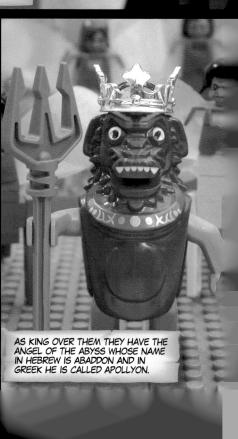

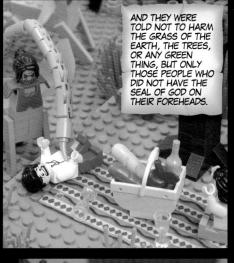

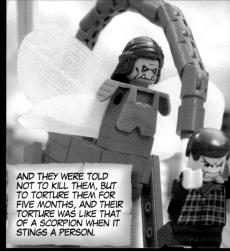

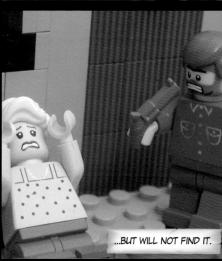

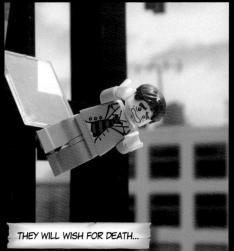

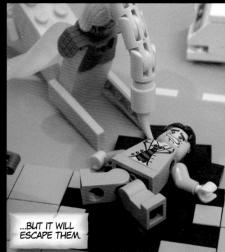

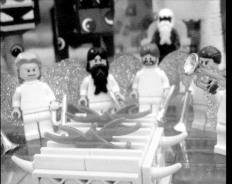

THEN THE SIXTH ANGEL BLEW HIS TRUMPET, AND I HEARD THE GOLDEN ALTAR SAYING TO THE SIXTH ANGEL, "RELEASE THE FOUR ANGELS WHO ARE BOUND AT THE GREAT RIVER EUPHRATES."

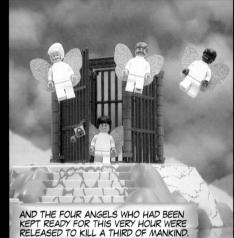

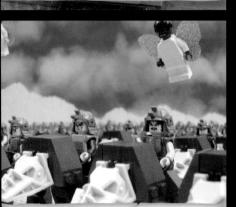

THE NUMBER OF THE ARMY OF THE HORSEMEN WAS TWO HUNDRED MILLION. THE RIDERS HAD BREASTPLATES OF FIRE, OF SAPPHIRE, AND OF SULFIR. THE HEADS OF THE HORSES WERE LIKE THE HEADS OF LIONS.

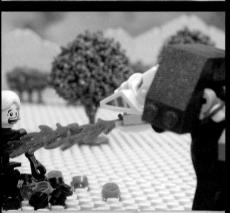

AND OUT OF THEIR MOUTHS CAME FIRE, SMOKE, AND SULFUR. A THIRD OF HUMANKIND WAS KILLED BY THESE THREE PLAGUES. BY THE FIRE...

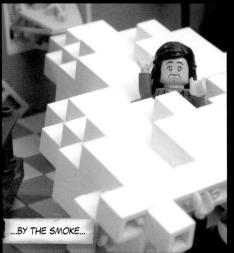

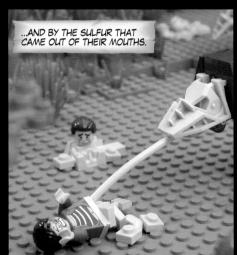

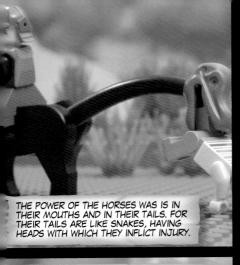

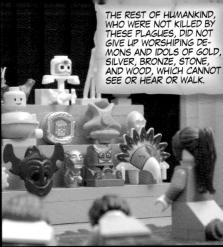

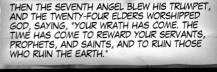

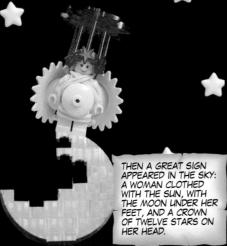

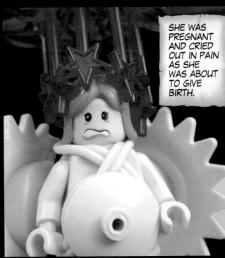

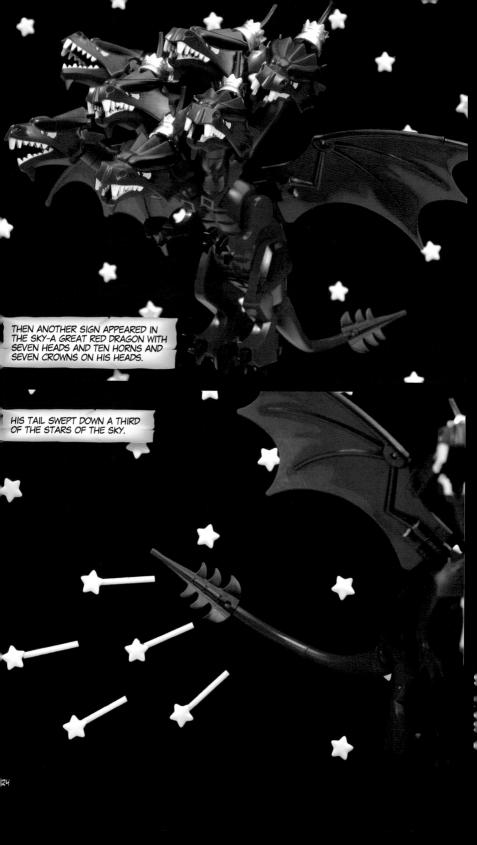

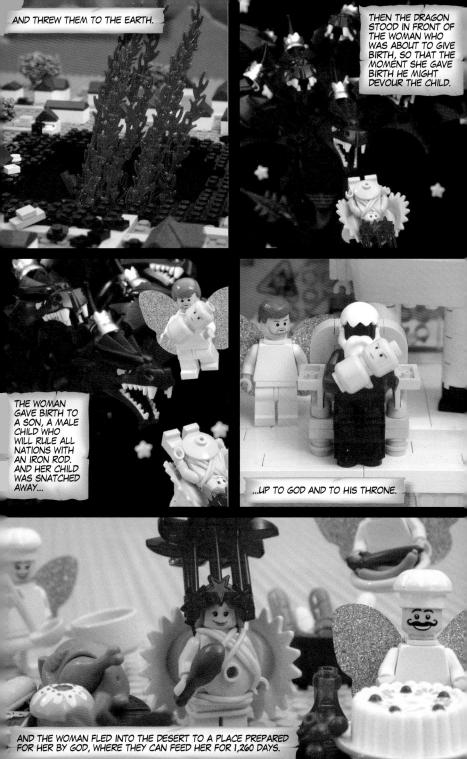

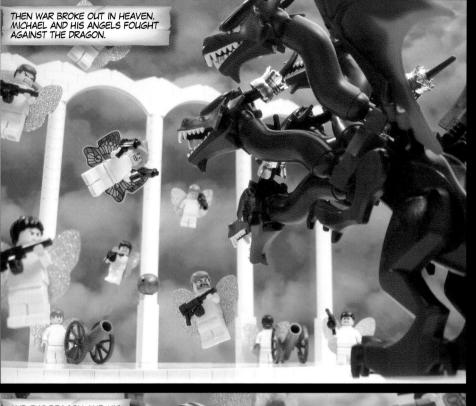

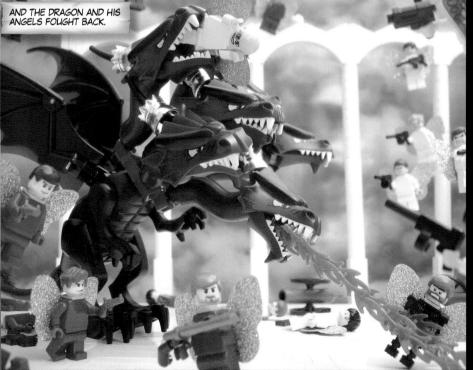

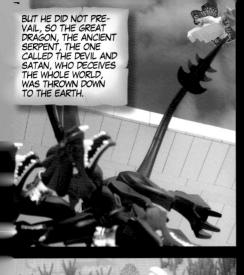

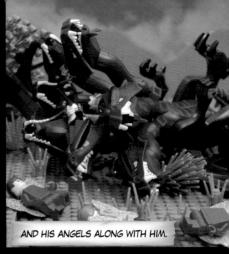

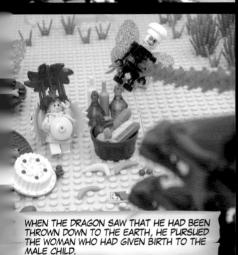

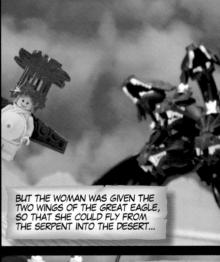

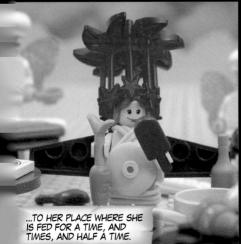

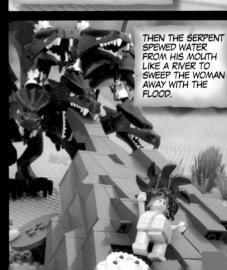

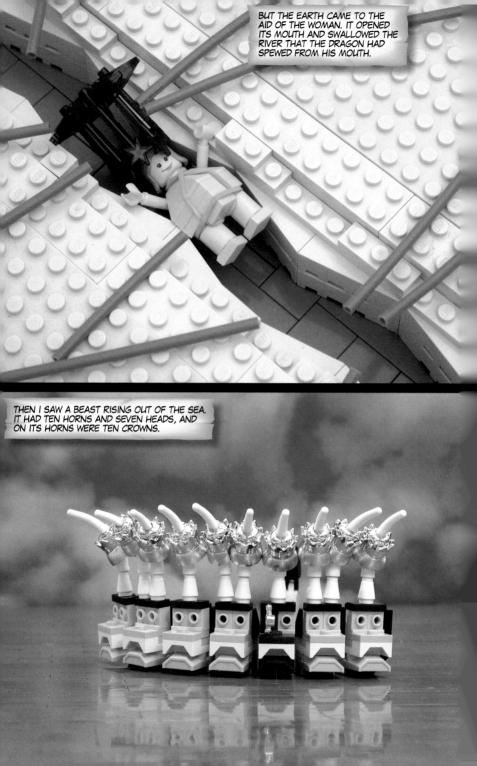

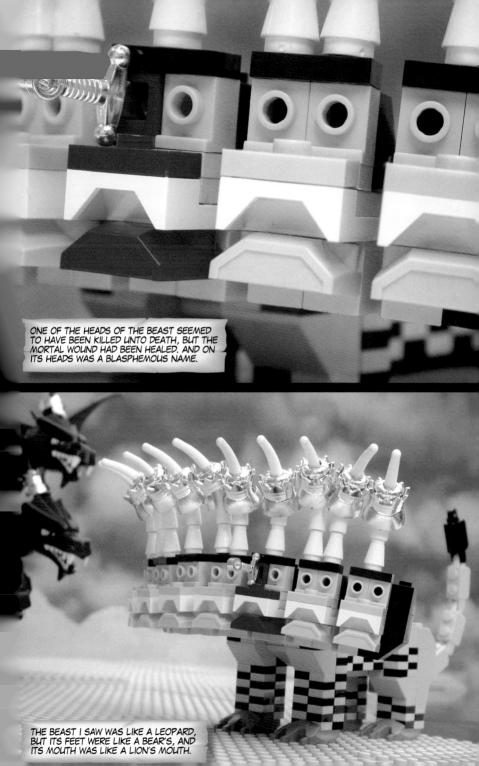

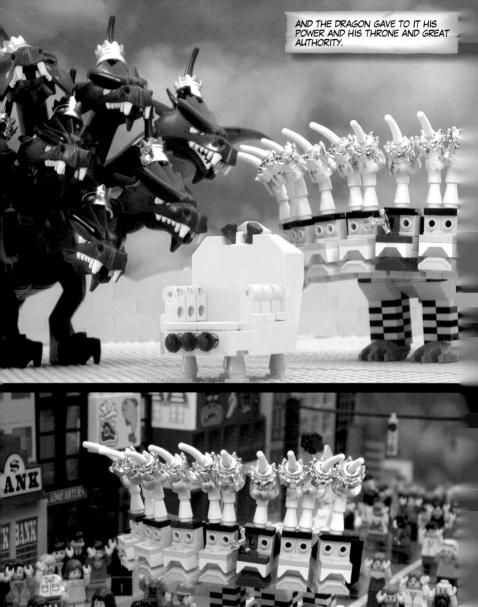

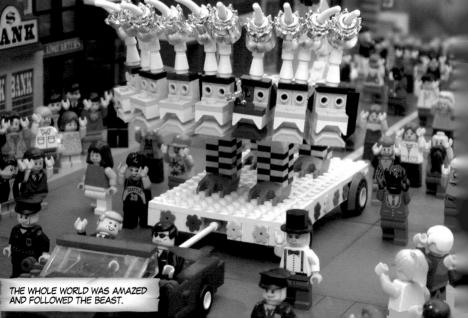

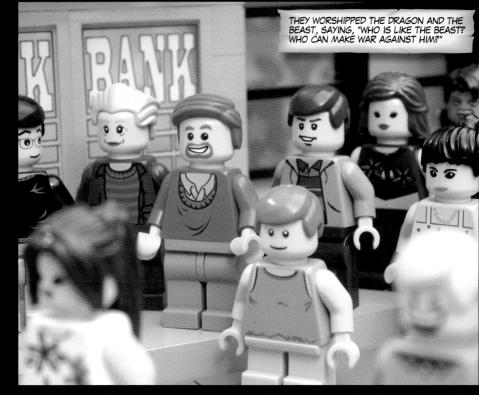

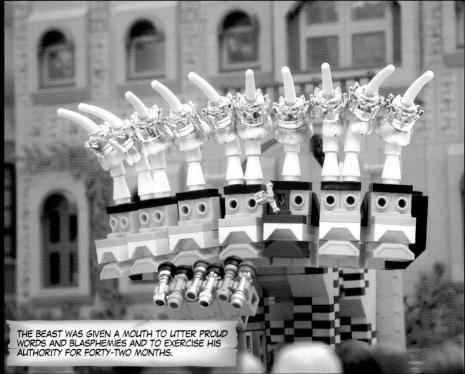

Rv 13:3 | Rv 13:5

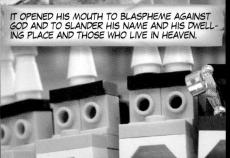

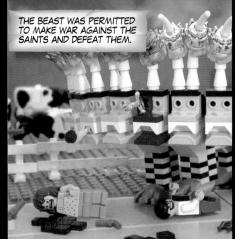

Rv 13:11

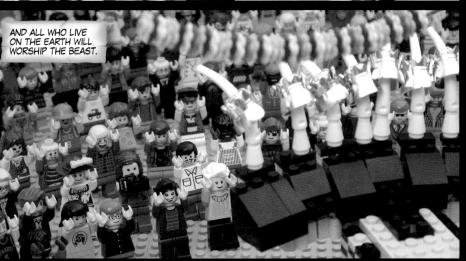

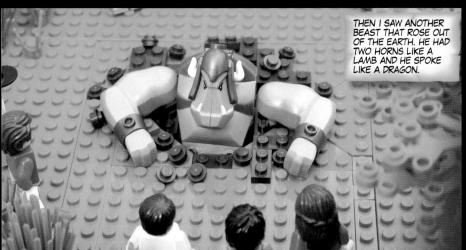

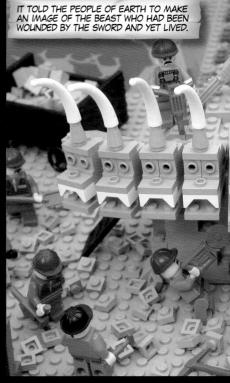

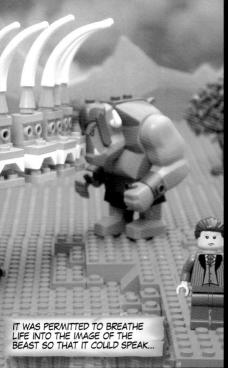

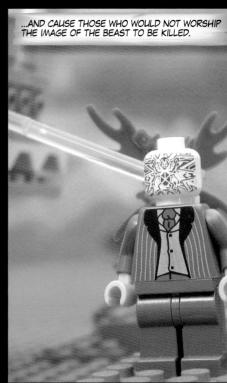

Rv 13:12-13 | Rv 13:14 | Rv 13:15 | Rv 13:15

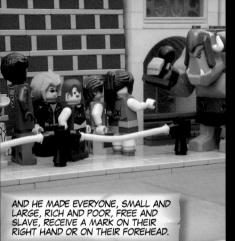

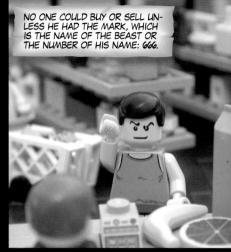

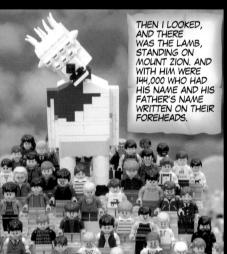

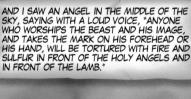

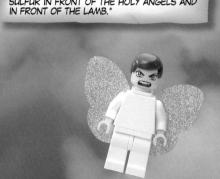

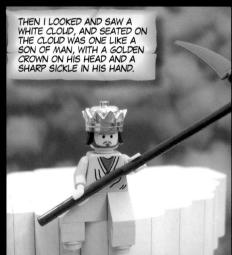

14:1 | Rv 14:4 | Rv 14:6, 14:9 | Rv 1

THEN ANOTHER ANGEL CAME OUT OF THE TEMPLE AND SHOUTED TO THE ONE WHO SAT ON THE CLOUD, "USE YOUR SICKLE AND REAP, FOR THE HOUR TO REAP HAS COME, BECAUSE THE HARVEST OF THE EARTH IS RIPE!"

ANOTHER ANGEL CAME OUT OF THE TEMPLE ANOTHER ANGEL CAME OUT OF THE TEMPLE AND IN HEAVEN, AND HE TOO HAD A SHARP SICKLE, AND ANOTHER ANGEL SHOUTED TO THE ANGEL WITH THE SHARP SICKLE, "USE YOUR SHARP SICKLE AND GATHER THE CLUSTERS OF GRAPES FROM THE VINES OF THE EARTH, BECAUSE ITS GRAPES ARE RIPE!"

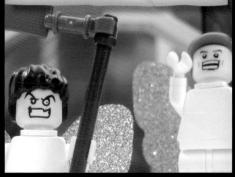

Rv 14:20

14:19 Rv.

Rv 14:19

Rv 14:17-18

Rv 14:16

14:15 R۷

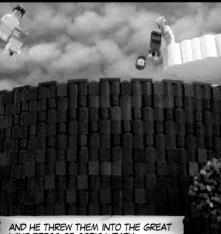

WINE PRESS OF GOD'S WRATH.

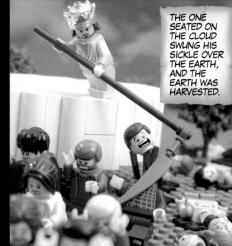

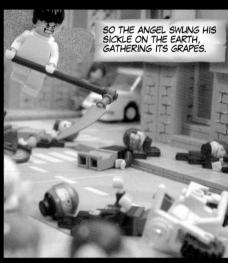

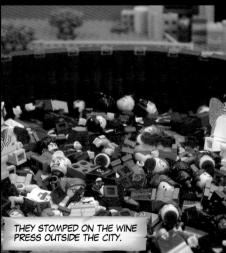

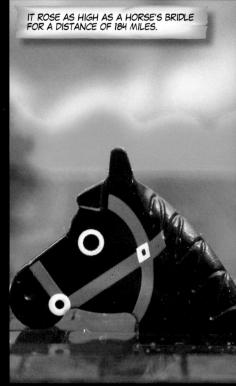

Rv 14:20 | Rv 14:20 | Rv 15:1, 16:1, 16:6-7

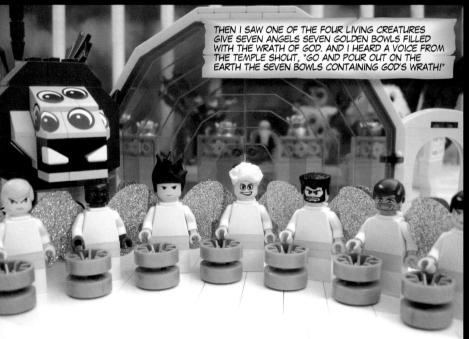

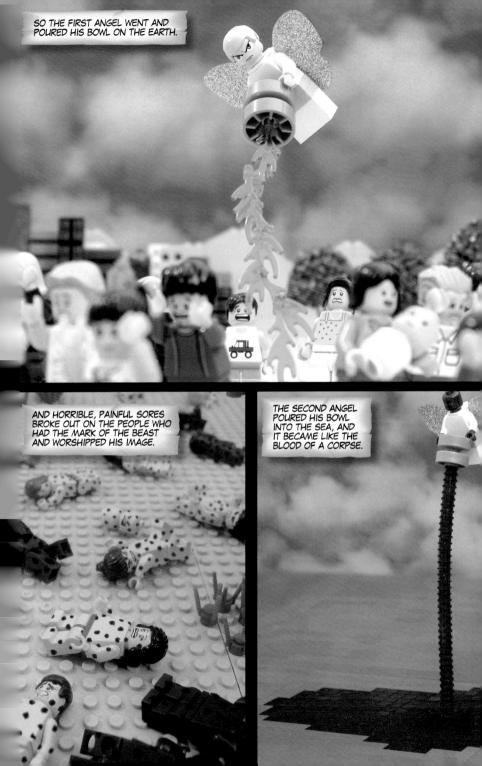

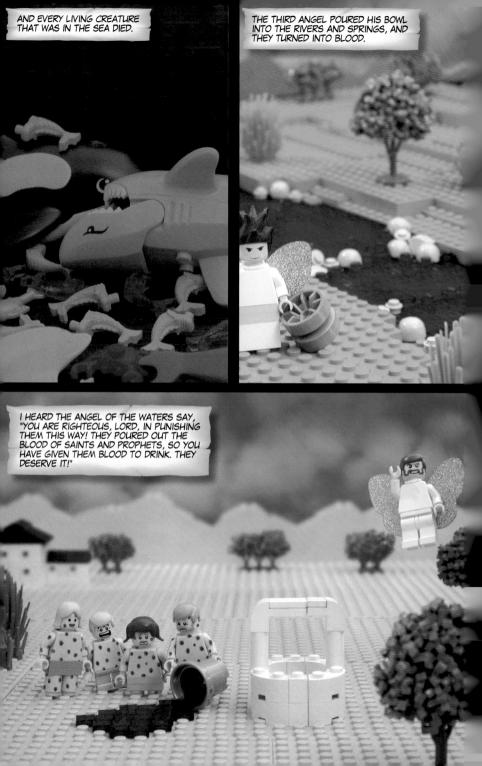

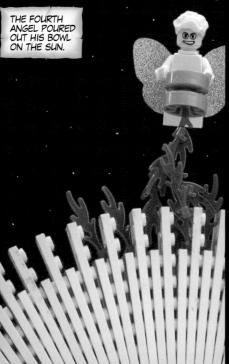

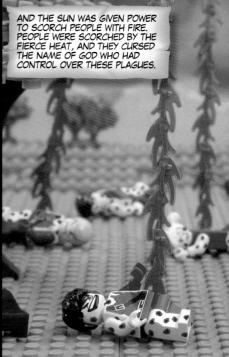

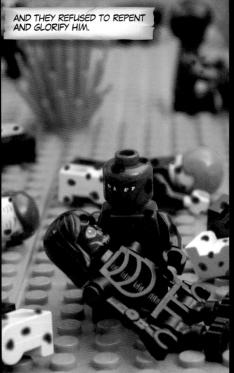

AND HIS KINGDOM WAS DARKENED. AND PEOPLE GNAWED ON THEIR TONGUES IN AGONY BECAUSE OF THEIR PAINS AND SORES. THEY CURSED THE GOD OF HEAVEN AND REFUSED TO REPENT OF WHAT THEY HAD DONE.

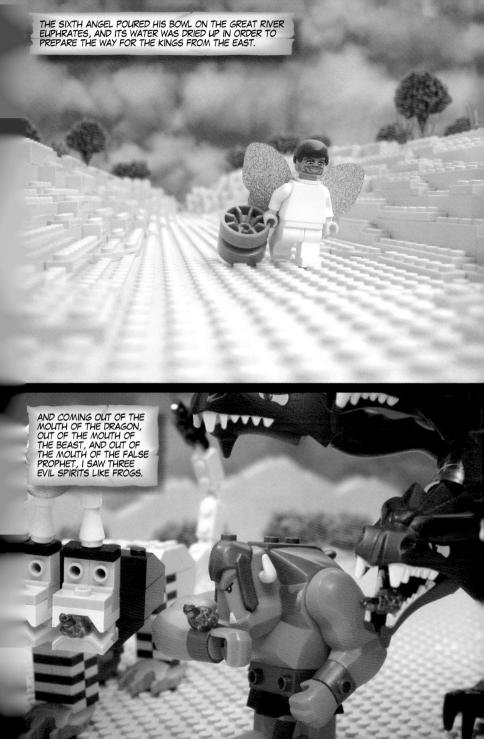

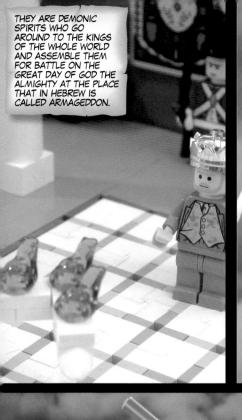

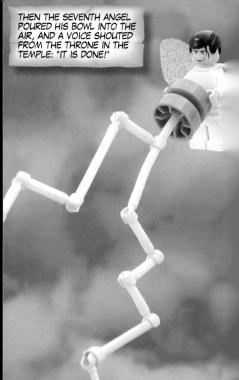

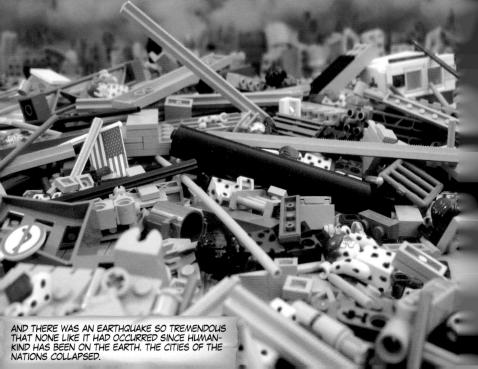

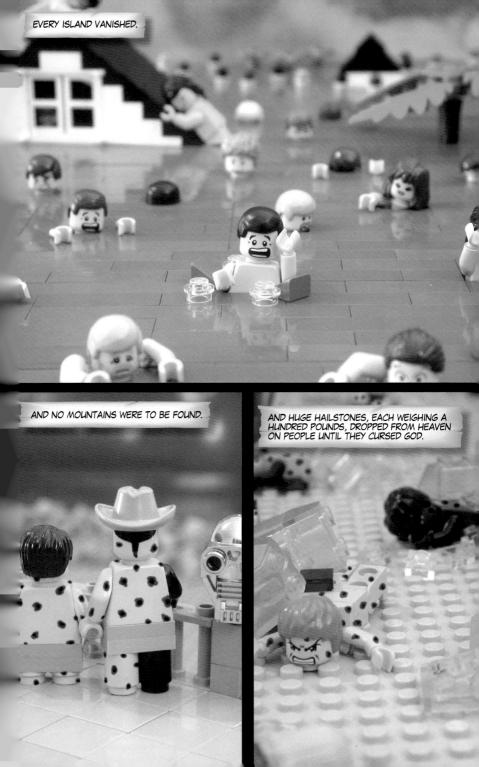

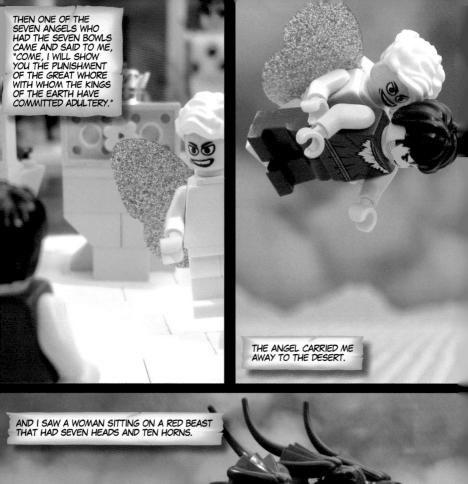

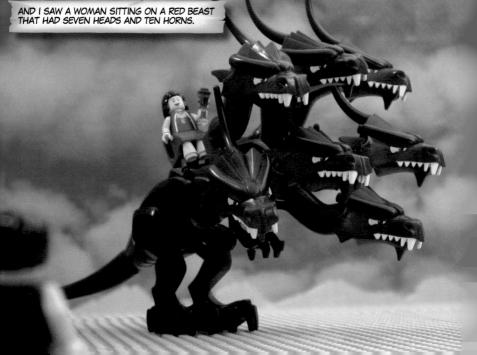

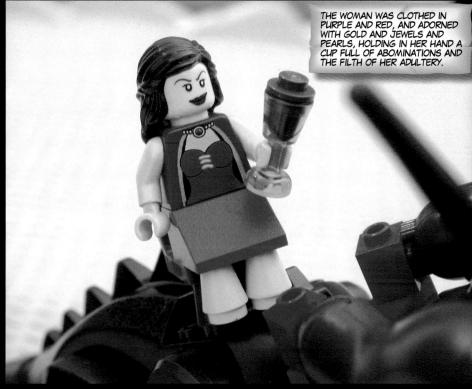

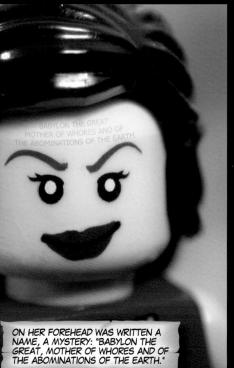

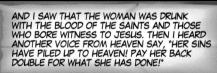

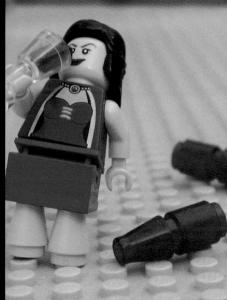

iv 17:5 | Rv 17:6, 18:

Rv 17:4 | Rv

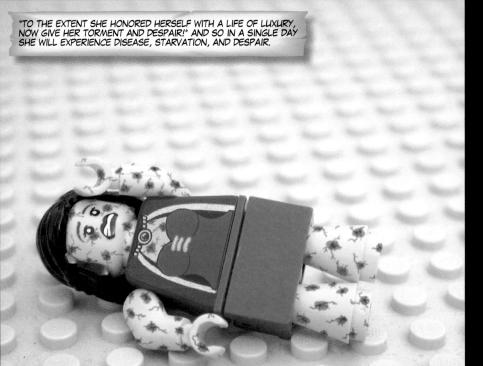

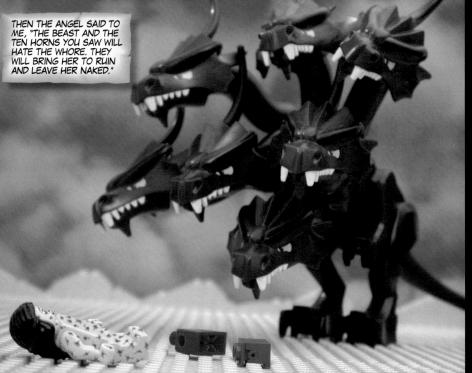

Rv 18:7-8 | Rv 17:15-16

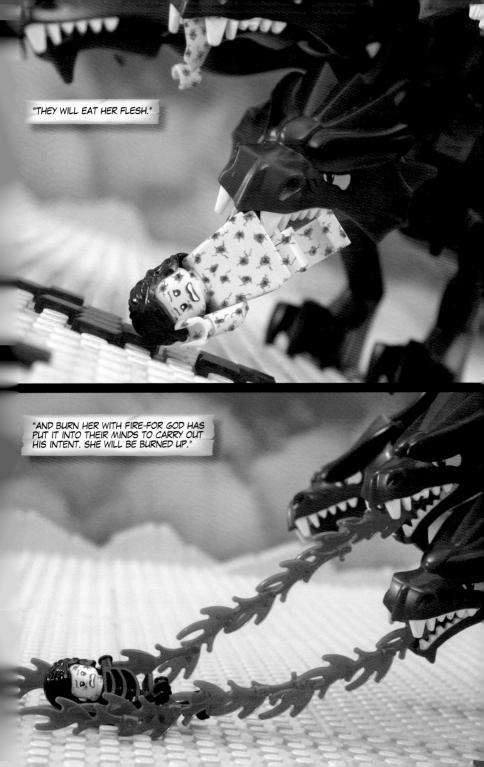

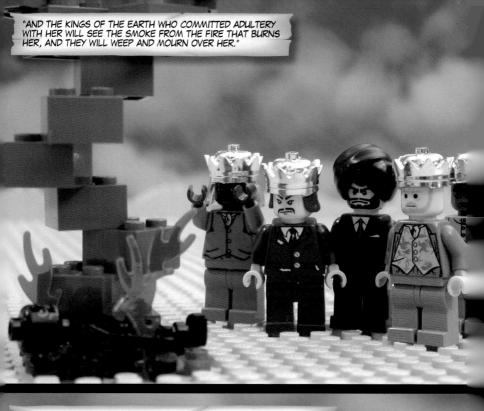

AFTER THIS I HEARD THE SHOUTING OF A GREAT MULTITUDE IN HEAVEN, SAYING, "SALVATION, GLORY, AND POWER TO OUR GOD! FOR HE HAS PUNISHED THE GREAT WHORE WHO CORRUPTED THE EARTH WITH HER ADULTERIES! HE HAS AVENGED THE BLOOD OF HIS SERVANTS!"

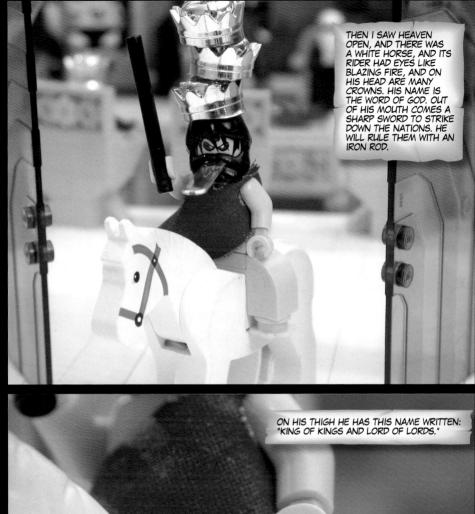

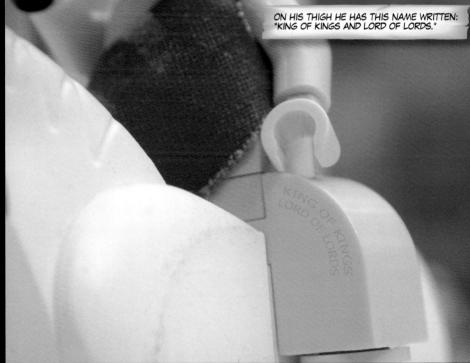

Rv 19:11-12, 19:15 | Rv 19:16

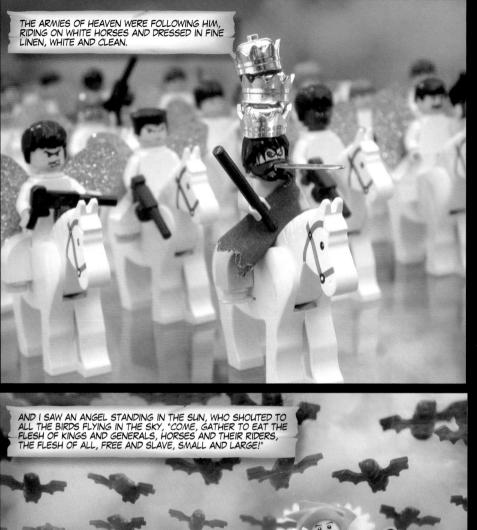

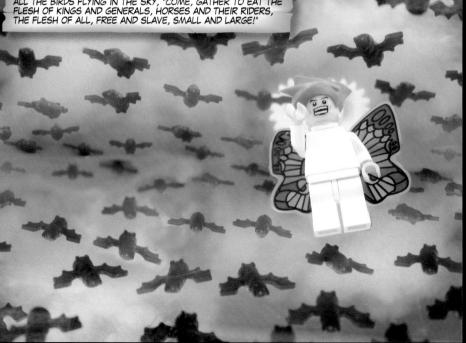

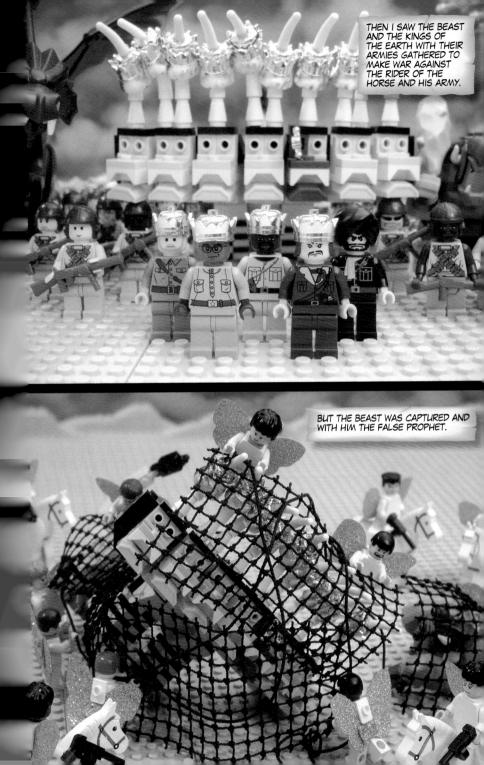

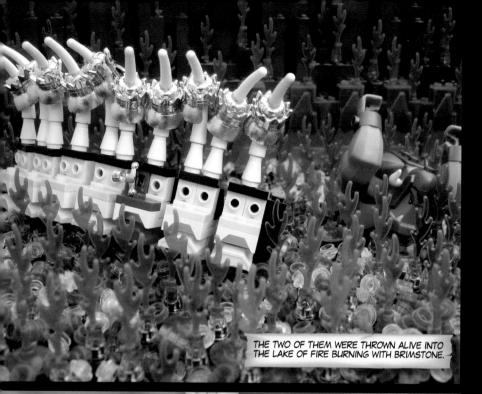

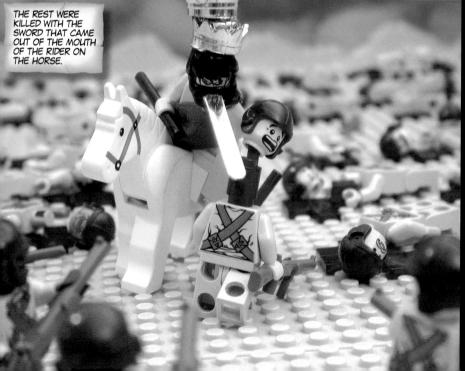

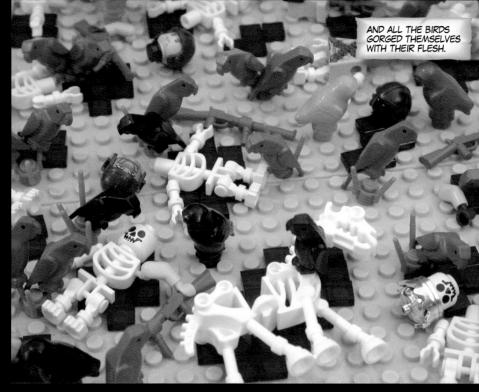

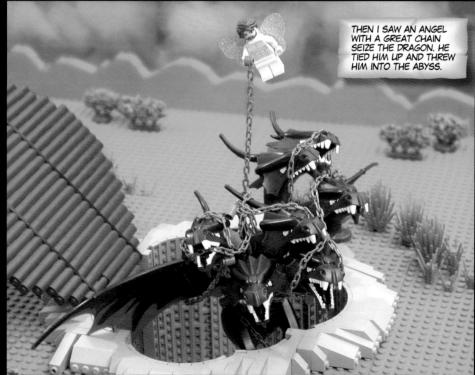

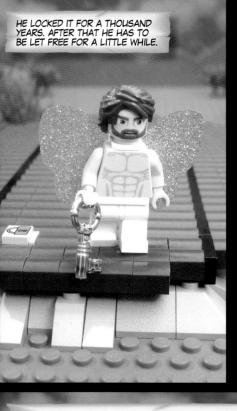

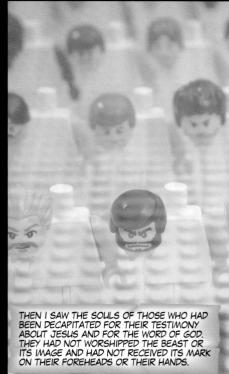

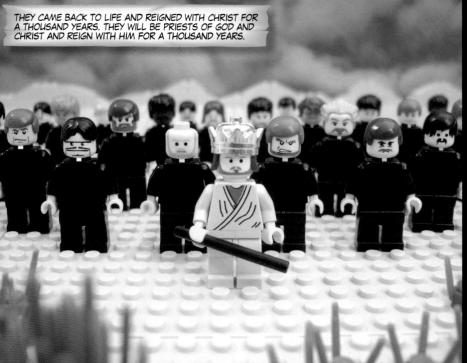

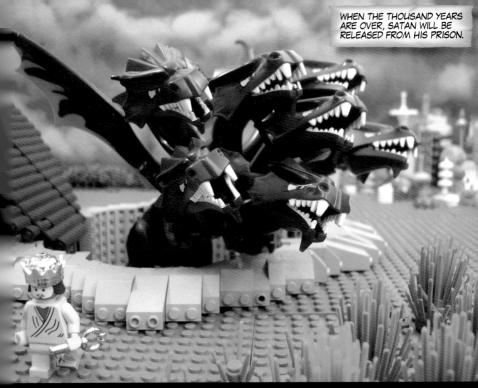

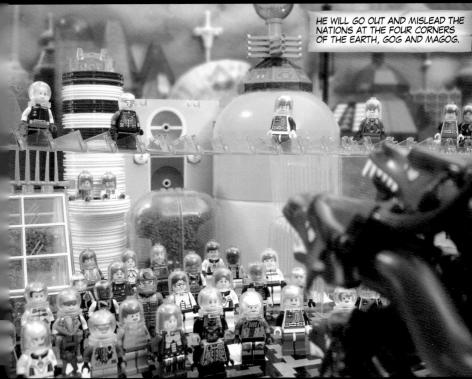

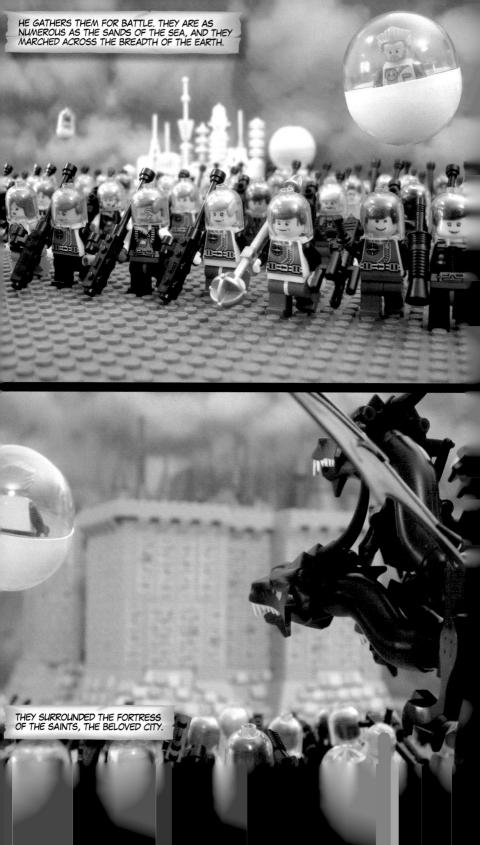

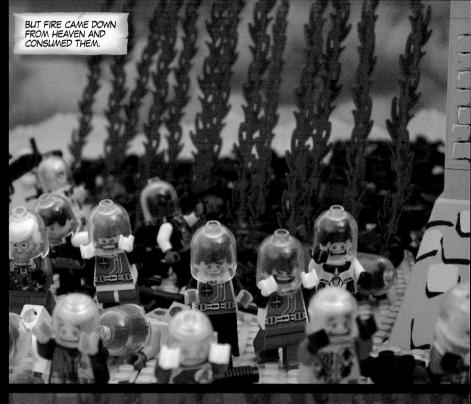

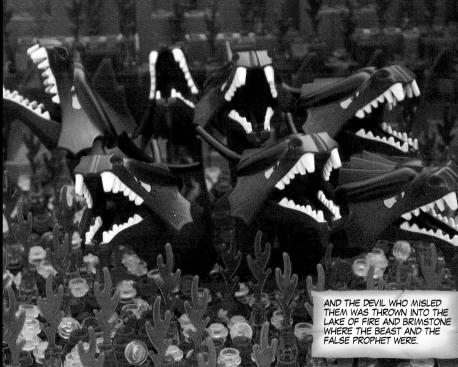

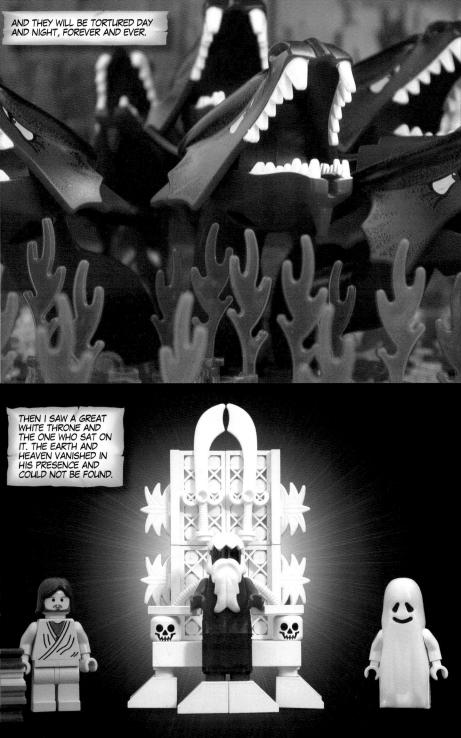

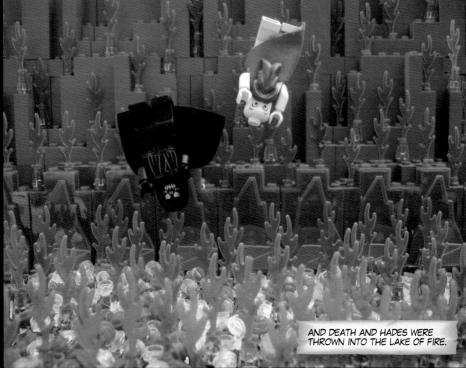

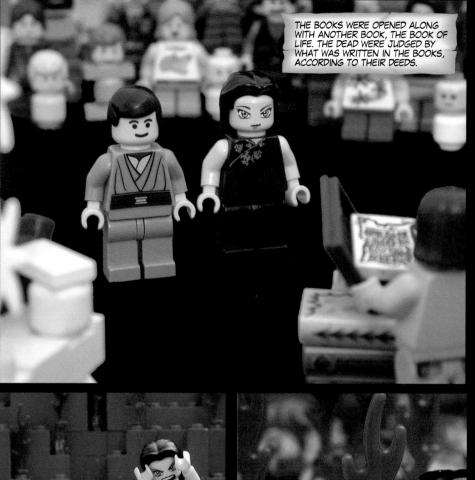

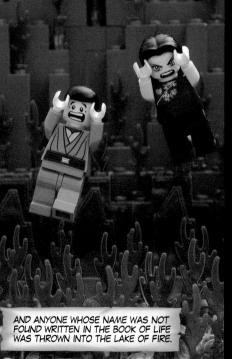

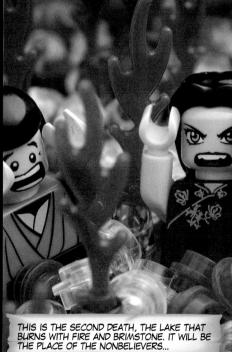

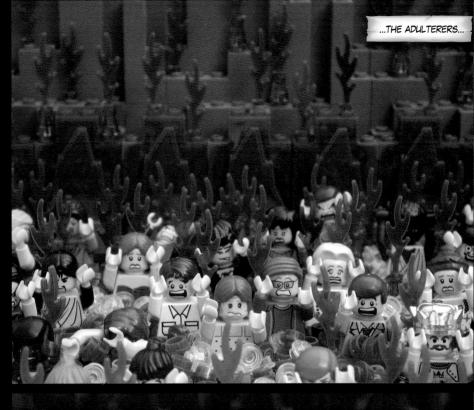

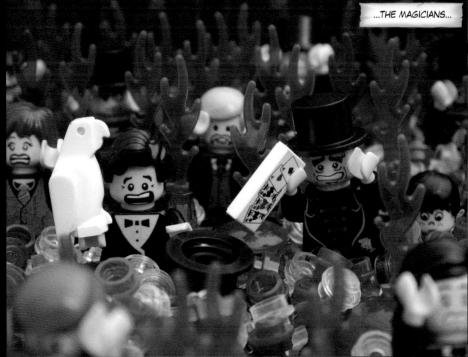

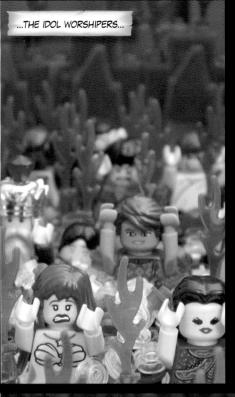

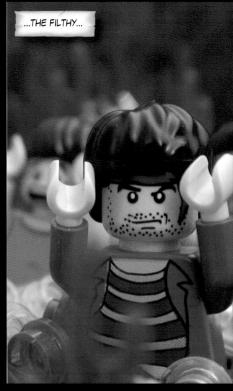

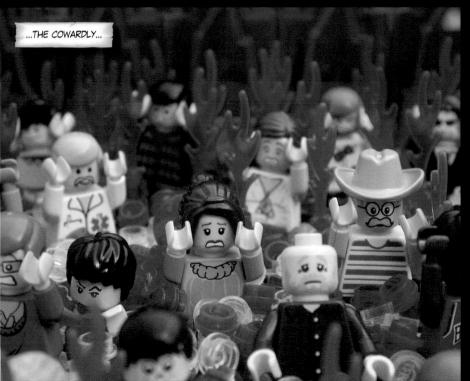

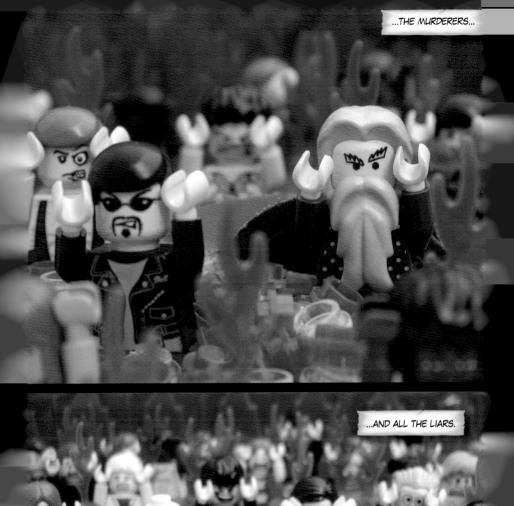

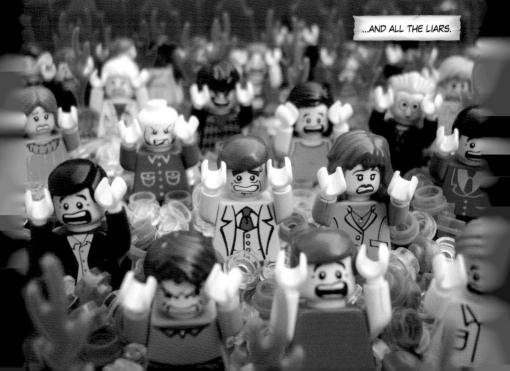

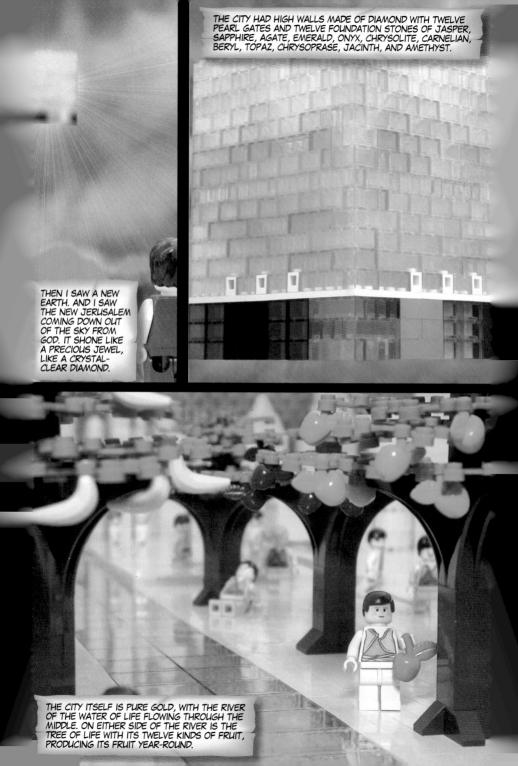

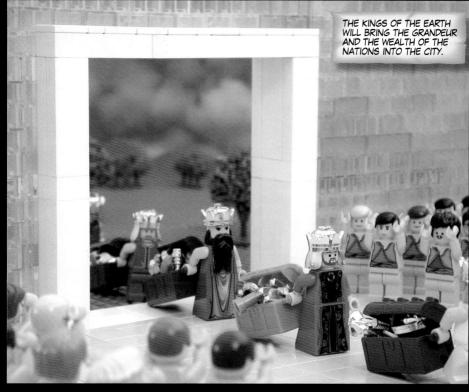

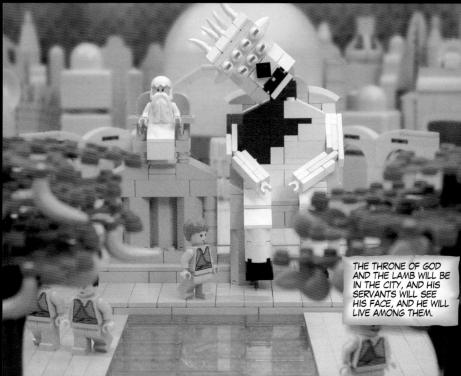

Rv 21:24 | Rv 22:3, 21:3

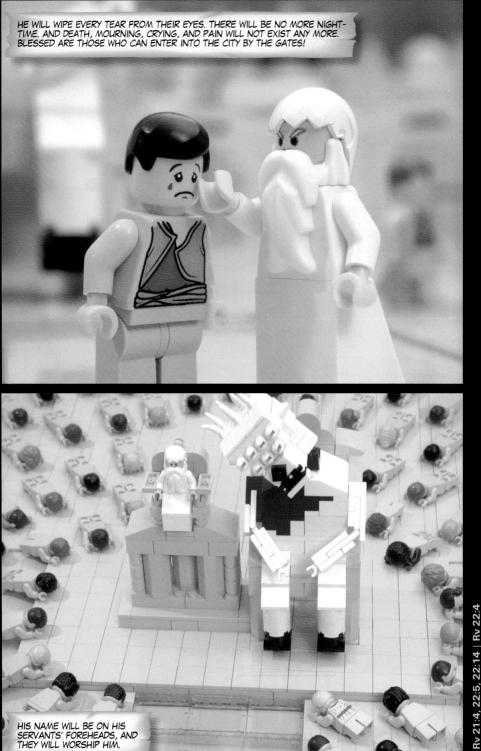

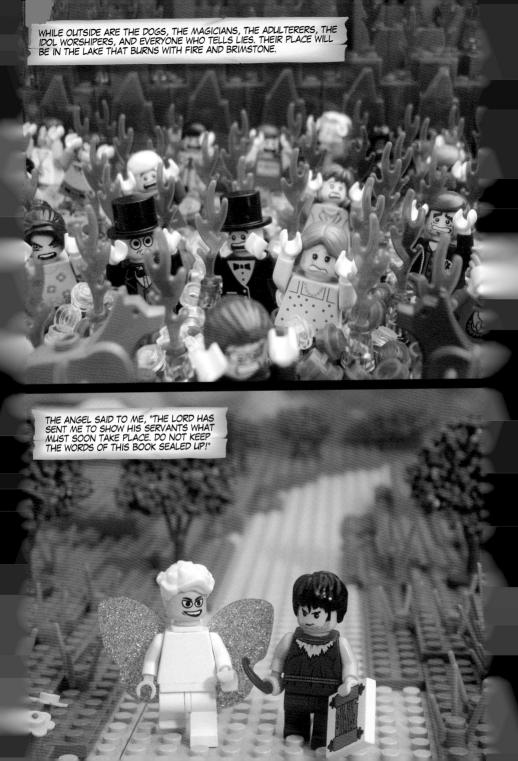

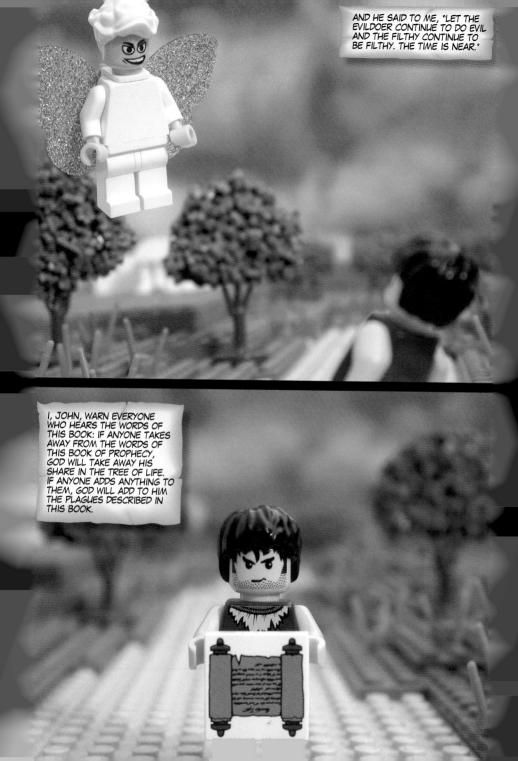

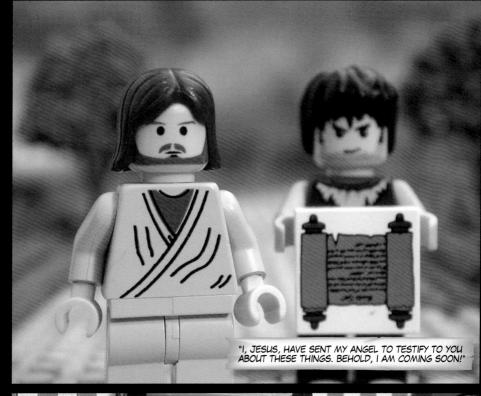

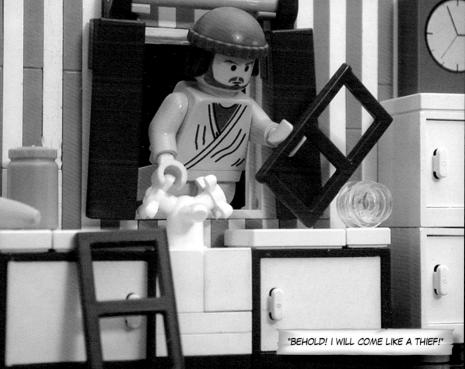

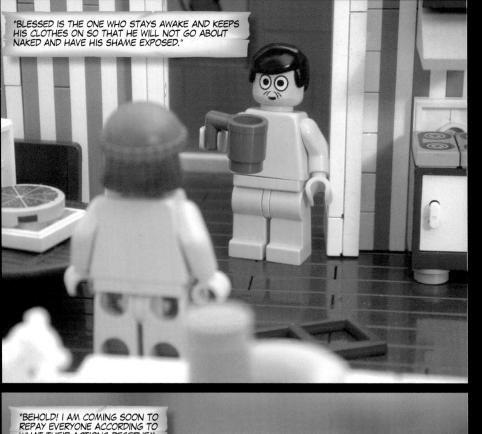

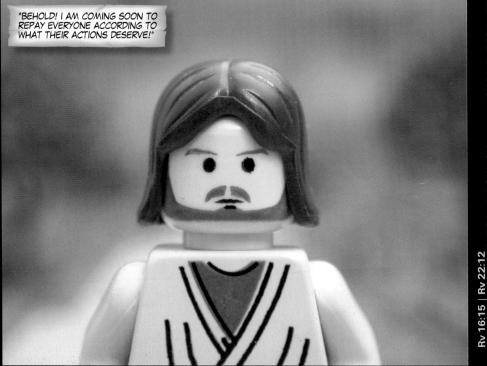